Literary value/cultural power

MANCHESTER
UNIVERSITY PRESS

Literary value/cultural power
Verbal arts in the twenty-first century

LYNETTE HUNTER
edited by Sarah Poulton

MANCHESTER UNIVERSITY PRESS
MANCHESTER AND NEW YORK

distributed exclusively in the USA by Palgrave

Published by Manchester University Press
Oxford Road, Manchester M13 9NR, UK
and Room 400, 175 Fifth Avenue, New York, NY 10010, USA
http://www.manchesteruniversitypress.co.uk

Distributed exclusively in the USA by
Palgrave, 175 Fifth Avenue, New York,
NY 10010, USA

Distributed exclusively in Canada by
UBC Press, University of British Columbia, 2029 West Mall,
Vancouver, BC, Canada V6T 1Z2

British Library Cataloguing-in-Publication Data
A catalogue record for this book is available from the British Library

Library of Congress Cataloging-in-Publication Data applied for

ISBN 0 7190 6181 4 *hardback*
 0 7190 6182 2 *paperback*

First published 2001

10 09 08 07 06 05 04 03 02 01 10 9 8 7 6 5 4 3 2 1

Typeset by Northern Phototypesetting Co. Ltd, Bolton
Printed in Great Britain
by Bell & Bain Ltd, Glasgow

CONTENTS

FIGURES

ACKNOWLEDGMENTS

The author, editor and publisher are grateful for permission to reproduce the following material: *Cat's Eye* by Margaret Atwood (London: Virago, 1989; 1997), covers reprinted by permission of Little, Brown and Company (UK). 'Letter Sycorax', in *Middle Passages* by Edward Kamau Brathwaite (Newcastle-upon-Tyne: Bloodaxe Books, 1992), reprinted by permission of the publisher. Medieval manuscript from Special Collections, in the Brotherton Library, University of Leeds, reproduced with the help of Chris Sheppard and by permission of the Library. 'The View' from 'Postcard Translations', in *Popular Narratives* by Frank Davey (Vancouver: Talonbooks, 1991), reprinted by permission of the author. Extract from *Drawing Down a Daughter* by Claire Harris (Fredericton, NB: Goose Lane, 1992), reprinted by permission of the author. Cover photographs from *WHO WILL BE IT?* by Susan Johanknecht, reproduced by permission of the artist. 'A Short History of Indians in Canada' by Thomas King, in *Toronto Life*, August 1997, reprinted by permission of the author. 'My Hometown …' by Emma LaRocque, reprinted by permission of the author. 'Love medicine' by Alice Lee, in *Writing the Circle*, ed. Jeanne Perreault and Sylvia Vance (Edmonton, AB: NeWest, 1990), reprinted by permission of the author. 'Kore' from 'Touch to My Tongue', in *Two Women in a Birth* by Daphne Marlatt and Betsy Warland (Toronto/Montreal/New York: Guernica, 1994), reprinted by permission of the author. 'To Nelson Mandela: A Tribute' by Andrew Motion, reprinted by permission of the author. Extracts from *The Martyrology, Book 5*, by bpNichol (Toronto: Coach House Press, 1982), reprinted by permission of Ellie Nichol. Extract from *Selected Organs* by bpNichol (Windsor, ON: Black Moss Press, 1988), reprinted by permission of Ellie Nichol. 'Journey Planner' from *253* by Geoff Ryman, www.ryman-novel.com, reprinted by permission of the illustrator, Roland Unwin. Extract from *Talking Animals/pisiskiwak kâ-pîkiskwêcik* told by L. Beardy, ed. H. C. Wolfart (Winnipeg: Memoir 5, Algonquian and Iroquoian Linguistics, 1988), reprinted by permission of the editor. Extract from 'The Patchwork Quilt' by Robin Melting Tallow, in *Writing the Circle*, ed. Jeanne Perreault and Sylvia Vance (Edmonton, AB: NeWest, 1990), reprinted by permission of the author. Excerpt from *The Question of Things Happening: The Letters of Virginia Woolf, Volume II: 1912–1922*, ed. Nigel Nicolson, copyright © 1976 by Quentin Bell and Angelica Garnett, reprinted by permission of Harcourt, Inc. Extracts from *The Letters of Virginia Woolf* by Virginia Woolf, the executors of the Virginia Woolf Estate and Hogarth Press as publisher published by Hogarth Press, used by permission of The Random House Group Limited.

This book is published with the help of a generous grant from Gresham College, Barnard's Inn, Holborn, London.

PREFACE

So many of us use words in ways we want others to value. We write letters, emails and poems. We tell stories to our children or our friends. Human beings have done this as far back as history can record, and the verbal arts are an intrinsic part of all societies. Indeed they have become a defining element in national cultures. Today we have education systems, the commercial arena of publishing and bookselling, and increasingly the world of electronic media, all laying claim to the knowledge of literary value in the name of cultural power. At the same time more and more of us are writing, reading, speaking and listening, and making up different communities that value the verbal arts in ways rewarding to ourselves. As the separation between what used to be called 'high art' and 'popular culture' dissolves, there is a real problem for many of us in deciding what to read, or to whom we want to listen. This book tries to look at a number of areas in the verbal arts that have been made peripheral in conventional criticism and aesthetics, and to ask how, given their importance to their communities, they might be valued.

The twentieth century not only saw people in many countries given the vote and hence technically given access to political power and social change, but also saw many people claiming access to cultural power. Although the verbal arts have been part of society, for social, economic and geographical reasons, not to mention political, they have been preserved only in small part. Valued literature, what university literature courses often now refer to as canonical writing, has held the prime place of recognition and reward. Yet as many critics such as Terry Eagleton and, more recently, Steven Connor have pointed out, this literature defines a privileged arena that was written and read by the privileged few. Increasingly, from the early twentieth century, more people from more diverse parts of society have been contributing texts and finding readers who value them. Much of this explosion of text was first controlled by the elaboration of genre, with publishers and booksellers expanding on devices in writing and speaking that defined the opening 'handshake' of recognition between the text and its audience, and carving their shelves up into 'travel writing', 'humour', 'science fiction and fantasy' and the like. The explosion has been temporarily contained by the construction of alternative or parallel canons – of women's writing, Black writing and so on. But more and more the plethora of genres and the generation of alternative canons, cannot cope with the sheer number and enormous diversity of writing and storytelling and, now, electronic text.

How do audiences choose what to listen to or read? How can we find or construct communities of other readers and writers, listeners and tellers, that are so important to valuing how we interact with words? If we democratise cul-

ture, what guidelines can be found not only for the gathering around similar interests that lies at the heart of fashion, but for the longer-term relationships that deal with and value differences? Democracy based on sameness works only within small, defined, self-interested groups, like the privileged white, proper-tied, mainly Christian and male class that dominated England from the late seventeenth century to the twentieth. Enfranchisement asks for a democracy that can account for differences as well. What is more, enfranchisement of cul-ture in the verbal arts means working out ways to value writing and reading, speaking and listening that does not necessarily fit easily into the guidelines offered by existing critical approaches.

These chapters are concerned to explore in simple terms what happens when we read or listen to texts that do not, in varying degrees, fit the criteria of canonical textuality. However, they are not concerned to propose yet more alternative canons. Rather, they try to explore how reading/writing, speaking/listening, can be situated within specific work so that labouring on texts becomes a way of communicating to other people, making communities, cohering needed values. The book begins by recapitulating recent commen-taries on the way that literary canons form, which is a fairly familiar story. It moves on to look at ways in which artists who do not find themselves adequately represented in existing ideas of literary value have responded, and asks ques-tions about the implications of changes in the verbal media of oral storytelling and electronic media for their responses. The chapters then turn to the many texts, from past as well as present, which have been perceived to be peripheral to 'valued literature', and discuss specific and different contexts in which valu-ations could be made, and activities that might be involved.

These chapters do not offer a theory that answers the questions, nor do they attempt to generalise. They are attempts into approaches that are only just beginning to open up. Working on texts in specific locations is what I have called 'situated textuality' in my recent book *Critiques of Knowing*. In situated textuality, much like situated knowledge which has been elaborated by Donna Haraway and the philosopher Lorraine Code, common grounds for value cohere not only around similarity but around the recognition of the differences in which we participate. The process is one of becoming a friend to the text, and through this activity building textual communities.

Among the many textual communities that supported me during the writing of this book I would like to mention three. First, there is the University of Leeds, where I work in the School of English and teach, among other things, on a number of courses in the postcolonial area. Second, there is Gresham College in London, which is a unique institution that offers free public lectures on eight areas of knowledge, with the remit to speak about leading research to a gen-uinely diverse audience. It was during the course of holding the Gresham Professorship in Rhetoric from 1997 to 2000 that I worked out much of the

following book. I am grateful to the College for the opportunity of doing so, to Maggie Butcher for encouragement and to the audiences for the testing and stimulating environment that challenged much of how I have been trained to think. The third community is that of my immediate friends and family who have prompted many of the directions of these essays. But in particular, working with the editor Sarah Poulton has offered an exceptionally supportive location for the development and cohesion of the book.

Lynette Hunter
Professor of the History of Rhetoric
University of Leeds

CHAPTER ONE

What is literary value?

This chapter argues the point that *many people simply do not know what literary value is any more.* Many universities in the UK teach little or no American literature, although this writing is a major English-language treasury. Fewer still teach the new literatures of the Commonwealth, which are arguably even more diverse and enriching. However, the fact is that we cannot teach, learn about or read literatures that do not get into print.

Book publishing is a capital-intensive industry that, over the past four hundred years, has developed an internal structure of editors and readers trained to gauge audience reception and marketing possibilities. Risks are rarely taken, although since the use of computer-assisted printing came in with the 1970s it has been more possible to do so. Over the last twenty years there have been waves of specialist publishers focusing on women's writing, or on English-language writing from particular Commonwealth countries, or on immigrant writing. For a short time these books feature prominently in the bookshops, but either are then assimilated into the run of other books or, more often, disappear completely. What is more, it takes a long time to learn how to read writing from cultures and places outside the ones we have been trained to recognise. All children in the UK are taught to adopt a conventional aesthetic response to the verbal arts for at least ten years, from the age of five to fifteen, and often longer: it is the keystone of their education. Adapting to very different criteria quickly and easily is impossible. The difficulty of the process is accentuated with drama because so much is 'left out' of the text, and is even more apparent with the literatures of the new electronic media. The chapter looks in particular at the way that contemporary American literature, because of more consistent publishing patterns for it in the UK, has had a chance to begin to enter the canon of English literature: to be reviewed in newspapers, discussed on media arts programmes, and taught in schools and universities. As well as discussing some of the authors who are left out, the chapter also asks why.

Rhetoric, communication and value

What is literary value? Throughout these chapters I will be asking this question, although they are not linked particularly in any other way. For this first chapter, I want to raise a few other direct and immediate questions related to 'What is literary value?': Do you read any more? If you do, how do you choose what you read? Do you ever get the sense that someone is choosing for you?

I do not expect you to have a specific answer, either to these questions or to the larger issue of value. Throughout the recorded history of writings about literature, oratory, storytelling or the verbal arts in general, people never have found a specific answer. One of the earliest texts on oratory, storytelling and the then new custom of writing talks about the way that we find what we value only through the interaction between speaker and audience, writer and reader: those communities that lie behind the word 'communication'. The idea of interaction comes from Plato's *Phaedrus*. This will be one of the few references I make to rhetoric, but, since I am a student of rhetoric, let me give you an idea of how I understand the term: rhetoric is, for me, the art of persuasion. In everyday English we tend to think of 'rhetoric' as manipulation, coercion and complexity – persuasion to do things we do not want to, and hence, bad. However, persuasion can also be towards 'good' action. We can never take for granted that people will know what a 'good' action is. Like me, I imagine that many of you have had the experience of changing your minds, with the attendant grim sense of humiliation, or possibly the joyous 'thank God I found that out before I did it'. Or, remember the horror and disgust in the summer of 1997 at the projected flogging and execution of two British nurses in Saudi Arabia, and the equally forceful surprise from Saudi Arabia that people in England did not seem to want justice to be done? Rhetoric is there precisely to deal with such differences. It does not deal with them by ignoring or eradicating them, because sometimes differences have to remain for a time and we need ways of continuing to talk to each other, but by providing the possibility of negotiation and discussion.

During the Renaissance, there was an interesting way of differentiating rhetoric from logic, which is also persuasive. Logic was symbolised by the 'closed fist', a fist possibly of anger, or aggression, and certainly closed in upon itself, in its own world. In contrast, rhetoric was symbolised by the 'open hand', the hand that gives, or that shakes hands, even

with people we are not sure we trust. You can see this close to home, in young children who cannot get their way over something because they cannot explain or get it into the right words. They stand with tense fists at their sides, frustrated. Almost inevitably, however, as they learn how to articulate, to discuss, it is often the adults who adopt the clenched fists, feeling outwitted, sometimes because they have been. Learning those skills with words is learning about rhetoric. Rhetoric's open hand always tries to form a community of communication.

I have spent a little time discussing rhetoric because it is fundamentally tied to value. It is the way people argue over, worry about and, frequently, come to decisions about value, so that they can act and do things. Yet for writing today, for the whole range of how we use words, value is a problem.

For instance, if I were to suggest that you should write down on a piece of paper the four most important writers in your life, you would probably want to know first what the list was for – Education? Revelations about your inner life? Representing your culture to another's? If the list were for education, I can almost guarantee that there would be a high level of consistency. When I have asked groups that I have taught about this, they invariably come up with Shakespeare, one nineteenth-century novel, one Romantic poet and, usually, a modernist such as James Joyce. The choice reflects the 'canon', that set of authorised and authorising texts that I will consider in more detail in a moment. If the list were for revealing inner life, it would be bound to be much more varied, although I would anticipate quite a bit of consistency depending on your age or cultural background. However, if the list were for reaching out to another community and saying, this is our best, or this best conveys what we value, would you choose important texts on the basis of style? Narrative? Culture? How could any one not put Shakespeare's writing on the list, even if they were not English? Except for the United States, there have been schemes of education modelled on the 'O' Level or GCSE, and the 'A' Level, to which Shakespeare has always been central, all over the English-speaking world, including in India, Canada, Australia, New Zealand and Jamaica. Claire Harris, who is from Trinidad and Tobago, says: 'We studied the British syllabus, then wrote exams set and marked in England. We learnt English folk songs, put on Gilbert and Sullivan. British gym mistresses taught us Morris dancing among other survival skills' (Harris 1986: 117). Read, for example, the following extract from the poem by Derek Walcott, 'Ruins of

a Great House'; the entire poem is filled with references to, among others, Horace, Shakespeare and John Donne:

> Stones only, the *disjecta membra* of this Great House [...]
> I thought [...]
> Of men like Hawkins, Walter Raleigh, Drake,
> Ancestral murderers and poets, more perplexed
> In memory now by every ulcerous crime.
> The world's green age then was a rotting lime
> Whose stench became the charnel galleon's text.
> The rot remains with us, the men are gone.
> But, as dead ash is lifted in a wind,
> That fans the blackening ember of the mind,
> My eyes burned from the ashen prose of Donne.
>
> (Walcott 1962)

Even if we work in a very different cultural world, can we leave out those common grounds for understanding? Furthermore, if we do include them, how do we make room for the other stories, songs and poems more immediate to our culture and society?

Education and the canon

What gets into, and what stays out of, the canon is decided largely by an interlocking relationship between education and publishing, and I will now look at both in turn, starting with education. In the 1860s to 1870s, Matthew Arnold and others proposed and saw through the passing of the Education Acts. Among the many problems he was faced with was that of what the pupils were to learn. The 1870s were, in effect, revolutionary: suddenly, within ten years, every city, town, village and hamlet in England had to teach its young people between the ages of six and twelve. Space had to be found, which meant that in many places schools were built, a lot of which are still with us causing problems today. What is more, children had to be habituated to going to school, teachers found and decisions made about what to teach. The teachers were frequently women, or impoverished men, neither with sufficient income to buy several copies of books by individual authors. As a result, Arnold and his associates compiled a textbook, which was an anthology of the texts thought most appropriate for teaching the young people of England. The textbook also made it possible to examine them all on the same basis.

Arnold's anthology brought together valued literature for teaching. Among other writing, it contained work by Shakespeare, Pope, the Romantic poets who had been so influential on Arnold's generation, and writing by his friends: Tennyson, Browning and Arnold himself. It was class-specific to the upper-middle classes (with the exception of Shakespeare), and it was writing wholly by men. This should come as no surprise. After all, Arnold lived in a period when the value of English writing was going through enormous upheaval. Writing of any kind takes education and time, and if you are writing to earn a living, time is short. It was only in 1709 that writers were legally recognised as having any right over their published writing; when copyright was invested in the writer, the writer became an author and could control the money earned from their writing. Yet it was only just over a hundred years ago, in the late nineteenth century, that they really started to exercise this control. Although writers today would no doubt claim that they were not paid sufficiently.

That writers started to be paid a reasonable wage was one of the many revolutions brought about by Charles Dickens, who was himself the archetype of the lower-middle-class man 'made good'. One of the best known examples of his help was the contract negotiation he worked on with Elizabeth Gaskell, who had received a pittance for her first book, but went on to make £200 for the second. While not much by Dickens's standards, £200 was still no mean sum. Curiously enough, it was during the latter part of the nineteenth century that writing in English came to be valued so highly that it could be taught for the first time in universities, along with the classics. Writing for money had been long-despised; even putting your name on a piece of writing was not considered correct in the days before the writer self-consciously attempted to create a media personality that would turn them into a commercial entity. Broadside ballads or chapbooks, the cheap books carried rolled up by pedlars along with their buttons and ribbons, were not 'literature', and the people who wrote them probably did not have much time to spend rewriting and polishing; the time they spent writing was not leisure but work. Consequently, prior to the end of the nineteenth century, most of the valued English writing was written by people with education, time and money.

Arnold's canon remained in place for fifty years, until after the First World War and another extraordinary decade, the 1920s, which saw a swift widening of the franchise. In 1929 England finally attained adult

enfranchisement, and for someone my age, born shortly after the Second World War, it requires once again an act of imagination to understand what that rather dry 'fact' might have meant to people. From my readings over many years of texts from that period, I would suggest that people not only felt an extraordinary excitement because of the way a 'vote' was seen as an access to political power, but also that they felt they had a right to access cultural power. Certainly it was during this time that F. R. Leavis, along with T. S. Eliot and others, set about reforming the canon. They added women such as Jane Austen and George Eliot, as well as writers from different class positions such as Thomas Hardy and D. H. Lawrence. They also added some of their friends, including T. S. Eliot himself.

Exclusions and aberrations

Seventy years later that canon is still largely in place. Nearly every 'A'-Level student of English Literature reads some Shakespeare, possibly some Chaucer and maybe Pope, usually a Romantic poet, always a nineteenth-century novelist, plus one or two twentieth-century writers. However, it is quite extraordinary that few texts are incorporated from the major treasury of English-language literature in the United States, and rarely any from the immense wealth of English-language writing from Commonwealth countries. American writers in the canon include Sylvia Plath and Arthur Miller, and it is interesting to speculate about why they are there. Plath, you might suppose, because she lived in England, wrote here, married here (famously), died and is buried here. Perhaps she counts as English? Certainly she counts more than, say, James Joyce or Samuel Beckett. More to the point may be the way in which her life and death were presented to English society. Recent studies of her literary fame point out the way that media interest turned an undeniably good poet into someone who could stand for a generation of women.

Arthur Miller is more of a problem. Along with Eugene O'Neill and Tennessee Williams, Miller had plays produced in the UK throughout the decade immediately following the Second World War, when, arguably, there was little new happening in English theatre. After a further decade, this time of silence, Miller entered the canon with his plays *The Crucible* (1953) and *Death of a Salesman* (1949) at the end of the 1960s, when American Studies were taking off. Miller may have

been adopted because his plays are comparatively accessible. You have only to remember that *The Crucible* was produced in the UK the same year as Beckett's *Waiting for Godot* to recognise the conventional, almost nineteenth-century technique in Miller's work. Also, I would suggest that the subject matter of his plays was considered more appropriate for young people. The issues raised by *The Crucible*, about what dreadful things people do when given access to power, are more palatable than the overt portrayals of sex and violence in the plays of O'Neill and Williams. The unique aspect of Miller, however, is that he created an image for himself. After all, he had been married to Marilyn Monroe; he had mixed with the great and the good in American politics; he self-consciously carved out a role for himself as a social commentator in the civil rights world of the 1960s, by, for example, retrospectively constructing *The Crucible* as a play about McCarthyism when it predated that period. One of his directors, Elia Kazan, suggested that he was simply trying to cover up the fact that the play was about a failed marriage. His timing was impeccable, as his productions returned to England just in time to catch the wave of interest in American Studies, and to benefit from a period of financial leniency that even saw an Arthur Miller Centre for American Studies set up at the University of East Anglia.

Despite these and a few other additions, there has been only gradual movement in the canon, and there is not much overt debate about it. Yet I cannot overemphasise its importance: we train all our young people to read by way of these writers; they acquire most of their sense of literary value and aesthetic taste from these writings. Nevertheless, in this country of extraordinary diversity of verbal cultures, we rarely include others, even though we are very good at claiming Scots and Irish writers as English in order to do so. There have been open and vociferous debates in the United States, France, the Netherlands, Spain and Canada about the canon, but not in Britain. In the American debate that has continued to flare up at least since 1990, Frank Kermode, a prominent literary critic, has come out with implacable statements on 'literary value' and 'the impoverishment of the literary curriculum by making Shakespeare, for example, a set of preachments on the doctrines of modern feminism, or by teaching texts from the subliterature in preference to the "classics"' (Adams, 1990). Kermode has faced equally implacable opponents from the Black community or the community of women's studies, so that some universities in the United States teach, for example, only literature from the Black communities.

They fight it out in the pages of *The New York Review of Books* and else-where. Here, Alastair Fowler's statement from the 1980s that 'Little of "the best that is known and thought in the world" comes into university courses on Women in Literature that was not already within literature's unexpanded limits' (Fowler 1982: 10) has simply not been taken up.

There is no debate about why the work of major English-language writers from India, such as Nayantara Sahgal, is not in the canon in England. Sahgal, who could be compared to a more visible and engaged Indian version of Doris Lessing, has produced work which stems from the 150-year tradition of English-language writing in India. Her writing is part of a common cultural base not only for Asian Indian writers in India and the UK but also for several generations of English writers and readers who recognise the need to understand a part of their cultural heritage. However, neither the cultural mediators nor the educational and publishing institutions that maintain that mediation know how to value her writing. It may even be the case that their current activities prevent that valuing. Sahgal herself says that 'the publicity, the hype, the commerce surrounding [a novel] are so relentless that this most magical way of passing one's time has been relegated like all else – like music, art, and sport – to the status of merchandise, and ourselves to one more form of bombardment' (Sahgal, 1993: 12).

Literary prizes, marketing and the canon

The argument is that the canon is necessary for education partly to ensure equable examinations, largely because it offers a common cultural ground for people so that if, for instance, you want to explain something by referring to a story or a poem, the person you are speaking to or writing for can understand your point, but also because in the end you cannot read everything, so how do you choose? Generally speaking, we allow the canon to choose for us. Possibly more telling, however, is that the canon is necessary for publishing. In fact, many of the criteria by which people decide on literary value are at root to do with publishing.

Consider, for example, the Orange Prize debate of the early summer of 1998. The Orange Prize for Fiction is awarded to a book, in English, written by a woman. In the summer of 1997, the debate started because Richard Gott, writing in the *New Statesman*, complained that publish-ing was being taken over by women: women editors, women publishers,

women readers and now women writers. Lisa Jardine, an eminent scholar at Queen Mary and Westfield College in London, defended the prize, pointing out that women frequently get left off other lists, which is indeed the case, and saying that the prize was a celebration of the richness and variety of women's writing. She has a point; after all the same complaints would not be made about, say, a prize for writing by people from the Black community. Jardine went on to say that writing in England was 'parochial' and 'narrow-minded', of no interest to anyone outside a very small world (Reynolds, 1997). Inevitably, this comment attracted swift retaliation and questions such as: Shall we give the world a literary equivalent of Benny Hill? In *The Guardian*, Steven Poole responded by declaring that 'Knowing your milieu inside out does not make you narrow-minded', and that 'Jane Austen was not "parochial" in writing about English country life, nor was Dostoyevsky in writing about Petersburg society', nor Conrad in 'writing about life at sea' (Poole, 1997). The Orange Prize debate was rather like the American canon debate, but in effect it was all about publishing. However, my point is that implicitly behind all the arguments was the idea that eventually we could agree on who was right. We would, in the end, know who was right about value.

I do not think that literary value works like this any more, if it ever did, because now we lack the rules of thumb for deciding what to read. We do not need to worry about the lack of agreement, but we do need to worry about the difficulty of determining value for ourselves.

England is a nation of scribblers. Nearly everyone in the country can write and, if they cannot, we get very worried about it. We train young people for at least ten years of their early life, from around five to fifteen or sixteen years of age, to read and write. In the process they learn not only how to fill in licence applications and read cinema listings but also about the canon and canonical value. Nevertheless, every year hundreds of thousands of people try to get into print with letters to newspapers, which I think are an immensely difficult literary form, and full-size books that are categorised in your local bookshop as fiction, travel writing, cookery, sport, poetry, politics, biography. The result is that there is so much to choose from that it is frightening. Wherever I travel I find that even book reviewers, critics and writers reading around their own work are saying that they cannot keep up. Perhaps this is why we still pay attention to the Booker Prize: the judges are supposed to have read so much.

What is your experience of bookshops these days? Bookselling chains such as Waterstone's, Borders or Chapters try to control your sense of being overwhelmed by their sheer enormity by categorising books, and creating physically small spaces for science fiction, or poetry, or humour, or philosophy. I am sure that this is one of the reasons we continue to go back to the same shop, because they become familiar and relatively secure in the face of the enormity of publication. Yet these latter-day chains are a far cry from those small, often dark and frequently slightly seedy bookshops described so well in George Orwell's *Keep the Aspidistra Flying* (1936), where customers had a personal relationship with the impoverished owner and may even have kept an account. I have to admit that, faced with so many books, I do buy a book at times by its cover. I read the reviews on the back, nervously aware that they may all have been written by friends of the author, I go through the inside back flap which tells readers about her or him, naively trying to work out if they have a life interesting enough

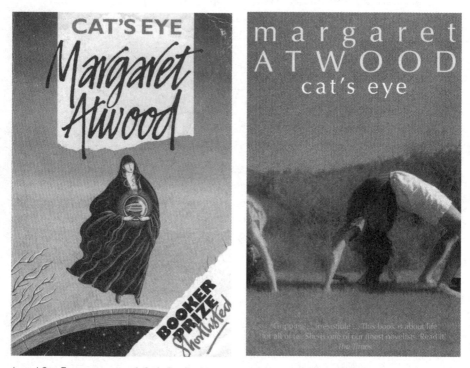

1 and 2 Front covers of *Cat's Eye* by Margaret Atwood, 1989 and 1997

to write about something interesting, and know all the while that this is walking right into manipulation by the publisher's marketing designer. Nevertheless, it works. Look, for example, at the difference between the covers of two publishings of Margaret Atwood's novel *Cat's Eye*: completely different messages are sent out by one, which has a sombre, futuristic cover with a cloaked woman on a bridge, and by the other, a realistic cover which shows girls doing backstands. Note also that on the earlier futuristic cover the title is prominent, whereas on the later one it is Margaret Atwood's name that takes prominence. Or, consider the first tinfoil cover, which was found on Jeffrey Archer's popular thriller *Kane and Abel* (1979). I used to think that tinfoil would never get on to 'serious' books until the Rushdie–West collection of Asian-Indian literature that appeared in the summer of 1997.

Publishing and the canon

The circle of publishing relations looks something like this:

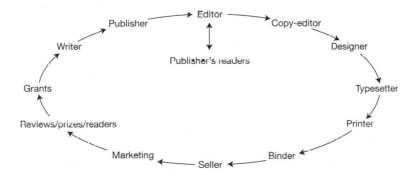

Until very recently, publishing has been, of necessity, a capital-intensive industry. If you are a publisher, you have to put all your money up front to produce books that possibly no one will buy. Because of the way that books are printed, it has not made sense to produce a few and test the market, so a publishing house needs to decide from the start whether it will print three hundred or three thousand or three hundred thousand. As a result, publishers have to be very sure of their markets, and of their products. When a writer submits a manuscript, the publisher's editor will decide if it fits in with other books the publisher is selling on their list. They may send the script right back, or they

may send it out to publishers' readers who are asked for an opinion. On the basis of that response, they may ask the writer to rewrite, recast, excise whole sections and so on. Eventually the manuscript comes back, and the publishers can begin the procedure of copy-editing, design and production.

Publishers and booksellers work in close co-operation. During the nineteenth century, the massive circulating library called Mudie's was the final arbiter on any literary book. Upcoming scripts were regularly sent to the library by publishers, to ensure that Mudie's would take them into their stock, hence guaranteeing a profit. If Mudie's readers objected to elements in the script, such as the colour of the heroine's hair, the entire character of the villain or the language used, then it would go back to the writer for changes. These days similar exchanges still take place between certain high-street booksellers and publishers. What is more, even if the book is a 'classic' it may need editing for the present day. In fact, on the whole publishers do not like producing classics unless there is a very good reason, such as a film version of the book coming out. There needs to be a definite cultural impetus to bring them back, and the most significant factor in this is education. The canon is very useful for this; in fact it is usually only texts in the canon that get reprinted. An excellent example is the gradual climb toward popularity of books by the Brontës. Part of the result of women being allowed to take university degrees (only in 1949 at Cambridge) was that women got jobs in universities, and by the 1970s were beginning to ask why it was mainly writing by men that was taught. As a direct result of that institutional change, people went searching for classics by women writers, and found, or re-discovered, the Brontës. *Wuthering Heights* (1847), *Jane Eyre* (1847) and the rest are now staple parts of the canon, and publishers, seeing the thousands of copies that could be sold because they were required for a course, have responded to demand. Despite this, they are not very good at being proactive, and find it extremely difficult to be so with new writers.

A different approach to literary value?

Since the Renaissance, new writing in England has had a very specific function. Like any other artist, the writer is a licensed critic, traditionally given the leeway to have a long and critical look at society, to satirise its conventions, to be subversive, to question and challenge and, ultimately,

to construct new ways of looking at the world that society comes to value and eventually to use in shaping new conventions, new rules of thumb for behaviour. So, by definition, writers are not necessarily writing in ways that the audience will easily recognise. Indeed, among the many definitions for 'literature' as opposed to any other writing is that it uses language in a way that is different from the familiar; hence 'popular' writing is not literature because it plays towards convention often because the writer needs to make money. Only those who do not depend on writing for their living can afford to alienate their audience. This also raises the question of how readers read, for they may make conventional writing 'literature' by reading it differently. What is interesting is that as these writers become recognised, and their challenge to convention valued, they enter the canon. The canon is thus a curious and potentially explosive paradox of change and subversion controlled within the legitimating walls of education and publishing.

As I indicated earlier, writers of valued literature whose work ended up in the canon initially wrote from their own experience, their own needs and vision. The writing carried out a very important political function by waking people up to questions that needed to be asked, and values that needed to be affirmed. Yet the writers did so from within their experience, addressing issues and hopes specific to the powerful group from which they came. Just like the politicians who claimed to represent the people while they really represented only a small group, the writers whose work became part of the canon also represented only a small group of people. As Nayantara Sahgal says, 'present writing may well be an elite rehearsal for the more representative performance yet to come' (Sahgal 1993: 7). Until well into the twentieth century, publishers, like educators, seemed to have much less of a problem in assessing value. While there were still too many books to publish, the audience was more or less defined, and you knew who you could get to review things. Now artists come from all segments of society, from different class and gender positions and are of many different ethnicities. These new writers write about their concerns but do not necessarily claim to represent their audience, nor, if they are new to England, would it make much sense to us if they did. Instead, they frequently work by opening the door to discussion within their communities, and potentially among other communities. I would suggest that writers or poets are no longer Shelley's 'legislators' of the world, but rather, negotiators of the local. This requires a different approach to literary value.

Canons need to be there, although we need fresh ways of negotiating them, but we need also to create new ways of valuing and of reading for new situations. In a rather British way, the educational system has been changing the canon slowly – certainly in universities, more recently in 'A'-Level syllabuses – with an impact on publishing that means that the general reader sees new books. It is almost surreptitious. Yet while it may work for the people who value new reading communities, surreptitiousness does not necessarily help to encourage discussion among different communities. That discussion and negotiation has to be learned actively, rather than accepted conventionally. We do not want simply to pay lip service to other writing communities, as this becomes a kind of populism that accepts that there are a lot of different standards in different places, while evading any attempt to try to work on what might be valued in that other writing, how it might communicate, or not, with our own. Value is not something universal that we will all agree to, but something we work on within local settings; it is something in which we can participate and not simply 'receive'.

How do we find those settings? That is a difficult question to answer and I will address it in some of the later chapters, while challenging many of the grounds we take for granted in literary value.

CHAPTER TWO

Global voices: second-rate writing from Third-World countries?

Much writing from the Commonwealth has the vitality and rigorous experiment with literary form that is desperately needed in UK literature. Despite this, there is still a cliché that English-language literature from Commonwealth countries – indeed from anywhere outside the UK – is but a poor cousin to writing by English writers. People committed to valuing this writing have produced a counter-move by saying that the texts 'write back to the Empire'. Basing my response upon the writing of recent Canadian and Indian subcontinent writers, I would want to go further and argue that the literature offers radically new ways of thinking about society, individuals and nations. Coming from two quite different political relationships with the UK, one 'Second World' and one 'Third World', nevertheless, some writers from these two geographical areas have common ground, in the way they bring their exploration of language to the study of the limits of nationhood in the emerging global economy. *Traditional aesthetics has argued for four hundred years that the artist is a 'licensed transgressor' of the regulations imposed by the state, but these new writers are more concerned with shaping the image of the nation itself.*

The reason I have included a question mark in the chapter title is that I do not think the writing is second-rate at all. What is more, I am unhappy with the description 'Third-World country', with its implicit evaluation of a place as not the best, nor even the second best, but making a third rank. Both 'second' and 'third' rankings imply a 'first-rate' writing and a 'First-World' country, and it is the relationship between these which is at the centre of this chapter. The relationship calls upon a notion of national literatures and national identities; and necessarily also asks how individuals and writers relate to those national identities,

and how the people living in those nations relate to either or both. The basic questions I will work around are these: Do artists represent us culturally? and, Is the artist a cultural hero?

Representation and political change

In the first chapter I mentioned that artists are traditionally the licensed transgressors of the state, the people who are allowed to question, criticise, even subvert the activities that nations allow their citizens. However, the word 'allow' needs some explanation. Let us think about the democracy we live in, in the UK: one man, one vote, although these days it is one person, one vote. Yet the idea that we might all somehow converge upon the London parliament and express our opinions is simply not practical. (It is almost practical in this electronic age, but not quite.) Along with many European nations over the past few hundred years, the UK has decided upon a representative democracy as the governing strategy of the state. If you have a representative democracy, you need a sense of what will be represented; and until this century that meant a small group of citizens of property. You also need ways of negotiating over appropriate representation, and failing this at least agreement about adequate representation – a sense of: this will have to do.

Representation in politics and art as representation are closely connected. Art is where representation is questioned and possibly changed. Revolutions are supposed to change things, but they frequently end by substituting one authoritarian group for another. There have been many studies in recent times about the problems with this political model of 'adequate representation', partly because in contrast to the past 250 years there is now a much greater diversity of people to be represented; and partly because after the full franchise did arrive, in the UK in 1929, many people still found that they were not represented. The frustration over that could be said to have been the root of the 1968 unrest.

Why was it that people were not represented?

One reason is that the representations hammered out over the previous 250 years up until 1920 had had all sorts of effects on those people excluded from representation – almost as if shadow-representations were being built behind the mirror. Think, for instance, of Alice from Lewis Carroll's novel *Alice's Adventures in Wonderland* (1865): on one

side she is a prim and pretty, well-brought-up young girl, and on the other she is a mass of strange dreams that cannot get free. Think also of Jekyll and Hyde, and the multitude of split personalities that litter the nineteenth-century novel. Think of all those fantasies where people go to try to make their own representations, to escape. Think of the 'Gothic'. Think of Peter Pan.

Another reason people found they were not represented in either art or politics is that recognised, valued and legitimate ways of presenting the individual, which had been in place for 250 years, are difficult to shift. When you gain access to political power, you are expected to behave the way everyone who has had power has behaved, rather than carve out a new kind of activity. So, for example, the dialect stories of the mid nineteenth century that tried to present the language and way of life of people outside the ruling groups are long forgotten because they are not 'proper English'. Moreover, writing from the English-speaking places outside of England has had difficulty being recognised and valued, in proportion to its ability to fit the allowed representations on offer.

Breaking the circle: writing oneself out of the 'victim' position

This rather caricatured sense of 'allowed' representation causes terrible problems for writers, such as those from Canada and the Indian sub-continent, who use the English language in ways that are specific to other cultures, although an increasing number of writers in England also fit this category, as well as writers from other parts of the world, and it is in this sense that I use the phrase 'Third-World countries'. In this chapter I want to focus upon the writing from people in different cultures and societies, writing that, to varying extents, educators and publishers in the UK do recognise and value. Hence this writing is implicitly fitting into allowed representations, even as it challenges them. What I would like to suggest is that this writing is frequently perceived by people in England as talking about relationships between nation and individual, between state and subject, which are similar to our own: whereas it may be suggesting something else.

The problems facing English-language writers from Canada, or from India, or Pakistan, or Bangladesh, or Sri Lanka, are different, but are bound to the same source: that the language is imbued with the traditions and structures of another nation. For some that other nation has

swept in, taken over and to a very great extent ignored and therefore erased the values of the existing culture, and, because it is so powerful, its language conveys power. Every time you use English, you are using the language of the powerful, the language that has painted your own history out with a swath of crimson blood. How can you use that language without duplicating the erasure? For others the relationship with English is more tricky: English may be your language of birth, but it may well not be the same kind of English as the valued language of the privileged people who rule. How can you use that language as a representative medium without duplicating the tight interlocking, not only between the individual and the ruling powers of the nation but also between the subject and the state? – the nation being partly if not wholly someone else's country, to which you are writing yourself in as subject, subservient to, allowed by.

In the middle of the twentieth century, the critic Frantz Fanon studied French colonialism using the structures of psychoanalysis to describe the terrible schizophrenia that resulted from the dilemma in which colonised peoples found themselves, and which he discussed most famously in his book *Black Skin, White Masks* (1967). He described a seemingly inextricable mirroring, which others such as V. S. Naipaul wrote into his book *The Mimic Men* (1968). More recent writers such as Homi Bhabha and Salman Rushdie have extended the image further; and those people who care about this writing have argued that the books write back to the Empire, or have picked up on Rushdie's phrase that the Empire is writing back to the centre after many years of being overwritten by it. Yet there is a great sense of oppositionality, by which I mean that what writers do is only in reaction to something they see in the mirror, so that they are locked in a continual debate or contest that can never end, nor bring anything new.

Margaret Atwood wrote a poem about this deadlock called 'The Circle Game', which was not explicitly about new writings in English, but about families and daily life: that children get caught into ritual games that come to define their lives into a series of oppositions – child/parent, lover/loved, individual/society or history or geography or nation – and the desperate need to break the code. Later she formalised her ideas into a book, *Survival: A Thematic Guide to Canadian Literature*, which was published in 1972 and has been dismissed by many people. However, this book, or essay, outlines the structures of victimisation as the main force in cultural domination, and is absolutely clear

about the need to act not against the culture that dominates but against the position of victim, although she is not so clear on how this might be carried out.

Much more recently, in 1997, while delivering the Arthur Raven-scroft Memorial Lecture at Leeds University, Amitav Ghosh was quite open about how he saw that circle, the relationship between nation and individual in a colonial context, working. In some readings, his work could be an excellent example of the Empire writing back to the Centre. Ghosh writes books that you do not want to put down: they are accessible, and tell a good story. His novel *The Calcutta Chromosome* (1996) negotiates precisely the oppositions of 'power' and 'colonised' in a text that isolates the India of the 1890s and that of the 1990s, and relates across the hundred-year history between them from a later New York perspective of around 2020. He takes a form found in many other writings from the nineteenth century on, the mystery or detective story, and crosses it with a little science fiction. There are echoes here of Charles Dickens's classic thriller 'No. 1. Branch Line: The Signalman', or of G. K. Chesterton's *The Man Who Was Thursday*, but overall the novel is more like that radical announcing of the postmodern in *The Erasers* (1966) by French novelist Alain Robbe-Grillet, which has many progeny not the least among Canadian writers.

This form of the novel questions factual, behavioural or moral certainties, by establishing counter-examples in much the same way as the certainties themselves are established. *The Calcutta Chromosome* raises issues central to colonialism, racism and power, by dramatising or giving a narrative to the previously unheard. The strategy is important because we can hear it easily; the 'Centre' can recognise the issues and actually listen to suggestions. Yet at the same time the strategy casts the lives of the previously unheard into largely recognisable characteristics; it binds them to roles and spaces that the Centre has allotted – especially those of science which make up much of the content.

In his paper Ghosh said that the Indian novel in English allows for a universalising civilisation, and paradoxically at the same time a sense of place and parochiality. The combination of universality and parochiality is a central feature of the novel as a genre, and of the history of response to modern 'representation', that we are all unique individuals at the same time as being 'universal' or representable. However, there are two problems. First, whose 'universal' is this? According to Ghosh it is the Nobel Peace Prize universal. The universal of people in the nineteenth

century who read each other's novels, in other words the universal of a
very small group of like-minded writers and critics, people among the
privileged and powerful. That this literary form is valuable is
undoubted, but that it is universal is not. Second, the 'place' conveyed is
bound into that universal; this place may by its parochial detail critique,
satirise or ironise it, but it must take the grounds of that universal as the
floor upon which to dance. The novel is a genre chronologically concur-
rent with representative democracy in western nations. It has been a
central place to discuss, contest and possibly redraw those representa-
tions. It offers a form that people can feel comfortable with at the same
time as engaging them. So it is not surprising that publishers and
educators in the UK are more interested in the novel than in poetry.

Further challenges: Hariharan, Rushdie, Atwood and Ondaatje

There are many ways of challenging this interlocking relationship
between the novel, representation and the nation, and I will now con-
sider several more writers who all offer different approaches. Writers,
for instance, such as Githa Hariharan, whose novels and short stories
focus on the detail, the parochiality of personal experience, drawing on
the mythology and the stories of the older people around her. Her book
The Thousand Faces of Night (1996) is a helpful example of writing back
to the Empire, embedding the novel with folk-tale. It is significant that
Ghosh has said that folk-tale is truly universalising because it leaves out
the parochial, and that it is found these days more in the media or in
film. Nevertheless, Hariharan uses it with the opposite impetus: far
from being universalising, it is intensely local. In her book folk-tale is
used structurally to break down the larger assumptions that the novel
form can carry, such as the concept of linear time or naturalistically
realised, psychological characters. The sheer weight of local story or
folk-tale, and the many diverse interpretations it can generate, question
the stability of the grounds on which we might base an evaluation.

Ghosh describes these stories or folk-tales as originating in the
Panchatantra or *Five Chapters*, which was compiled early in the first
millennium and which passed into Arabic in the sixth century as *The
Thousand and One Nights*. It can be no mistake that Hariharan's book
is called *The Thousand Faces of Night*. Hariharan uses a completely
different set of stories to challenge the fixity of 'representation' that is
on offer from the British colonial past, and the United States's colonial

present. These stories 'allow' her to live differently, or at least to suggest that this is possible. Their permission comes from quite a different place, not particularly powerful in the global democracies, and her corporate-man husband never understands them.

At the other extreme, pushing the 'universals' into such excess that they disintegrate, is the writer Salman Rushdie. If we take his novel-allegory *The Satanic Verses* (1988), we find a book that on one hand makes large claims for a perception that is transnational and universal-ising – it can move from Pakistan to England and metamorphose the culture as it does so: claims to universalism, which is one of the main reasons people have been so upset with it. Its publication in 1988 was perceived by some Iranian Muslims, for example, as so insulting that a death-threat was placed on Rushdie. Subsequently, bookshops in Eng-land stocking the book were attacked, and in Bradford, Yorkshire, Rushdie's books were publicly burned. On the other hand it speaks in a profoundly moving way about the difficulties of migration, the way that lost culture stays with us like a ghost limb that we have forcibly had to amputate. I think most people have had similar experiences, but not necessarily on the same scale, even though more and more people worldwide have become 'migrants'. In fact, *The Satanic Verses* is a major contribution to English culture, because it attempts to subvert the usual English representations of immigrants from Pakistan and Muslim immigrants from many countries, as 'foreign', by writing ways that immigrants become part of society and no longer foreign. In other words, though it may be the 'Empire writing back to the Centre', it is also a recasting of those terms, where 'Empire' has disappeared, where 'Centre' and 'margin' are dissolved into a joint existence.

What is interesting is that, despite pushing the 'universals' of race and ethnicity out of the picture, Rushdie's artist is still a hero. The Artist is the one who can open up possibilities for others. In a sense this was Rushdie's undoing, that the book was too heroic. It claimed to repre-sent people who are making their own negotiations with society. It is as if the book works for the in-place English rather than the immigrant society. Yet part of the problem with *The Satanic Verses* is how the book is written. How many people have actually read it? Very few from my personal questioning although the readership is growing. Rushdie plays radically with words, syntax and rhythm, and produces what I call the 'hundred-page introduction' novel, which readers have to learn how to read as they go along. We all need good reasons for this investment of

time, and if we do not have them we will not persist. My reasons were that I had read and enjoyed other Rushdie novels; I had read similar works in roughly the same contexts and was willing to take a chance on this one for their sake; and, most important, I had a reading community with which to discuss it. Other readers clearly had different contexts for reading, contexts that read the book as naturalistic rather than allegorical; those readers also had different reading communities which were either not supportive so they stopped reading, or were constructing quite different arguments to those of my own. However, it is through that radical play with language and literary form that Rushdie manages to push the universals over the edge.

If style is perceived to be difficult, readers will often stop reading, and the tension between writing 'differently' to make 'literature', but not writing 'too differently', preoccupies many: writers write to be read after all. Margaret Atwood is a writer who has chosen not to play with the building blocks of language, to which readers frequently find it difficult to adjust their ears. Instead, she experiments with genres of the novel such as romance, travel writing, gothic, horror/mystery and science fiction: larger-scale techniques which are familiar to us via film and television. This emphasis on genre makes her writing, like Ghosh's, eminently accessible. In fact, such is her popularity that she seems to have singlehandedly kept Virago Publishing from sinking. What is more, people do listen to her.

Atwood's work is concerned with two Centres: England and the United States, and she is far more worried about the latter. For example, in her novel *The Handmaid's Tale* (1985), the United States is characterised as a paradigm for the twentieth-century political systems of extreme individualists versus the totalitarian state, which is conveyed here by fundamentalist religion. The state allows only certain roles to valued citizens, especially the women, who function as Marthas, Handmaids, Wives, or sink into the mass of Econowives. The book is an exceptional display of how easy it may be to be brainwashed, to go along with, to become complicit in, those roles or representations. Its narrative offers an allegory of Nazi Germany or collaborative France, but also of Iran and the Romania Atwood was visiting on behalf of the international organisation PEN in the early 1980s when she was writing.

Her next novel, *Cat's Eye* (1988), offers more gentle criticism of England. It starts off with the extraordinary double life led by a young girl and her family who live in the backwoods of Canada because the father

is a forest-insect field researcher, while the Second World War rages across the other side of two oceans. When the family moves to Toronto after the war, the girl, Elaine, has to learn how to *be* a 'girl', and her brother has to learn how to be a 'boy'. In a section marvellously titled 'Empire Bloomers', with all the double senses that conveys, Elaine and her friends learn from Eaton's Catalogues – the now defunct Eaton's being like a Canadian version of John Lewis:

> here we treat these catalogues with reverence. We cut the small coloured figures out of them and paste them into scrapbooks. Then we cut out other things – cookware, furniture – and paste them around the figures. The figures themselves are always women. We call them 'My lady.' 'My lady's going to have this refrigerator,' we say. 'My lady's getting this rug.' 'This is my lady's umbrella.'
>
> Grace and Carol look at each other's scrapbook pages and say, 'Oh, yours is so good. Mine's no good. Mine's *awful.*' They say this every time we play the scrapbook game. Their voices are wheedling and false; I can tell they don't mean it, each one thinks her own lady on her own page is good. But it's the thing you have to say, so I begin to say it too.
>
> (Atwood 1989: 53)

At school the girls learn about going in through the 'girls' door, as well as about the English flag and the British Empire; they learn from their mothers about what women are allowed to do. On their side of the playground, the boys learn similar things. Eventually Elaine learns how to be an artist, and her brother how to be a scientist: the paradigmatic representors of the nation. The paintings by Elaine that we 'see' throughout the novel are expressions that negotiate the representations around her. Each section of the novel has one focused piece of art, such as the triptych of her mother, which fades her image completely out of the picture by the third panel; or the women who fall off the bridge on to the jagged rocks of the men below; or the Three Muses: the marginal people of Elaine's life, Miss Stuart, Mrs Finestein and Mr Banerji who are also society's 'marginalised'. Given that the novel traverses the difficulty women have in loving one another, even the claim that they are brought up to hate one another, Elaine never quite works this out, never paints a picture of this except in the very effort of producing the book.

Her brother learns the science of the stars, a fantastic world, displaced from our own yet supposedly powerful. He never negotiates the real world, but lives in a narcissistic cocoon. Ninety-nine per cent of the time he fits into this heroic mould, or it fits him. Just occasionally, such

as when he goes chasing butterflies on a military exclusion zone, or
when he attempts singlehandedly and singlemindedly to halt a terror-
ist hijack, do we see his self-absorption for the narrow megalomania
that it is. He dies in the hijack events because it never crosses his mind
that the terrorists will not obey him. Atwood's artists may also be
heroes, but at least they lead split lives: in public and responsive to the
media, supposedly responsible to the public and representing them,
negotiating representations for them. However, they also have private
lives as individuals, subject to representations, bound by them. At least,
unlike scientists, Atwood implies, artists know that they are not per-
sonally heroes, only representing that nation/individual negotiation.

Atwood's *The Robber Bride* (1993) is a novel for the 1990s. Her
central characters are mostly women: the marginalised, the self-
marginalising drop-out, the conventional and the New Woman. The
book is global, transnational, playing with the amoral; wildly seductive,
promising everyone something but in the end taking all energy away.
Here Atwood introduces the interesting concept that nations and
national identities can twist us and mould us and distort us, but at least
we have four hundred years of learning about how that happens; we
have the rules of thumb to know how to work in that system. In a
transnational, global culture we just do not know enough, yet, about
how to respond. Moreover, the struggles are shifting. As nations lose
their economic controls to global structures, where does power over
negotiation lie? Perhaps the relation between the nation and the indi-
vidual can become an important agency in responding to global pres-
sures, which will inevitably come alongside the need to create and
maintain markets for transnational corporations. Just as along with
McDonald's we have the extraordinary volume of writing on national
and local foodstuffs, so perhaps with art, along with the Nobel Peace
Prize literatures that Amitav Ghosh describes as 'universalising', we
will have local literatures and new kinds of emerging national litera-
tures seeking to resist, criticise and redraw the representations allowed
this time by the global.

What is fascinating about Atwood is her ability to analyse the present,
to see what will come of it and lay it all out as a possibility, in great
achievements of imagination. At another extreme from her explicit com-
mentary, almost like criticism, on the nation and transnational capitalism,
is the writing of another Canadian, Michael Ondaatje, which focuses
on the individual as subject. His early, richly metaphorical writing and

lyric prose documents in book after book the tension of the artist as simultaneously heroic lawbreaker and structuring legislator. Many readers will know either the book or film form of *The English Patient* (1992), which is the product of a long line of inquiry into the rights of the individual as against the rights of ruling powers. In the preceding novel from which he brings a number of characters, *In the Skin of a Lion* (1987), Ondaatje talks about the artist as a social being, part of a very small community of anarchists, whose actions stem from passion and love, and seem to change nothing in the face of the ruling powers. Nevertheless, their stories and dances give them presence, insert them into history, allow them to clothe their shadows and represent themselves. Ondaatje allegorises here the whole procedure of art within Canada. Unlike Asian countries, Canada has few representations, and no history of its own. The artist does not represent people within the nation, but gives people the agency to represent themselves – although Ondaatje does not go so far as to say that this has an impact upon the nation.

The English Patient puts the morality of individual and state more starkly, by stripping it of its 'artistic' justification and leaving only passion or love. It asks whether the passion of the stateless individual has any rights. Whether the 'unrepresented' have any guidelines or responsibilities to behaviour. Why should love respect the 'sides' of global warfare? And, if all war is immoral, does it matter? Ondaatje gives us many guidelines in the book as to the responsibility we should all shoulder for global awareness – but how do we connect that with the intensity, or indeed the banality, of daily life? He does remind us of the brutality of fascism, and he explicitly foregrounds the other worlds of Asia and North America that could have remained outside the conflict yet somehow got caught up in it. He reminds us also of the nomadic worlds of North Africa which continue on outside the conflict: this is not a *world* war. What is more, if we have problems with the betrayal, then why should artists be let off the hook when they 'betray' their nation? Is this another example of the difficulty of working within a transnational society where we do not yet know what the guidelines are?

As Ondaatje has matured, and particularly since he wrote the family history *Running in the Family* (1983), he has become more and more aware of who holds power in his society. However, the nation he sees is not a well-defined state but one that acts almost as another individual within the larger global scale of transnational power. The shift of economic power from the nation state to the transnational corporation

fundamentally disarranges the relationship between the subject and the state. If Atwood's artist both represents the public and is also the subject of representation, is both heroic and unheroic, Ondaatje's artist is almost blind to the public. His artist knows the public exists but does not interact with it; his artist behaves as a hero when it is simply inappropriate – or, the public takes him as a hero when, of course, he is 'only human'.

The value of unrecognised, non-canonical forms

Despite many similarities there is a gulf of difference between these Canadian writers who frequently turn to other people's stories and histories to write their own, and the Indian subcontinent writers who have a parallel tradition upon which to draw. Many readers will be familiar with the critical work of Gayatri Spivak, in which she tries to find a vocabulary for valuing what cultures outside the mainstream are doing in terms of what she has called the 'subaltern'. The idea of the subaltern was popularised through the article on 'Can the Subaltern Speak: Spec- · ulations on Widow Sacrifice', which Spivak first gave as a paper in 1984. Although I respect the work being done, I have a problem with the word 'subaltern', partly because of the connotations of 'sub' with inferior, and 'altern' with alternative, not necessary; but also because 'subaltern' is the lowest rank of British army officer, not powerful but representing power. In addition, a large number of Spivak's discussions deal with the marginally powerful people such as intellectuals or valued writers, who are privileged, if not part of the ruling group. Yet it has to be said that recently she has paid more attention to people right outside issues of ruling power.

More immediate for me is the work of Himani Bannerji, a Hindu from Pakistan, now working in Canada. In one piece of autobiographical criticism that acutely describes her experience of writing in English, and is remarkably similar to Githa Hariharan's work, she bases a story that is a grieving for her mother's death within an allegory taken straight from Bengali epic. Parts of it read like a grossly out-of-place horror story by Angela Carter, until Bannerji talks us through it. A brief example:

> *She gently pulled me towards her, while walking nimbly into the forest. In the gathering darkness I noticed that her feet were faintly luminous and suspended above the ground. Keeping her great head poised, her gaze fixed*

at the gnarled entrance and tremendously muscular arms of the forest, she
uttered repeatedly.
 – Bhayang nasti. There is nothing to fear. Aisho. Come.
 … Where shall we go? I asked, where hide and seek shelter for the night?
What will nourish us and quench our thirst?
 – Woman's body is both the source of uncleanliness and life, she said. So
have the sages spoken. Let us go into that gate, that body, she said, to ascer-
tain the verity of their famed masculine, Brahmin intellect and pronounce-
ments. Let us, O daughter of woman, enter into your mother's womb, the
disputed region itself, where for many months you sat in abject meditation
and waiting, nourished by the essence of her life. (Bannerji 1995: 161)

Bannerji goes on to try to explain the context for her relationship with
her mother, but notes that

> we can perhaps see how it expresses a sensibility alien to English and the
> post-modern literary world that we inhabit. I need to struggle not at the level
> of images and language alone – but at the levels of tonality and genre as well.
> It is a text with holes for the Western reader. It needs extensive footnotes,
> glossaries, comments, etc. – otherwise it has gaps in meaning, missing edges.
> (Bannerji 1995: 169)

From this point she tells us not about the social and familial context for
the writing but about the literary: How the epic, and fiction that used
its motifs, was a form read largely by women for relaxation in the mid
twentieth century. She also reveals that Bengali literature and even lan-
guage was part of the common world of the home and the daily lives of
ordinary people, rather than the English-language world of men work-
ing at their business. Hence, to her, the Bengali epic brings memories
of being with her grandmother and mother, and she tells another kind
of story about this closeness:

> *I am about eleven years of age, by now secretly nourished with the romantic*
> *and sentimental extravaganzas of much of nineteenth and twentieth century*
> *Bengali fiction. I know however that I can not disclose much of what they call*
> *in Bengali 'untimely ripeness' to grown-ups. But I am lonely. My brothers are*
> *young and callow. We are too high up socially to mix with many people, and*
> *hindus to boot in the Islamic Republic of Pakistan which substantially nar-*
> *rows socializing. I say to my mother, 'Do you think it's fair that Gobindalal*
> *should have killed Rohini like that? I don't think she alone is to blame.' My*
> *mother is not pleased. Krishnakanter Will, Bankim's classic fiction on lust,*
> *adultery and murder is not her idea of a young girl's reading. A flour and*
> *dough covered hand grips my wrist. 'Don't touch those shelves, don't ever*

read these books without my permission. They are not meant for you.' 'What should I read then?' I ask defiantly. 'Read – read – good books. Those you have in English.' 'I don't enjoy reading in English,' I say. 'I have so much trouble figuring sentences out, that I don't even notice what they are really saying. And besides why do you have them if they are not good books?' After a short period of silence she said, 'OK, you can read some of them. Read Ananda Math. *Read* Rajsingha, *but definitely not* Bisha Briksha *or* Krishnakanter Will.' (Bannerji 1995: 177)

This kind of writing is Himani Bannerji's linguistic and literary home. If English-language readers from outside that culture and society want to read it, they have to be able to fill the gaps. Again, I think we need to ask why we would try to do so. Bannerji argues that people outside ruling power, and people working on words outside recognised and valued canonical literature, not only have another culture but also have one that has far more potential for thinking about radically new ways of relating to national culture. Turning to other literary traditions can open the door to different kinds of actions and representations that we could take up. In Canada, however, turning elsewhere is tricky. The alternative traditions of British, American and European writing are steeped in canonical value. Despite this, there are many Canadian writers who are trying to make traditions and communities of value out of the structuring elements of language and literature, and often not with the novel.

Deciphering postcards, acting differently

I want to end this chapter by looking at one of my favourite writers, the Canadian Frank Davey, who is a precise and very funny observer of the way that images catch us and hold us down to certain kinds of behaviour. He also suggests what we might do to act differently. The sequence *Postcard Translations*, which he wrote about fifteen years ago, has considerable currency, and was developed by Davey out of postcards sent by his great uncle to his grandmother in the 1890s. Take, for example, 'The View'. All the 'translations' offer a title, which refers to the picture we imagine on the front of the card, then a section of continuous prose which unpacks responses to this image, and finally a single italicised line of short phrases that are like icons that the picture generates. With 'The View' the scene is clearly a landscape, and we find out immediately that it is a mountain scene. Yet the first-time reader will not necessarily know

The View

Mountains can be humanized in a 3 by 5 field. Distances are
great to look at. You can approach in an air-conditioned bus or
gaze from the balcony of a five-star hotel. Everyone was
saddened when that silly government discontinued the dome car
through our Rockies. Spectacular sunsets, which I'm afraid he
misread as "supertanker sunsets." In the morning after breakfast
I would sit on the upper patio and let the spirit of the Eibsee rise
toward me. Some rooms overlook the gardens. She said it was a
wonder they got any business at all done in Simla. The picture
postcard has nothing to do with communications and nothing to
do with art: it is merely an inexpensive way to allow the traveler
a large role in the packaging of nature.

The local. A Grizzled trapper. Eggcups. Man and nature. Museum quality.

3 'The View'. Extract from 'Postcard Translations', in *Popular Narratives* by
 Frank Davey

what to do with the prose that follows. What is interesting about the for-
mal devices is that the reader has to allow the title, prose and italicised
icon-line to intercomment, in order to make much sense of what is there.
Again, why should we bother to try? I bothered because his society is
supposedly close to mine and I wanted to find out about it. I also knew
so many people who liked him as a person that I guessed I might find
something to like in his writing.

The first line of prose, 'Mountains can be humanized in a 3 by 5
field', clearly relates to the short-phrase icons 'Man and nature', or pos-
sibly 'Museum quality', or even 'The local'. However, it connects most
tellingly with the statement that postcards allow the traveller to pack-
age nature. Postcards are not to do with art, because art questions and
criticises packages for the world, even if it builds new packages at the
same time. What postcards do is allow ordinary people to find a short-
hand code for saying the unsayable. When we receive a holiday post-
card, we do not usually get excited about the image itself; they are
invariably slightly faded and rather flat two-dimensional pictures. What
we respond to is the implication that the scene holds the ability to cause
emotion or physical response – in this instance, in the only line that is
attributed directly to the feelings of the writer, the way the spirit of the

mountains will 'rise toward' us, engulfing us. Nevertheless, the end
result of the postcard is that the natural landscape and the emotion
become cultural objects, things that can be exchanged without any
emotion and with little thought.

To work in any other way, the postcard must be relentlessly personal
and local. 'The View' means more to someone who has travelled the
transCanada highway than to someone who has not. If you knew the
prime minister at the time, held by some to be recklessly ignorant, then
you read the 'supertanker sunsets' with a dry ironic humour. Moreover,
if you know Frank Davey, you will recognise the apparently completely
out-of-place phrase 'Eggcups' in that final line, as an invitation to laugh
at incongruity, to play at making something make sense (Davey 1991:
41). Do the eggcups sit before the writer as he gazes out toward the
Eibsee; or do they work like small inverted mountains; or, like a storm
in an eggcup, do they contain immensity for the individual that is triv-
ial or banal to others; or ...? The point is that the significance of the
card, the energy that makes it more than a banal cultural object, comes
from Davey's re-description or his writing around its implications.

A number of the postcards explicitly address the way popular culture
is important for maintaining political representations, while art should
try to challenge them. At the same time the cards frequently raise the
issue of colonial and cultural domination. An individual may come to
terms with a mountain in Canada or India, in much the same way. How-
ever, if nature is packaged by commerce to satisfy the western tourist,
then ways of representing it in India become a version of western
cultural domination. Yet how can we make sense of, understand, speak
to, communicate with, other cultures without re-packaging each other
into inadequate commodities? In one answer, 'The Elgin Marbles',
Davey juxtaposes 'The postcard hereby becomes an important vehicle
of exchange and a foundation of the shared values of human culture'
with 'You should see the African collection'. A little later, and despite the
'universal' values of the Elgin Marbles at the British Museum, 'You
should spend as little time as possible in Athens', because of pollution.
Despite the Attic grace, these peoples were also 'Scandalous, barbarous'
(Davey 1991: 57).

The italicised counterpoint makes the paragraph resonate with
Keats's 'Ode on a Grecian Urn', which itself raises questions about the
validity of western metaphysical traditions, and how to cross cultural,
social and historical difference. At the same time, the question of who

'owns' the Elgin Marbles raises issues of cultural ownership. Why does Athens want the Elgin Marbles back? Is it because there is only one copy and it should be a national resource? Or that the Acropolis functions to define part of the cultural specificity of Greece, and that the Marbles are in London is a sign of continuing cultural domination? Perhaps, Davey suggests, 'You should try fiberglass' and produce many replicas, just as books are multiply replicated writings (Davey 1991: 57). This might circulate the image more widely, like a suddenly popular work deriving from a small but significant publication. Simultaneously, however, entrance into the world of commercial objects could release the representation into uncontrollable global significance.

Davey goes so far as to suggest that places outside 'valued' literature, such as postcards, offer radically new ways not only of relating to national culture but of contributing to it and shaping it. Representations are no longer something the nation allows its individuals, and that artists negotiate on behalf of individuals. Instead the representations carried by words can become the way that individuals very specifically contribute to a national identity. What is more, their own actions no longer need the writer as artist to mediate them, but can be worked on by each person within a specific writing and reading community.

Endnote

It strikes me that Atwood, Rushdie, Ghosh and Ondaatje *are* involved in thinking about the 'Centre' or the 'Empire' in ways that partly lock their writing into its assumptions. This writing is valued and listened to, and, to greater or lesser extents, seems to speak directly to traditionally marked English-language readers precisely because its assumptions are familiar. Yet each of them pushes the novel into new areas, with a variety of techniques that destabilise that familiarity and suggest other relationships. What diverts the reader's attention from these alternatives is that there is still the continual return to the writer as the person responsible for representing the dilemma of the individuals in their nation. The artists are to a greater or lesser extent heroic.

American postmodernism dismantles the available traditions from a position of cultural power, and is, I would suggest, in a rather different and often cynical position. However, a third group of writers who are not so concerned about a wide readership, or about appealing to the 'universals', do care about finding ways to say the self, to articulate

personal experience, alongside canonical value, in areas that have noth-
ing to do with representation but with involving the reader in thinking
about how to say their own experience. (Hence the recent interest in
diaries, journals, autobiographies.) When you look at writers producing
this kind of work, there is a radical difference between those such as
Hariharan and Bannerji who call on other parallel traditions and those
such as Davey who cannot do so because their 'traditions' are thor-
oughly imbricated with the English and American language outside of
which traditions they want to work. Nevertheless, all three are often
laying foundations for a national or communal cultural value through
challenging and difficult work, into which they invite us.

CHAPTER THREE

Orature, oratory and getting the message heard

The most valued aspect of our entire culture in England is probably the written word, and as a result literary art has tended to define aesthetics to a great extent. However, many cultures around the world, including some within the UK itself, continue to maintain and value the oral. It is possibly the predominance of radio, television and film that has made us aware again of the alternative traditions that exist in so many hidden places around us, yet a myth still persists that oral performance is less rigorous, less skilled and therefore less valuable than writing. *Conventional literary value counts on an artistic object that remains stable:* this, after all, was the secret of the success of the printing press, limitless copies of the same words going out to people in different places. It has been argued that the invention of this mass medium made possible the representative democracies that many western countries now have in place, by making it possible for a large number of people to have the same information about government decision-making at roughly the same time: this is analogous to, but different from, meeting in the agora or market-place to listen to speeches in Plato's time. The difference has made it difficult for us to value verbal arts that change from performance to performance, yet there are a substantial number of societies whose cultures are still oral, and whose verbal arts are frequently dismissed as crude and naive. This chapter will focus on the oral art forms from Africa and the Black diaspora. It will look at training in oral performance, at examples of orature and also at the infusion of oral performance techniques into writing by Black writers.

In the previous chapter I talked about the frustration felt by many English-language writers from outside England, with the language itself: its power to suffocate, to deny words needed to articulate experience that goes on outside of the parameters of colonial power. Nearly

all the people working with words at whom I will look in this chapter begin with that difficulty; and I want to focus particularly on writing that incorporates elements from the oral and spoken, as well as on oratory itself. To do so I could look at a number of different verbal traditions from all over the world, but I would like to focus on a field that is arguably already too broad, that of verbal cultures in the Black diaspora. At this point I should say that I agree with Eileen Julien who writes:

> there is nothing more essentially African about orality nor more essentially oral about Africans ... this is not to question an African predilection for words well expressed ... What must be recognized, it seems to me, is that speech/listening is a mode of language as is writing/reading. The art of speaking is highly developed and esteemed in Africa for the very material reasons that voice has been and continues to be the more available medium of expression, that people spend a good deal of time with one another, talking, debating, entertaining. For these very reasons, there is also respect for speech and for writing as communicative and powerful social acts.
> (Julien 1992: 24)

Because our entire system of literary value in England privileges the written as a fixed object, a printed text that remains stable, many people think of oral texts as naive and even childlike, and of oral techniques as simple-minded. There is also a tendency to think that the people who use oral skills are not as sophisticated as those skilled in the written word. Bearing this in mind, the basic questions I would like to raise for the following set of stories about verbal arts are: first, Should we think of the oral craft with words as less demanding and less valuable than the written? and if not, then second, How do we find out enough about those arts to value them?

Rejecting the colonial tongue: Ngugi wa Thiong'o

Although I am going to concentrate on people who do use the oral to extend or breathe new life into English language and literature, I will begin with the writer Ngugi wa Thiong'o, who felt his situation was ludicrous, Ngugi was writing in English when he had another, home language, to write in which brought him closer to his intended audience. In 1977 he began to write all his creative work in Gikuyu, his birth tongue, after several years of writing in English to considerable acclaim. His

work since then has been translated into English, indeed some of the translations are equally skilful, and he has responded to critics and readers in English. However, he writes creatively consistently in Gikuyu and has found the popular and politicised audience he was looking for partly through the language change, but also partly through a shift toward the use of oral techniques in his prose, poetry and plays. A good example is the novel *Devil on the Cross* (1982), and an article by Kabir Ahmed analyses the oral techniques it employs in detail, illustrating a number of the different reading skills that it is necessary to bring to such a text. For example, in one scene where the characters are attempting to justify themselves by praising their achievements, Ahmed points out that one needs to be familiar with Gikuyu oral traditions which include the proverb 'self praise is no recommendation', to understand the implications of the scene (Ahmed, 1995: 56).

In *Decolonising the Mind* Ngugi gives an account of his early education in language and story. He begins by telling us of his extended family and the importance of storytelling for young children:

> There were good and bad story-tellers. A good one could tell the same story over and over again, and it would always be fresh to us, the listeners … The differences really were in the use of words and images and the inflexion of voices to effect different tones.
>
> We therefore learnt to value words for their meaning and nuances. Language was not a mere string of words. It had a suggestive power well beyond the immediate and lexical meaning. Our appreciation of the suggestive magical power of language was reinforced by the games we played with words through riddles, proverbs, transpositions of syllables, or through nonsensical but musically arranged words. So we learnt the music of our language on top of the content. (Ngugi wa Thiong'o, in Thieme 1996: 80)

This is a scene that is reiterated throughout studies of communities centred on orature, or oral literature. The oral skills are needed for survival, they are necessary to negotiation and important for successful persuasion, over land, property, marriage, action – just as reading and writing are in our culture. In writing about 'The Riddle', Hezekiel Njoroge notes that through learning riddles children are learning language competence skills, observational skills, normative skills, memory and intellectual skills and entertainment skills (Njoroge, 1994: 45–65). As the young person acquires these skills, they become more and more respected, and those who achieve the more difficult memory and intellectual skills become revered. They join the group of oral performers

called griots, who hold a place directly analogous to the rhetorician in
the oral traditions of classical Europe. Depending upon the political
structure, griots speak for the group or the leader, but they also work on
words imaginatively and in participation with the community.

For the first four years that Ngugi went to school, he was taught
locally and in Gikuyu. However, after the 1952 state of emergency in
Kenya the schools were taken over by the English, and Ngugi recounts
a story all too familiar in the history of European imperialism. He says:

> one of the most humiliating experiences was to be caught speaking Gikuyu
> in the vicinity of the school. The culprit was given corporal punishment –
> three to five strokes of the cane on bare buttocks – or was made to carry a
> metal plate around the neck with inscriptions such as I AM STUPID or I
> AM A DONKEY. Sometimes the culprits were fined money they could
> hardly afford. And how did the teachers catch the culprits? A button was
> initially given to one pupil who was supposed to hand it over to whoever
> was caught speaking his mother tongue. Whoever had the button at the
> end of the day would sing who had given it to him and the ensuing process
> would bring out all the culprits of the day. Thus children were turned into
> witch-hunters and in the process were being taught the lucrative value of
> being a traitor to one's immediate community. (Ngugi wa Thiong'o, in
> Thieme 1996: 80)

Ngugi did well within the system because he was good at English.
Despite this, he realised later in his life that the people he wanted to
read his books could not do so because they were written in a language
within which they did not work. So he returned to writing in Gikuyu,
much to the dismay of many English-language readers who felt, as he
puts it, 'abandoned' (Ngugi wa Thiong'o, in Thieme 1996: 82). His
move echoed that of Chaucer and Dante, both of whom had abandoned
Latin for their vernacular tongues centuries before.

Infusing English with oral techniques: proverbs and folktales

If Ngugi rejected English, other writers either retained it or had no
choice since it was their birth tongue. Nevertheless, in common with
him, many have turned to techniques and devices from the oral tradi-
tion. A primary device has been the use of proverbs and folk-tales from
the communities in which they have grown up, although there is a
potential difficulty in understanding the complexity of these tales when
they are rendered in print. For instance, take two short proverbs about

Kalikalanje, the 'fried one', recounted by my colleague Jack Mapanje, from Malawi. The first version of this proverb tells of a woman who is widowed when she is six months pregnant, and who develops a craving for human flesh. She goes to a wizard who agrees to get her the flesh in return for the child when it is born. Soon after her boy is born, and while the mother is out, he jumps into a frying pan and fries himself, and when she comes home he announces that he is Kalikalanje, the fried one.

Eventually the wizard comes to claim the child and the mother is very sad, but she 'arranges' for the wizard to capture him. Yet either by luck or by cleverness the child escapes each time, and, finally, when he is up a tree looking for honey, his dog kills the wizard who is waiting at its foot. The boy takes the wizard's intestines and gives them to his mother to eat, which she does, not knowing what they are. The tale ends with the mother sad that the wizard is dead, but happy that her son is alive.

The second tale has the same story but a different plot line. At the start a pregnant woman tells her husband that she craves ostrich eggs, and he agrees to get them only if she gets him water 'from where the frogs do not croak' (for a printed version see Schoffeleers and Roscoe 1985: 183–185). This water is, however, guarded by a wizard, who lets the woman have some on the condition that she agrees to let him have the child, once it is born. After the child is born, and while the mother is cooking, he leaps into a pan and cooks himself, emerging as Kalikalanje. When the wizard comes to claim the boy, the mother attempts three times to create a situation that will allow him to capture Kalikalanje. What is difficult to understand is whether she is trying to prevent his capture, or is colluding in it. Eventually Kalikalanje kills the wizard, comes home and kills his mother.

If these tales were to be performed, there would be a number of different ways in which they could be presented. For example, in *African Oral Literature* Isidore Okpewho talks about the way that dramatisation and dance are closely interrelated in Malawian storytelling, by quoting a description of a masked dancer, the kapoli, who

> begins to dance by paddling with the left leg then the right one. The dancing builds up slowly and warms up to the required climax. The drummers play the drums with their palms but you see from their head and body movements and facial expressions that they are part of the song and the performance too. The audience-participants wear beaming faces; and they imitate the continuously elastic and plastic body movements of the kapoli as they take up the chorus and clap their hands. Some of them talk to each other

indicating that the song refers to so and so who is among the crowd. They
point at him and laugh as the performance goes on. The kapoli acts the role
of the woman complaining in the song. He moves towards the audience-
participants, slightly bends towards them, clasps his arms and puts them
behind on his back as the women jubilantly join him, melodiously singing
the song. He shakes his head as the woman's gesture of making a plea to the
husband to leave her free.

<div align="right">(Mvula, in Okpewho 1992: 47)</div>

This proverb need not be involved in such complex masking, but it will
likely be preceded by a call and response opening, by dramatic flour-
ishes added by the orator or even additions to the story, and by ongoing
audience participation.

The tales are apparently simple but in performance very complex.
To understand their proverbial content we could turn to the opening
scenes, to the woman who is widowed and the woman whose husband
will do her a favour only if she does one for him. Or we could look at
the wizard who helps these women: Does he use special powers, or is
he representative of power in general? What gives him the right to
stand guard over clean water, or to offer someone human flesh? Or we
could consider the desires of the two women: one wants human flesh
and tries to save her son; the other wants ostrich eggs and seems will-
ing to give him up. Or, we could think about the endings: in the first
tale the child forgives the mother, but she eats the wizard and is sad
that he is dead; in the second, the child kills the mother although it is
not absolutely clear that she has given him up to the wizard. Or we
could simply ask, Why is the child 'fried'? and, Does it make a differ-
ence that in one tale the mother is absent and in the other the mother
is present?

What unsettles and deepens our reading is the ambiguity of the
actions of the mother and the child. Without performance we do not
know, and may not even be alerted to the possibility, that the mother is
helping or hindering the child's escape. Without performance we do
not know whether the child is escaping through luck or cleverness or
help. Furthermore, without performance we have no clue as to the
status of the wizard; he could be being presented as having rights to act
as he does, or as being authoritarian, or as misusing his power. The
more we understand about the performance context, the more complex
the proverbs can become, and the more the reader will become a
reader-participant and begin to value them.

Many contemporary African writers, and writers from England, the Caribbean and the Americas, have turned to the use of folk-tale. In an essay on Amos Tutuola's *My Life in the Bush of Ghosts* (1954), Ato Quayson comments that the novel has drawn criticism from readers who say that Tutuola 'merely translates in a literal fashion from the Yoruba in which all the old legends are still verbally told', as if this is a problem (Quayson 1995: 104). Quayson delicately follows the rhetorical strengths of the text to argue for the value of using the folk-tales, and goes on to talk about the way later generations of Nigerian writers, such as Ben Okri, who lives partly in England, take the folk-tales and push them even further into the novel form, breaking up its conventions. This employment of folk-tales parallels the use of Hindu mythology by writers such as Himani Bannerji, to which I referred in the previous chapter, although because that mythology has been written down it has more 'value'. What do we really mean by that phrase – 'has more value'? I would suggest that it simply means that we have more rules of thumb for evaluating, a better vocabulary for understanding and hence more ways of participating in the text.

Fulfilment of character and generic disjunction

Wilson Harris, who comes from Guyana and also lives in England, talks about the vital importance of pushing at the novel, of pushing at the received generic conventions. Almost inevitably this will make things more difficult to read. In 'Tradition and the West Indian Novel', Harris argues that the twentieth-century preoccupation with consolidation of character in the novel needs to be different in the Caribbean novel, in that it needs to move to fulfilment of character. Consolidation edges readers towards acceptance rather than dialogue; it generates a tension between the individual and the society very like that to which I referred in the second chapter between the individual and the nation. What is more, Harris deplores the focus on 'suffering' that results, the negativity of the 'victim' position as Margaret Atwood would have it (Atwood 1972: 25–43). He argues that the Caribbean is steeped in 'broken parts of such an enormous heritage' that appear like a 'grotesque series of adventures', so we need to look at the individual and search for an 'inward dialogue and space when one is deprived of a ready conversational tongue and hackneyed comfortable approach'. In doing so Harris is confident that 'one relives and reverses the "given" conditions of the past' (Harris 1996: 532–533, 534, 537).

There are many ways of approaching this 'reversal' and the previ-
ously mentioned 'fulfilment' of character. For example, in the following
extract from 'My Mother' by Jamaica Kincaid, from Antigua and the
United States, note how rapidly the prose moves into the non-realist,
almost allegorical mode that challenges the idea of consistent character:

> Immediately on wishing my mother dead and seeing the pain it caused her,
> I was sorry and cried so many tears that all the earth around me was
> drenched [note the excessiveness here]. Standing before my mother, I
> begged her forgiveness, and I begged so earnestly that she took pity on me,
> kissing my face and placing my head on her bosom to rest. Placing her arms
> around me, she drew my head closer and closer to her bosom, until finally I
> suffocated. I lay on her bosom, breathless, for a time uncountable, until one
> day, for a reason she has kept to herself, she shook me out and stood me
> under a tree and I started to breathe again. (Kincaid 1995: 204)

The story moves into fully fledged allegory as the mother covers herself
with oil from the 'livers of reptiles' and grows 'plates of metal-coloured
scales on her back' (Kincaid 1995: 205). Moreover, as the narrative
develops, the metamorphoses become more extreme. For someone
trained to read English literature, Kincaid's story resonates strongly
with translations of Ovid and the writings of Spenser, but is radically
different from them because unlike them she is writing in a period that
follows three hundred years of the realist novel. Even in her more 'real-
ist' writing there are subtle undercurrents of disruption. Take the scene
in 'Columbus in Chains' from *Annie John* (1985) when the protagonist
comes back from school where she has been punished for writing rude
comments under a picture of Christopher Columbus, and looks forward
to her mother's comfort. However, her father has arrived back first and
is entertaining her mother with stories:

> My mother brought me my lunch. I took one smell of it, and I could tell that
> it was the much hated breadfruit. My mother said not at all, it was a new
> kind of rice imported from Belgium, and not breadfruit, mashed and forced
> through a ricer, as I thought. She went back to talking to my father.
> My father could hardly get a few words out of his mouth before she was a
> jellyfish of laughter. I sat there, putting my food in my mouth. I could not
> believe that she couldn't see how miserable I was and so reach out a hand to
> comfort me and caress my cheek, the way she usually did when she sensed
> that something was amiss with me. I could not believe how she laughed at
> everything he said, and how bitter it made me feel to see how much she
> liked him. I ate my meal. The more I ate of it, the more I was sure that it was

breadfruit. When I finished, my mother got up to remove my plate. As she started out the door, I said, 'Tell me, really, the name of the thing I just ate.'

My mother said, 'You just ate some breadfruit. I made it look like rice so that you would eat it. It's very good for you, filled with lots of vitamins.' As she said this, she laughed. She was standing half inside the door, half outside. Her body was in the shade of our house, but her head was in the sun. When she laughed, her mouth opened to show off big, shiny, sharp white teeth. It was as if my mother had suddenly turned into a crocodile. (Kincaid 1985: 83–84)

In small, intimate, yet devastating ways Kincaid denies us consolation of character.

A writer who takes a different stylistic approach to the question of the consolidation of character is Claire Harris, from Trinidad and Tobago and now living in Calgary, Canada. In *Drawing Down a Daughter* (1992), a prose section called 'A Matter of Fact' plays formally with generic disjunctions as she creates a collage effect around a series of characters. The book begins as a conventional novel which tells the story of a young woman who has become pregnant, but the man in question refuses to marry her, and runs off only to be seduced and destroyed by La Diablesse. The novel opening moves quickly into an oral folktale which might have been the source of the story, but then the writer, whose presence we sense only from movement through various different genres, finds out that the events actually did happen. The newspaper says so, the police reports say so, yet the events seem to have happened after she wrote her story not before. The entire story becomes a collage of different printed media, including autobiography and romance as well as the other genres already mentioned. They convey the sense of Wilson Harris's 'broken parts' of a tradition for representing the individual, parts from the conventions of the European novel, from film, from newspaper, from African tale, that are brought together here to tell a story, although the story does not quite add up. Claire Harris speaks elsewhere in 'Poets in Limbo' about the difficulty of writing about her self, her blackness, her body, her womanhood, her Caribbean birthright and Canadian life. The collage gives us the sense of there being no consistent characterisation available for her, yet displays the difficulty of Wilson Harris's notion of reversal and fulfilment.

Nation language and word-music forms

A different approach again is taken by E. Kamau Brathwaite, in which he explodes the English language just as Claire Harris explodes generic stability. Brathwaite goes for the roots of the English language and has been credited with the idea of a 'nation language', which treats the distinctive Englishes of the Caribbean as languages in themselves rather than as dialects or creoles. He works very largely from music, from jazz or calypso. He says in *History of the Voice* (1984) that

> In order to break down the pentameter, we discovered an ancient form which was always there, the calypso … It does not employ the iambic pentameter. It employs dactyls. It therefore mandates the use of the tongue in a certain way, the use of sound in a certain way … Compare
>
> (IP) To be or not to be, that is the question
>
> (Kaiso) The stone had skidded arc'd and bloomed into islands
> Cuba San Domingo
> Jamaica Puerto Rico
>
> But not only is there a difference in syllabic or stress pattern, there is an important difference in shape of intonation. In the Shakespeare (IP above), the voice travels in a single forward plane towards the horizon of its end. In the kaiso, after the skimming movement of the first line, we have a distinct variation. (Brathwaite 1984: 17–18)

One of the best ways to understand the rhythmic difference is to listen to the singing of calypso. Calypso, merengue, dance hall, compas and reggae are all musical forms which use words and which have been at the forefront of the cultures of the Black diaspora. Some have claimed that there is a direct connection between performers of these forms and the griot of African culture, and they do all speak for communities in modes that encourage participation, even though they do so in different ways. Reggae, for instance, uses predominantly English lyrics and Jamaican choruses. Think of the well-known classic by Bob Marley, 'No Woman, No Cry', and you hear the written quality of reggae which has been attributed to its use of standard English.

When these word-music forms began to move into American and English culture in the 1950s with the phonograph revolution, they were usually produced on 45s with instrumental music on the other side. This led in turn to a new form where the deejay would talk over the music, often interacting with the audience, and in the process this performance

developed into dub and rap. There is a lot of disagreement about the difference between dub and rap, although the former could be thought of as words over the top of music and rap as words with musical accompaniment. A celebrated rap performer, Benjamin Zephaniah, has been recognised as a valued artist by no less an institution than Cambridge University where he held a Fellowship. However, his work is still not considered valuable enough to be widely taught. In addition, Jamaican dub poet Jean 'Binta' Breeze is even further from recognition. This is partly because she is one of the few women artists in a predominantly male, if not macho and misogynist, hip hop world, one of whose traditions, like calypso, is to berate and belittle women, but mainly, I suggest, because we do not know how to talk about the kinds of language rearrangements in which she is engaged. Nevertheless, if you read and/or listen to her poems as oral performances, you can hear the stylistic patterns of varieties of repetition, parallelism, piling and association, tonality, ideophones, digressions, imagery, allusion and symbolism that Okpewho notes as typical of the highly sophisticated oral literature of African cultures (Okpewho 1992).

Brathwaite has turned not only to music to explode the conventions of written English but also to the writing of poetry in 'nation language', or alphabetically rendered varieties of English that engage in 'calibanisms',

> spelling, breaking, spacing, shaping words in ways that dislocate them from their familiar associations and meanings but more importantly allowing nuances, echoes, puns, rhymes and particular kinds of music 'out' of the language that history has imposed on him to express his experience and vision.
> (Brown 1995: 128–129)

Brathwaite's 'X/Self's Xth Letters from the Thirteen Provinces' plays with this form as he writes, significantly, of the computer:

> Dear mamma
> i writin you dis letter/wha?
> guess what! pun a computer o/kay?
> like i jine de mercantilists!
> (Brathwaite 1987: 80–81)

The poem from which this excerpt is taken dates from 1987, but in a rewriting of 1992 Brathwaite reorganises the poem typographically on the page to reinforce the rhythm of the words and their power of dislocation:

Dear mamma

i writin yu dis letter/ *wha?*
guess what! pun a computer o/kay?
like i jine de mercantilists?

well not quite!

i mean de same way dem tief/in gun
power from sheena & taken we blues &

gone
...

say
wha? get on wid de same ole

story?

okay
okay

okay
okay

if yu cyaan beat prospero
whistle

•

No mamma!

is not one a dem pensive tings like ibm or bang & ovid
nor anyting glori. ous like dat!

but is one a de *bess* tings since cicero o
kay?

(Brathwaite 1992: 76–77)

Brathwaite has come round to arguing that the computer can help him present written text in a way that is closer to the oral; he refers to it as 'writin in light' (Brathwaite, in Brown 1995: 126). In the reworked poem not only do we find the dislocation of the written by larger oral structures such as folk-tale, or by smaller oral devices such as repetition and phonology, but by the medium itself.

Claire Harris is one of the most extreme experimenters with all of these elements, particularly in her combination of linguistic dislocations with typographic play. Yet other work benefits enormously from

insisting on the crossover with music. Unlike many 'language poets' as they are called, Zephaniah and Brathwaite have overt political, social and cultural aims that are embedded in their poetics, which the imme- diate performance context of the word-music forms clarifies. Jean 'Binta' Breeze moves easily from one register, of nation language, to another often more 'standard English' register, yet the intonations of her voice conveyed by her recordings always remind us of the ironies, sarcasms, satire, parody and social observation with which she engages. If, in contrast, we turn to a section of the poem *Drawing Down a Daughter* by Claire Harris, which is conveyed by the page alone, we could be at a loss as to how to read. Take the following:

> Girl all of us in this family know how to make float how
> to make bakes the real real thing and acra not even
> your father's mother make so good and pilau and
> callaloo with crab & salt pork barefoot rice rich black
> cake cassava pone (is true your Carib great aunt on your
> dad side teach your mother that) but the coconut ice cream
> and five-fingers confetti buljol souse those are our
> things
>
> Child this is the gospel on bakes
>
> first strain sunlight through avocado leaves
> then pour into a dim country kitchen through bare
> windows on a wooden table freshly scrubbed
> *I'm warning you a lazy person is a nasty*
> *person* flurry of elbows
> place a yellow oil cloth on this a bowl
> a kneading board a dull knife spoons
> then draw up an old chair have a grand-father carve
> birds flowers the child likes to trace sweep of petals
> ...

> (Harris 1992: 44)

Notice how the rhythm and intonation changes on the other side of the central line 'Child this is the gospel on bakes'. The vocabulary becomes standard, and the layout returns to a more familiar free verse typogra- phy with smaller pause marks rendered by extra spaces. Indeed, in a recent article Nigerian poet Femi Oyebode argues that what we find in the oral is closely linked to prosody and its pitch, tone, rhythm and tempo, which contemporary poetry only partly compensates for through traditional layout (Oyebode 1995: 91–95).

Valuing orality: 'Burn Sugar'

Continuing in this domestic vein, I would like to finish by taking a look at the short story 'Burn Sugar', by M. Nourbese Philip, which lies right along the border between the oral and the written, and reminds us of the questions with which I began this chapter: Should we value the oral skills less? and, if not, How do we find out enough about them to value them? It seems to me that the answer to the first question is clearly 'no', but the answer to the second is more problematic. However, at the same time we live in a country where these skills are increasingly being circulated and distributed. The immigration to England of many African and Afro-Caribbean writers has made this work available here, and there are substantial communities of writers and orators that have built up. Many of these communities are keen to participate in the surrounding cultures, and I feel personally that it would be a great loss to myself if I did not begin to learn to participate as well.

'Burn Sugar' is a story about a young woman who has left her home in the Caribbean for a large city in North America, possibly New York, and for the first time since she left, the Christmas cake her mother always sends has not arrived. From the first page, the conventionally educated English reader can see that the language is ungrammatical, words are not spelled correctly, and often a first reading for someone not used to the nation language rendition is very confused. Nevertheless, on rereading, the story acquires immense power as the woman recalls her childhood, especially the making of the cake. The memory circles around images of the burn sugar, the essential ingredient of the cake. For instance, as her mother heats the sugar and it turns from white to light brown to dark brown to black, the young woman remembers wondering if it would turn white again with intense heat.

The image is central in many ways. The story is partly about race, and the experience of being 'made black' by people in a country not used to you, whereas you have come from a culture where everyone around you is a shade of roughly the same colour. Now that the young woman lives in a world where she had adopted the patterns of a primarily white culture, its consumerism, its representations, its ways of life, she wonders at one point if she has not become 'white' inside. The story is also about the change from youth to older age, from girl to woman, from a traditional culture to a foreign one. As it proceeds the reader watches the young woman trying to make the cake, caught in an

attempt to relive part of her past and her tradition, and at the same time worried about the smoke alarm going off in her very western apartment. As she thinks about all these changes in her life, her narration becomes increasingly formal and Latinate, with words like 'transformation' and 'metamorphosis' taking hold of the rhythm (Philip 1988: 17). Then she suddenly forgets a vital stage in the making of the cake, and she telephones her mother, who breaks the formal register abruptly with the question, 'Is only black cake child, is what you carrying on so for?', and, when questioned by her daughter about the deeper significance of the cake, she responds:

> 'Let me tell you something girl,' Mammy voice was rough, her face tight tight – 'some things don't have no meaning – no meaning at all, and if you don't know that you in for a lot of trouble. Is what you trying to tell me, child – that it have a meaning for we to be here – in this part of the world – the way we was brought here? That have a meaning? No child' – the voice was gentler now – 'no child, you wrong and don't go looking for no meaning – it just going break you -' (Philip 1988: 18)

The mother has had to put her recognition of brutality away, but the daughter is surrounded by it, and has to deal with it – which she does in preparing and modifying the cake that she eventually bakes.

However, there is an additional point to recounting this story. 'Burn Sugar' has been criticised as poor and badly written. Nourbese Philip has had a lot of trouble finding publishers for her work, although now she is becoming more established after twenty years. 'Burn Sugar' has been criticised for the irregular grammar, the 'bad' spelling, the different registers of nation language, standard English and the formality of some of the final scene which has been seen as excessive, almost as if compensating for the lack of control over the text. I would argue that the story is a profoundly searching insight into changes of many kinds, which has been embedded into what is essentially a recipe – you could almost make the cake from this story. What is more, as Nourbese Philip well knows, the recipe is a genre that lies right along the boundary of the oral and the written, with many people finding out about how to cook from watching and talking to others, and only occasionally going to a book for something different or special.

The story asks us to understand something about the Caribbean, the writer's own life and orality, and to value it – otherwise, after a slightly confused first reading, the story may be put aside, and we will miss out

on the densely rich possibilities it offers. The context that we as readers are willing to bring to a reading is vital, and can radically change our attitudes about a piece of writing. For example, if we know, as I do, that Nourbese Philip, from Trinidad and Tobago, was a practising lawyer in Toronto, we can get a hold on the formal English of the concluding sections of this story, and understand it as a possible gesture towards parody. We also need to make an effort to find out about some of the oral storytelling techniques, and some of the linguistic elements.

So, if we listen to Jack Mapanje, Wilson Harris, Claire Harris and E. Kamau Brathwaite, we might then note how Nourbese Philip uses the nation language insistence on the present tense alternating with abrupt past tenses of the standard English in the opening lines, to convey some of the frustration and anxiety of the young woman. Or we might be aware of the way that the storyteller often gives the audience the isolated noun or verb as a tag, and then amplifies around it, as in, for example 'she say, the Mother had said' or 'Wherever she is, happen to be', because when you are a listening audience it is so easy to miss a key phrase. Or we may hear the way that the teller of the tale plays with repetition, extending the tension and creating humour, as in 'rip, rip off, rip the brown paper, prise off the lid, pause …' with its gradual extension of phrasing and cumulative assonances of 'r' and 'p'. Or we may understand that, having told a scene, the teller needs to refocus the audience before moving on, as with the concluding sentence-phrase, 'The cake' (Philip 1988: 11).

Nourbese Philip has written at length on many of these issues both in poetry and critical prose, so we can also turn to her to find out more about how to read her writing. The only simple answer to the second question − How do we find out enough about oral literature, orature and writing with oral techniques to value them? − is to read more, to listen more and to talk more about the writing with other interested people. We should also be aware that one of the gifts that most of the other writers mentioned give us is that they write commentaries about language, speech and writing, so that we can begin to hold conversations about these issues with the writers themselves.

Telling stories/telling tales

One of the key elements in conventional literary value is the idea of the work being produced by one person. The book may be reprinted many times, but the style is unique. Yet in North American First Nations and aboriginal societies, the so-called Fourth World, there is no copyright on words but on the story itself. ('Aboriginal' became the word used widely during the United Nations Year of Aboriginal Peoples. However, 'First Nations' has become, at least temporarily, a dominant phrase in Canada to refer to Aboriginal peoples.) This chapter will discuss the 'stealing our stories' issue that has arisen time and again over the last decade, as First Nations writers have objected to the use of their stories in the western media. This objection comes about not least because the telling of stories works not only as cultural but also as social, political and religious learning. I will also consider how the fact that the teller is not a unique individual but a member of a community asks us to rethink completely the criterion of 'original genius' when we are building literary value.

An introduction

This chapter might have the title, 'The Creation of Hope'. As I read and reread First Nations texts in preparation for writing it, I came across the word 'hopeless' again and again. However, repeatedly, that hopelessness had been pushed aside as the words brought back hope. One way in which First Nations communities bring back hope is in the act of writing. Most of the peoples whose texts I will look at come from cultures that are primarily based in oral traditions, yet writing has become a way of participating in the society around them. The difficulties and benefits of that participation underlie much of what this discussion will go on to explore.

Whether they are oral or written, nearly all First Nations texts have some kind of formal introduction that is there to locate the speaker,

but in doing so partly locates the audience as well. As you will know if you read the Preface, I am a Professor of the History of Rhetoric, and I teach literature and other verbal arts at the University of Leeds. In doing so, I try to help people learn how to read: attentively, with analysis and critique, but also in ways that encourage us to articulate the elements of our own lives and to understand better those of others. I hope that this is what I am doing in this chapter.

First Nations introductions always need to contain a citing of sources, both for the stories and for the knowledge from which the speaker will talk. For all the texts that I will discuss, I have permission either directly or indirectly to speak from them. I have the inspiration to speak about the issues these stories raise from elder Christine Miller, who has encouraged me to keep working on reading and telling when I have found the words difficult – which is often. To her, and to other elders, those people who have shared their knowledge with me, both here and elsewhere, I give my respect.

Another thing about First Nations introductions is that they may not be formal in presentation, indeed they may tell you about the speaker's mother or grandfather or what they have been doing. What is more, once they have located the speaker, that person can be as vulnerable, didactic or personal as they wish, because a scope has been offered. At times, this vulnerability or didacticism can make the Anglo-American reader feel embarrassed. The First Nations voice can speak in ways that are alien to western culture these days, and can appear almost naive. For example, unlike in British culture, children's stories in First Nations culture are taken rather seriously, because the status of children is different. Children are the main source of hope. Yet it is the immediacy of the vulnerable voice, located firmly in the genre expectations that western readers and audiences bring to texts and which are analogous to introductions in First Nations culture, that forms the body of some of our most cherished texts. Nowadays, it is often overlaid with signals of displacement as if the writer or speaker is no longer confident in those expectations, and is running away from being found out. In contrast, Angela Sidney, a Tlingit elder from the Yukon, says, 'You tell what you know. The way I tell stories is what I know' (Sidney, in Cruikshank et al. 1990: 42). Not only what you say but how you say it from your own life and experience, both of these are knowledges needed in daily life, that the stories make it possible to say.

There is a double focus in this chapter: on the oral and written, and on the stance that the texts take up. The first emphasis picks up

elements from the previous chapter, and explores some of the things we need to know about the differing strategies in orature and literature if we are to understand more fully what is being said. The second emphasis tries to engage with the ways in which these writings and tellings bring back hope, through rhetorical structures that are often familiar but not fully domesticated to English culture: humour, elegy, allegory and irony. Each of these stances is profoundly located in social expectations – humour, as readers will know, is highly specific to peoples and places. Often, when I read these texts, I do not know whether they are funny or not, sad or not, with the same common grounds as my own, or not. I will try to offer ways of engaging with these differences, not to get rid of them but to value them.

'Fourth World' nations and erasure: the Canadian residential school system

First, I must begin with some background. Most of the texts referred to in the chapter are taken from Canadian First Nations peoples. However, the word 'Canadian' is not a sensible geographic distinction. First Nations communities cross internationally recognised national borders between Canada and the United States, the United States and Mexico, Canada and Siberia, and so on. Furthermore, there are over fifty First Nations in Canada itself and over five hundred bands or groups within these Nations. The reason for my focus on 'Canadian' is that these peoples form the communities that my research area covers. However, the national borders have begun to exert an influence on the structuring of First Nations cultures, if only through government policy in the arts. The federal government in Canada, which is largely responsible for First Nations affairs no matter which province they reside within, has distinctive publication policies that will support Canadian but not United States writers. For example, the En'owkin International School of Writing in British Columbia, which is one of the most important centres for encouraging First Nations writing, publishes the journal *Gatherings*, with the support of two Canadian arts agencies. In a 1996 issue of the journal (volume VII) there were contributions from other societies in the United States, New Zealand, Australia and elsewhere; nevertheless, the contributors' predominant country of origin was Canada.

However divided national borders may try to make First Peoples, they are united in common causes with other aboriginal peoples, and

are most visible to the First-World powers in their closeness to the land. These common causes have led to the epithet 'Fourth World' for aboriginal peoples the world over, which has no specific definition but which distinguishes these societies from Third-World countries. Fourth-World nations have never been colonised, nor are they post-colonial, they have simply been erased. They have not all been erased in the same way, because different governments have had different policies for painting out their existence, which range from extermination to cultural cleansing. In Canada, the single most important element, especially with regard to the verbal arts, was the residential school system policy in effect from the early years of the twentieth century until the 1960s, and even later in shadowy forms. Canada operated a supposedly benevolent despotism – First Nations people did not get the vote until 1962. These schools were, terribly, involved in the same abuses now attributed to church and state institutions in the UK, but with the added horror of the systematic targeting of an entire society, and with the added destruction of all Native American Indian languages.

The residential school system has touched nearly every First Nations person in Canada in one way or another. The presence is there in direct accounts such as Isabelle Knockwood's *Out of the Depths* (1992), which details with tragic clarity the appalling destruction of Mi'kmaw children at the Shubenacadie Residential School in Nova Scotia, from the 1920s to the late 1960s. While the tone is relentlessly documentary, it is tinged with a voice belonging to no genre that I recognise, one of seeking an accommodation to the horrors as the only way of proving to oneself that there was a reason for them. In her conclusion, Knockwood describes some children who do not even remember the beatings, who 'looked on the school as a refuge from homes where they were abused, frequently by parents who had themselves attended the school and learned physical punishment as a method of child-rearing'. On the other hand, there are the many who

> tell shocking stories of what happened to them there. Yet they all seem to make an effort to understand what motivated the priests and nuns who ran the school. 'I've tried to understand why the priests and nuns acted the way they did toward us and I can't justify any of the beatings no matter how much I try,' a former student, who is now a grandmother, told me. (Knockwood 1992: 156)

More subtly, but again in a voice of wondering bitterness that is not part of the register of recognised English generic modes, Metis writer Emma LaRocque writes:

> I looked at my hometown
> no longer a child afraid
> of stares and stone-throwing words
> no longer a child
> made ashamed
> of smoked northern pike
> bannock on blueberry sauce
> sprinkled with Cree
>
> I looked at my hometown
> Gripping my small brown hands
> on the hard posts of those
> white iron gates
> looking at the lions
> with an even glare
>
> How did they get so rich?
> How did we get so poor?
>
> (LaRocque 1992: 99)

This extract is part of a much longer poem by LaRocque, titled 'My Hometown Northern Canada South Africa', and its contained bitterness is found in a substantial number of First Nations texts.

Strategies used in oral literature and related written forms

Imagine what happens next to First Nations peoples, when, after forty and more years of systematic destruction, and with the access to political power that came in the 1960s, they want to restore some sense of dignity, of purpose, of community. One of the most important strategies would be to encourage cultural work, especially language-rooted arts, not only because they are the primary means of communication between human beings but also because they are so powerful in the print societies of the west. You may have lost your language, indeed it may have been destroyed. You may have lost your stories, your knowledge about telling, your understanding of how to listen. Moreover, you may find it difficult to tell your story in a Eurocentric generic form. In fact, First Nations cultures have on the whole proved incredibly robust,

but there have been many problems, not the least the transliteration between the oral and the written.

Many elders have been responsible for transmitting stories, and many writers and tellers have built their own, but another source that has been used for First Nations stories is that of transcripts made by nineteenth- and early twentieth-century anthropologists. During the eighteenth century, the Moravian missionaries from Europe who flooded into North America needed to find a written version of the languages they encountered, so that they could make the Bible available to be read by each individual. They devised a number of alphabetic systems for these languages, particularly Cree, since the Cree Nation occupied a landmass at least equal to that of western Europe. However, the Cree peoples, and many other First Nations peoples find their language more satisfactory rendered in syllabics, fearing that a lot gets lost when they are rendered as alphabetic. The later anthropologists frequently used these alphabetic systems for noting down First Nations accounts. Yet whether they did or not, there were many issues of difference intervening often silently between them and the storytelling event.

4 Story I, syllabic Cree

5 and 6 *facing page*
Story I, roman Cree
Animal sounds, English

Extracts from *Talking Animals/
pisiskiwak kâ-pîkiskwêcik* told by
L. Beardy, ed. H. C. Wolfart

[1] �ᐷᑉ·ᐤ ᐁᒡᕐ, ᐅ ᐊᒐ ᔑᐸ·ᐦ ᐩᐸ —
ᐸ ᐊᒐ ᓇᐦᐸᒡᕋᐦ ᐊᒉᐧᐸᒡᕂᐧᐛ, ᐸ ᐊᐦᐸᐦ — ᐁᒡ·ᐤ
ᐁᒡ ᐁᒡᑯ ᐊᒉᐧᐸᒡᕂᐧ ᐊᐩᐊ·ᐛ, ᕐᐦᑕᓇᐊ·ᐛ.

[2] ᐁᒡ·ᐤ ᐁᒡ ᐸ ᕆᒍᕋᐧ, ᐊᐧᑫᐤ·ᐤ·ᑐ
ᐃᐧᕆ ᐊᒉᐧᐸᒡᕂ ᐊᐊ· ᐊᒉᐧᐸᕋ ᐱᐩᐧ, ᐁᒡ·ᐤ ᐁᒡ
ᐃᐅ·ᐤ, "Come across, come across," ᐃᐅ·ᐤ ᐁᒡ,
ᐊᐸᕐᐦ ᕆᐧᐃᐩᐧᐦ ᐸᐦᕐ, ᐊᐊ· ᐱᐩᐧ ᐊᒉᐧᐸᕋ.
ᕈᐦᐯᐤ ᐤᐅ ᐃ·ᐦᐩᐤ ᐸᐦᕐ ᕆᒍ ᐊᐊ· ᐊᐨᐧ
ᐊᒉᐧᐸᕋ, "Too deep, too deep," ᐃᐅ·ᐤ ᐁᒡ.
ᐁᒡ·ᐤ ᐧᐃ·ᐤ ᕆ ᐊᑎᒍ ᐊ·ᐛ.

[3] ᐁᒡ·ᐤ ᐁᒡ ᐸ ᐱ ᐁᒍᐦᐃᐧ, ᐁᒡᑯ ᐊᐤ ᕷᕷᐧᐃ
ᐊᐨᐧᐤᐧ, ᐊᐷᕐ ᒍᐦᐸᐦᐩᐧᐃᐤ. ᐊᐧᐃᐤ
ᐅ ᐱ ᐊᒍᐦᐃᐧ ᐅ ᐱ ᐊᕆᐩᐦᕋᐧ.

[4] ᐁᒡ·ᐤ ᐁᒡ ᐸ ᐅ·ᐸᐧᐃ ᐊᐊ· ᒍᐦᐸᐦᐩᐧᐃᐤ,
ᐩᐦᐩ ᐊᐤᐧᐊ·, "It's coming, it's coming," ᐃᐅ·ᐤ
ᐁᒡ ᒍᐦᐸᐦᐩᐧᐃᐤ. ᐁᒡ·ᐤ ᐁᒡ ᕆᐱ·ᐩᔊᐧᐃᐤ ᐁᒡ
ᐊᐊ· ᕷᕷᐧ, "Where, where, where, where," ᐃᐅ·ᐤ

ᐁᒡ ᕷᕷᐧ, ᐅ ᕆᐱ·ᐩᐨᐧ. ᐁᒡ·ᐤ ᐁᒡ ᕈᐦᐸᕟᐧᐤ
ᐊᐊ· ᐊᐧᐃᐤ, ᐤᐧᐦᐤᐧᐤ ᕷᕷᐧ. ᐤᐧᐦᐤᐧᐤ ᕷᕷᐸᐧ.

There was the cultural difference between these white, Christian, often affluent men from Europe, the linguistic difference, the difference between the oral story and the written account, let alone the difference between the alphabetic and syllabic systems. What kind of status would such a story have for an early twenty-first-century First Nations person? It is clear that the stories are not used as if they were some unmediated, nostalgic source, but are taken up and reclaimed for the present. In any event, origin stories in oral societies are frequently recreated for each generation's needs.

Take, for example, *Talking Animals/pisiskiwak kâ-pîkiskwêcik* (1988), a collection of Swampy Cree tales told by L. Beardy and edited and translated by H. C. Wolfart. The book presents the tales in Cree syllabics, which were introduced in the mid nineteenth century, as well as in roman-type orthography, and in English. In the English version the stories have been rendered into fables, akin to children's tales, for the western reader. However, if we read across all three presentations of the stories, and realise that in each script the animals' speech is always present in English, the stories take on different connotations. In an oral

20 *pisiskiwak kâ-pîkiskwêcik*

STORY 1

[1] pêyakwâw êsa, ayahîw, ê-ati-sîkwahk ôma
-- kâ-ati-tihkisocik alîkisak, kâ-ihkihk -- êkwân ês
êkota alîkisak ayâwak, mihcêtiwak.

[2] êkwân êsa kâ-~ kâ-kitocik, nanâtwêwêmêw
wîci-alîkisa awa alîkis pêyak; êkwân êsa itwêw, "come
across, come across," itwêw êsa, akâmihk sîpisisihk
ohci, awa pêyak alîkis. kwêskitê nêtê wîsta ohci-kitow
awa kotak alîkis, "too deep, too deep," itwêw êsa.
êkwâni mwâc kî-nâtitowak.

[3] êkwân êsa kâ-pê-itohtêt, êkot[a] âni sîsîp akomow,
asici môhkahosiw. nâpêw ê-pê-itohtêt
ê-pê-nâciñôscikêt.

[4] êkwân êsa ka-~ kâ-wâpamât awa nâ-~, awa
môhkahosiw, ôhô nâpêwa, "it's coming, it's coming,"
itwêw êsa môhkahosiw. êkwân êsa sipwêyâmow ês âwa
sîsîp, "where, where, where, where," itwêw êsa sîsîp,
ê-sipwêyâmot. êkwân êsa pâskiswêw awa nâpêw;
nipahêw sîsîpa. nipahêw sîsîpa.

Talking Animals 21

ANIMAL SOUNDS

[1] At one time, well, when it was just about spring-time -- when the frogs are thawing, at that time -- there were frogs there, lots of them.

[2] And in their croaking this one frog was calling out to his fellow-frog; and he said, "Come across," come across," this one frog said, from across a little creek. From over there on the other side, in turn, this other frog croaked and said, "Too deep, too deep." And so they could not get to one another.

[3] And coming towards them, there was a duck on the water there, and also a bittern. A man was coming towards them, sneaking up to them.

[4] And when the bittern saw the man, "It's coming, it's coming," said the bittern. And the duck took off, "Where, where, where, where," said the duck as it took off. And the man shot at it; he killed the duck. He killed the duck.

performance, we can give the English animal words distinctive animal noises, so that, for instance, 'Where, where, where, where' becomes 'Quack, quack, quack, quack' (L. Beardy 1988: 21). This simple device begins to draw out the humour of the tales, their self-conscious play with the different scripts that acknowledges the gaps among them.

At the same time the device is not merely 'funny' but humorously provoking. Do the animals speak in English because they are ignorant and cannot speak Cree? (Do all ignorant animals speak English?) Do the animals speak in English because they have forgotten their own language? (Do people who forget their own language turn into animals? Do animals who forget their own language get killed?) Do animals who speak loudly in English, like the duck, get killed? (Do loud English-speaking animals always get killed, or only if they are English, or only if they are not?) The story has many meanings, depending on how we read the humour. Moreover, our reading of the humour will derive from our own cultural presuppositions.

As with many First Nations stories, readings of these tales depend on a sense of the possibilities in orature. Gerry William, a member of the Spallumcheen Indian band and teacher of both creative writing and storytelling, says that the two are 'fundamentally different': 'Storytelling is a group process.' 'Storytellers take the germinal of an idea and shape the story to suit their audience … Storytellers tend to use stock characters. It's the story, the message, which is important, not the messenger.' Storytelling uses repetition as a technique which becomes the 'steady beat of a drummer … The drumbeat goes on in their [the audience's] minds after they've left the circle. It beats in their minds for the rest of their lives.' 'The storyteller tells stories again and again, ensuring that at some point the listeners fully understand what's being said' (William, in *Gatherings*, 1996, 7: 158–161). These elements and others make telling quite a different experience from reading and writing, and they have their own formal qualities.

If we were to turn to one of the stories in a book 'translated' by Maria Campbell from Metis tellers, *Stories of the Road Allowance People* (1995), many of these elements would be apparent. Metis communities come from intermarriage between First Nations and either French or sometimes Scottish Europeans. As such, because of the government definition of who an 'Indian' is, the Metis are neither settlers nor indigenous peoples. They are not allowed on the reserves, and not wanted in the towns because of prejudices similar to those in England about

Romanies, Gypsies and Travellers generally: hence, 'the road-allowance people', a people reduced to living along the strips of road between the city and country. Metis communities have produced some elaborately interesting linguistic conventions that move between English, French and First Nations languages.

To some extent Maria Campbell has tried to catch the 'accents and grammar' that 'coil and spin lightly around the lives and voices of a complex and courageous people' (Marken, in Campbell 1995: 4). The first strophe of the story 'Jacob' begins like this:

> Mistupuch he was my granmudder.
> He come from Muskeg
> dat was before he was a reservation.
> My granmudder he was about twenty-eight when he
> marry my granfawder.
> Dat was real ole for a woman to marry in dem days
> But he was an Indian doctor
> I guess dats why he wait so long
>
> (Campbell 1995: 86)

Campbell catches not only the accents and grammar but the structure of the stories her tellers tell her. There is frequent repetition, particularly of key names that guide you through the story and its interlacing plots, of negative verbs like 'can', which stands for 'can't', the sounds of which pile up on each other when the story is trying to address difficult issues, and of single words with changing surrounding phrases that carry forward a narrative movement and transformation, such as 'cry' and 'sing' in the following:

> an he start to cry and he can stop.
> He say he cry for himself an his wife
> an den he cry for his Mommy and Daddy.
> When he was done
> he sing dah healing songs dah ole womans
> dey sing to him a long time ago
>
> (Campbell 1995: 101)

Through these, and other, oral techniques, Maria Campbell brings the stories to life, lets us hear the tellers by means of a tortuous route from Mitchif (a mixed language of Cree, English and French) into standard English, and then into what Ron Marken calls 'village English'. Marken observes, 'Degrade or silence the voices and you kill the culture. Take

away a people's language and insult its forms of expression, and you rub
out their singularity and character' (Marken, in Campbell 1995: 5). Camp-
bell's 'translations' bring this culture into our lives despite its erasures.

Elegy, allegory, irony and humour: learning to value First Nations writing

The story 'Jacob' offers a series of elegies: for a past way of life, for a
specific person, and for someone's 'self', a part of the humanity that is
destroyed by the denial of culture and the community it makes possi-
ble. Elegy runs throughout First Nations writing, and I find it the most
accessible generic form that is used. Like Eurocentric elegy, the focus
is on community: the dead person's contribution to community, the
feelings of the community left behind, grief as a tear in the lives of
those still living that must be retextured partly through the words.
Linda McDonald, an Athapaskan and member of the Liard band,
offers us an elegy for a grandmother, 'Their Time', in the collection
Writing the Circle (1990). Along with 'Jacob' which concludes, 'We
should never forget dem ole peoples' (Campbell 1995: 104), McDon-
ald stresses the need to remember the actions and time of the dead
person so that the time of those left behind is enriched. She says, also
in conclusion,

> What is important?
> Your time.
> My time.
> Whose time?
> We must never forget – their time
>
> (McDonald, in Perreault and Vance 1990: 188)

Yet take the elegy 'love medicine' by Metis poet Alice Lee, which is also
from *Writing the Circle*:

> i met a man
> i fell in love with
> if he did not love me back
> i thought i would die
>
> Kohkom
> was a cree woman
> a medicine woman

you have to be careful
with this
she said
it is strong medicine

she showed me
how to crawl inside him
and make him love me

today he died
i was still inside him

Kohkom
never told me
how to get out

<div align="right">(Lee, in Perreault and Vance 1990: 161)</div>

Here I find a distinct problem with the status of the image of the woman being inside the man. Is it an allegorical embodiment of the person in words, or a symbolic reconstruction of emotion, or a metaphorical translation of feeling, or a simile gesturing to parallel experience? As I move away from the allegorical/literal towards the simile, I can find more ways of explaining what I understand from the poem, but this makes me worry about missing the meanings it conveys and by substituting my own, somehow wrenching the text away from its own particular significances. What is more, this insecurity is not only poetic, whether the text is written or oral, but rhetorical, and rooted in the gaps in my social understanding.

I will return to this sense of wrenching awry, but will now address the other large issue in Gerry William's remarks, that of the audience. A storyteller tells tales in different ways to different audiences. In an article from 1986 by Barbara Godard, we can find a discrete analysis of how tellers engage all male, or all adult or all worker audiences with distinctly differing forms of the story. Indeed, implicit in Godard's article is a question about the whole process of audiotaping stories, because this necessarily opens them up to audiences which may not be appropriate. However, some tales clearly can be spoken in different ways, and not be threatening or improper. The collection of oral stories from Yukon elder women titled *Life Lived Like a Story* (1990), which was put together by ethnoanthropologist Julie Cruikshank, is a good example. From this collection we find at least two versions of the Moldy Head story, each from a different storyteller. We also find two Stolen

Woman stories from the same writer, each with a varied emphasis, and a shift in the position of voice.

Against this background, we might assume that written texts were far more stable. Indeed, as I have demonstrated in earlier chapters, the critical history of literature has, until recently, taken this for granted. If the assumptions about orality are that it is naively constructed, from semi-literate (that is, semi-civilised) peoples, tediously repetitive and rather embarrassing, assumptions about writing include its purported fixity of medium, its author-bound meanings and its inflexible treatment of all audiences as the same. Yet, of course, each medium simply offers communication from one human being to another in a different way, sometimes with engagement and sometimes not.

One way of looking at the difference in action is to read the densely allegorical origin stories told by many First Nations peoples, and see what happens when they are transliterated from oral to written or written to oral. I want to compare two such accounts, one oral story by Tlingit elder Angela Sidney and one written from a telling but specifically for the printed medium, from the Mohawk community of Tyendinaga. The Tyendinaga story tells of a happy community who live in the sky, until a woman becomes unexpectedly pregnant but will not say who the father is. A few years after the child, a daughter, is born, a man in the community falls ill and moves towards death – something that has not happened there before. After his death, the child becomes upset, and the village understands that this is the father. The young girl has many conversations with the dead man, and eventually gets pushed through a hole in the sky and goes down to earth to populate it.

Similarly, the Deisheetaan story from the Yukon tells of a happy, important family in the sky, with a beautiful daughter who becomes unexpectedly pregnant. Even though the pregnancy is not caused by human means but is Crow, the protean trickster of Native lore, trying to get born, the family is very upset. The child, a son, is born, and when he begins to grow up he wants to play with all the wonderful things hanging in his grandfather's house, and the old man is 'the only one that has them'. One by one the child plays with the sun, the moon, the stars, and ends up kicking them out of the house, and so the story develops. As an extension of this story, Sidney also tells of 'How Animals Broke through the Sky'. She describes the world in darkness, wet and cold, populated by animals who know that on the other side of the sky is a warm sunny place. So they decide to send first the bloodsucker through

to the other side, and then animals of increasingly large size, until Wolverine goes through dragging a dry moose skin that causes a large hole. When the people who live in the sun are away, the animals begin to steal things for the earth: the sun, the warmth, the summer. At last an old man comes out, waving his blanket, and says to these things, 'Don't go away for good … Go back and forth', and so now we have summer and winter on the earth (Sidney, in Cruikshank 1990: 42, 48–49).

The Tyendinaga tale is self-consciously adapted to the written page. The grammar and syntax are quite standard. There is a feeling of causality as paragraph leads to paragraph, and makes apparent sense. I say 'apparent' because the story is not one that a western reader would conventionally accept as describing the beginning of the earth. Moreover, while there might eventually be consensus about what the story 'means', each reader will have to cross the cultural and linguistic gap that it is the work of language to mark out. We interpret the story for ourselves, English-educated readers taking cues from the allegorical tone and what we know about genres of parable or fable. In contrast, the Deisheetaan oral story needs to be paced, to gain emphasis, intonation and an understanding of the speaker's relation to their audience if it is to be appreciated. The 'meaning' may be more obviously negotiated, as in a conversation, but interpretations will be as varied.

However, allegory is a highly problematic stance. It is at once literal and fabular; making analogies at the same time as embodying actual experience. Even within one culture, people are unlikely to understand the grounds for interpretation held by others. When I read these stories, I inevitably invest them with significances particular to myself. The Tyendinaga tale is curiously opposite to the Deisheetaan, in that the happy people from above make a hole in the sky and go down to earth, while in the other the disgruntled animals from below make a hole in the sky and steal what they need from above. I find myself reading one as a post-contact version of the Christian world, and one as a proto-Marxist uprising of the proletariat. Or, for example, and you need to know that I am co-editing *Romeo and Juliet* at the time of writing, many of the Yukon Stolen Woman stories remind me of Shakespeare: both are obsessed with stars.

When I read like this, am I colonising the text, appropriating its meaning? The issue of 'appropriation of voice' has been central to debates within and around First Nations communities for some time, and is most clearly focused on the anger felt by many First Nations

peoples when their stories are used by non-First-Nations writers in films, children's books, novels. In Eurocentric cultures we tend to think of copyright as tied to the order of words on the page, but for many First Nations peoples copyright resides in the narrative itself. Nations own stories, bands own stories, tellers own stories. What is more, I can see their point: if I tell their stories I inevitably pass on a version of First Nations culture which is at least at one remove. The dilemma is made more acute by the fact that I am not only a reader but a critic and teacher. Are my readings ethical to pass on? I do at least for these in this chapter have some permission.

Readers have a different kind of problem because they are often alone when they read with no one to alert them to the possibilities of other significances, other values, other ways of life. This problem is one that I personally locate most starkly in trying to understand ironic texts. Irony works by holding silent a ground common to both speaker/writer and audience/reader. This is one reason why it is so often humorous, because we enjoy not only the pleasure of collusion in this common but unspoken ground but also the discrepancies, the secrets and the potentially jarring double meanings. Yet if the common ground is not common, the irony disappears and what is left is often curiously empty, difficult and even so alien that we do not try to understand it.

The work of Lee Maracle is a case in point. Maracle's writing has been criticised severely for clumsiness and sheer bad writing. Yet she plays with the subversion of generic and linguistic convention all the time. If a Eurocentric reader knows that she is First Nations then possibly prejudice intervenes; the reader does not try hard enough to value the text, certainly does not try in the way that they would with, say, recognised writing by James Joyce. When I first read *Sojourner's Truth & Other Stories* (1990) I simply did not know what to make of it, but as I worked on the text, with guidance from others, I began to recognise its often bitter ironies. For instance, the short story 'Polka Partners, Uptown Indians and White Folks' soon introduces a wild fluctuation in register: '"Hay-ay." The roller tried to bolt but I ran him down, thoughtlessly scolded the purveyor of the passed-out man's purse before I relieved him of his catch. Tony standing behind me must have geared up my mouth. I peaked [sic] inside the wallet – there was a whack of cash in there' (Maracle 1990: 81). What is 'purveyor of the passed-out man's purse', so formal and correct, doing in the proximity of 'geared up my mouth' and 'a whack of cash'? It does not take long to read this as

ironic humour, from someone who understands standard conventions inside out and is having fun with them. This particular scene in the story develops into a fascinating description of the mugging that has just taken place, with the pronouns of mugged and mugger getting completely mixed up. The more serious purpose of this pronominal play is to test our assumptions about who is more likely to be the victim and/or who the perpetrator, the First Nations person or another. We soon find out that the mugged person is First Nations, but of a quite different background to the others who have come to his help. I learn not only about my prejudices but also about the complexity of the society which prejudice renders as cliché and stereotype.

As well as the story's seriousness, I am enjoying the skill with words, appreciating the irony, and getting the joke. In the complexity and craft of the writing the common recognition of prejudice and its social roots gets worked on. The engagement is a way of moving toward the valuing of ways of life I do not conventionally understand. That this can take place is largely because of the exceptional generosity of the writer for making it possible in the first place. The generosity of the writing, along with the work we do when we read, marks out the location of hope.

I want to come to the end of this chapter by referring you to a writer who continually underwrites this generosity with ironic humour, Thomas King, who is of Cherokee, German and Greek descent. His story, 'A Short History of Indians in Canada', from which he has allowed me to quote, develops a complex voice that criticises, laments, horrifies and yet gives hope in the humour. The story involves Bob Haynie, a businessman visiting Toronto for the first time, who comes across Indians flying into the sides of buildings during a walk along Bay Street in the early morning. On the same walk he meets Bill and Rudy, whose job it is to round up the casualties:

> Bill and Rudy pull green plastic bags out of their pockets and try to find the open ends.
>
> The dead ones we bag, says Rudy.
>
> The live ones we tag, says Bill. Take them to the shelter. Nurse them back to health. Release them in the wild.
>
> Amazing, says Bob.
>
> A few wander off dazed and injured. If we don't find them right away, they don't stand a chance.
>
> Amazing, says Bob.
>
> You're one lucky guy, says Bill. In another couple of weeks, they'll be gone.

A family from Buffalo came through last week and didn't even see an
Ojibwa, says Rudy.

Your first time in Toronto? says Bill.

It's a great town, says Bob. You're doing a great job.

Whup!

Don't worry, says Rudy. By the time the commuters show up, you'll never
even know the Indians were here.

(King 1997)

When I first started reading King's work I did not recognise that
humour, or at least I think I was afraid to do so in case it involved me in
ways I could not cope with. Christine Miller talked me through that
one, giving me the gift of laughing and getting on with it.

To conclude, I want to 'tell' a short passage from a story by Annie
Ned, an Athapaskan-Tlingit, that appears in *Life Lived Like a Story*.
Gerry William says that people should not tell stories until they have
heard them so often that they 'own' them for themselves, and I think I
am beginning the long process of understanding this. Here is part of
'Since I Got Smart':

Long time ago, what they know, what they see
That's the one they talk about, I guess.
Tell stories – which way you learn things.

You think about that one your grandma tells you.
You've got to believe it, what Grandma said.
That's why we've got it.
It's true, too, I guess –
Which way they work at moccasins …
Which way they make sinew …
Which way to fix that fishnet …
Some lazy women don't know how to work,
Don't believe what old people tell them.
And so … short net!

(Ned, in Cruikshank 1990: 317–318)

The last thing I want is to end up with a 'short net', so I had better keep
on reading.

CHAPTER FIVE

Electronic etiquette in the global community

Through email connections, Internet discussion groups or the World Wide Web, electronic communication has gathered around itself the idea of 'secondary orality'. It is claimed that this kind of communication with words resembles the manners of conversation far more than the conventions of writing. What the claim hints at is the completely different kind of verbal community that the electronic media make possible. *The book is a fixed object, which can be sold by a publisher to the reader by way of the bookseller. The entrenchment of this position makes possible copyright, contracts and censorship; it also makes possible the profession of authorship and defines the kind of person likely to produce work of literary value.* Electronic media challenge this model in many essential aspects. It is already possible to order 'books' directly from a publisher, cutting out the bookshop; it could as easily be possible to cut out the 'book', and to order a disk copy from a bookshop with individual sample copies, or order electronically so that a copy of the book is printed just for you – right there in the book/print shop. Both of these possibilities mean radical changes for printing and publishing, with all their associated editing and designing processes that partially define literary value. Yet neither need change the status of the author. However, as some extensive email conversation has shown, and as the electronic book experiment 'SwiftCurrent' indicated, electronic communication can change completely the relationship between the writer and the reader by changing the medium. Readers can overwrite writers' words; writers can customise their writing to very small audiences; more radically, readers and writers, as in a conversation, become indistinguishable from one another. Publishers can be cut out, and if they are, then the author has no protection. This chapter looks at the implications of electronic communication for the traditional model of publisher, reader and writer relations, and at issues of copyright and censorship.

An introduction to electronic communication

What I hope to begin to address in this chapter is the impact made by
the electronic revolution on the relationship between the writer and
the reader. This revolution has altered so many aspects of our lives over
the past few years, whether or not we actively sit down in front of a
computer: it has changed the way we interact with libraries and banks,
it has changed the length of queues in shops, and it has also changed
many of the ways we think about using words, most obviously in the
effect it has had on newspapers and magazines. However, the focus of
my discussion will be on the effects this revolution has had on the eti-
quette or courtesies of the writer/reader interaction, both in terms of
the ways texts are made and received, and in terms of the local, specific
display of words on a background, whether it be page or screen.

A brief but precise example from an email correspondence I held
with an Asian colleague, now working at a Canadian university, will
illustrate some of the issues. The very first email that this colleague
sent, was to me, in 1997, in preparation for a conference I was running
that summer.

> Dear Dr. Hunter:
>
> Thank you for your recent letter ...
>
> I have – I hope – figured out how to use my e-mail account on my new
> computer :-) and even learnt some of my daughter's high-tech icons, such as
> :-) !!!
>
> Uma Parameswaran

Note that my colleague ends the email with a curious typographical
convention, :-), which is called a smiley or emoticon. In my experience,
not many people use smileys. Their most consistent use is among
groups of computer aficionados, or, among novice email users who have
been told about them and feel that they should use them. If we visited
the World Wide Website for NetLingo, which is concerned with gath-
ering information about techniques and devices for communicating in
type but via electronic means, we would find a couple of pages listing
frequently used smileys. An earlier version of the list of definitions for
these devices included the suggestion that smileys 'compensate for the
absence of non-verbal clues'. Implicitly the definition indicates that the
medium thinks of itself as akin to oral communication, which also
brings to texts a wealth of non-verbal clues. Elsewhere in this site we

can find lists of acronyms and symbols, such as WB for Welcome Back, or WTG for Way to Go, or : – > for 'sarcastic', much in the same way that we might find the phrase TGIF for Thank God it's Friday, in a magazine article. Yet if I receive a message saying:

> dear Lynette WB WTG -> George

do I react differently than I would if I received a handwritten memo, perhaps even a card, with these words?

> Dear Lynette, Welcome Back, Way to Go, Yours George

Part of the difference is, of course, the terseness of the computer message, which may be due to the fact that email conversation mainly takes place over telephone lines at the moment, and hence costs money. It may also be due to the way that email encourages brief 'hailings' of others, which are not intended to develop into more extended dialogue. These hailings are similar to meeting someone on the street or in a corridor and exchanging passing words, which is an event even more curtailed than a 'chat'. They are also part of a world of small-group cultures that has emerged on the Web, cultures of enclosed sets of assumptions that build the illusion of a self-contained world within which, as within most club cultures, codes of communication are not there simply for ease and utility but to increase the illusion of completeness, and the exclusion of others. What is significant about the devices and techniques used in email hailings, and other electronic communication, is the implicit ground in the definitions of some of these terms, that electronic communication is closer to the oral than the written. Certainly there is a common currency in the phrase 'secondary orality', which is used to describe such communication. I want to argue that electronic texts are just as allied to writing and to printing as to orality. To do so, I will first take a bird's eye view of six hundred years of non-oral verbal texts, written and printed. The discussion will dip rather eclectically into the medieval as the age of manuscript, the Renaissance as that exciting period juggling the oral with manuscript and print, rather as we are juggling the oral with print and electronic, and the nineteenth century, as the flowering of print. Throughout this part of the chapter I will be asking, Have things really changed? and if so, What? In the second part, I will consider the implications of the electronic revolution for the production and reception of literary texts, and relations between writer, reader, editor and publisher. By doing so,

I will extend the discussion of non-oral verbal texts in Part I, and reinforce the case for the connection between electronic texts, writing and printing.

PART I

Medieval texts

In the introduction to this chapter, I defined the printed book as a fixed physical object, sold to the public by way of a bookseller. However, in the medieval period in England none of this would have applied in a recognisable way. For instance, there would not necessarily have been more than one copy of a book, particularly within one geographical region. If we imagine a small group of houses nestling in the Dales at this time, it is unlikely that we would find copies of the same book in each house. Hence the community that circulated around the knowledge conveyed by the book also circulated around it as a physical object. For example, unlike today when many readers of this chapter may have access to a personal copy of George Eliot's *Middlemarch* (1871–2), and be able to discuss it among themselves, at that time there would be one copy of the book held in a particular place to which we would have to go if we wanted to read it. Once there, it is likely that we would meet others who were there for the same reason, and the community for discussion would circulate around that specific copy. Books are rarely treated this way any more, except perhaps the family recipe book which is often in manuscript form, with inserted pieces of print or other handwritten recipes, and to which people turn for traditional foods like Christmas cakes, or, interestingly, for preserves like pickles and marmalades. What is more, there are vestiges of this veneration of the book as a physical object in the still frequently heard injunction to children, 'never to hurt a book'. In today's world, where we replace broken cups and plates simply by going out to buy another, why not do the same for books? Yet many of us still find the ill-treatment of individual books shocking.

In the medieval period, copies of books were usually constructed by the scriptoria of many monasteries and some nunneries, which must have made a substantial living from the work. These copies may have been commissioned by individuals who had the money to purchase

7 Medieval manuscript with marginalia, in the Brotherton Library, University of Leeds

them, but they may also have been part of the world of intellectual dissemination of the time. After all, these locations were also the sites for considerable thinking and debate. A monastery may have wished to circulate the ideas of a particularly distinguished thinker in the group, or people visiting may have wanted to take copies of his (sic) work away. Let us say that twenty copies were made and sent out to receiving libraries: these libraries would in turn have become partly identified by them to a much greater extent than the casual judgement of today that 'She reads detective fiction', and would go on to form intellectual communities around them.

We should also remember that the copies were made by writing out by hand from handwritten text. We only have to think about the idiosyncratic nature of handwriting to understand some of the issues that would come into play, such as difficulties in reading the original manuscript or the temptation to correct statements that the copier knew to be untrue, to recognise the instability of the process. In addition, medieval texts, famously, are often elaborately illustrated and displayed, again a function of the physical intimacy that people may have felt toward them. Certainly, when they were read, they were frequently written upon: with introductory material, with intertextual notes to sources or quotations, with intratextual notes to other places in the same manuscript that might be of interest to other readers, and with straightforward commentary. Sometimes the commentaries became so long that they were copied out into their own books, and in turn gave rise to other commentaries.

The story from these ideas that I wish to tell is one of readers who felt that they were part of a community that legitimated physical interaction with the page in front of them. The knowledge on the page was never in isolation, and the text, although written, was flexible.

Renaissance texts

What these issues of production and medium indicate is the ongoing concern that the written page may be immoral, because it cannot respond to its audience directly. Hence the reader may read out of context, receive the wrong impression and act on the wrong idea. This worry has informed the first five chapters in this book, and will remain a concern in the next chapter on hypertexts. During the Renaissance, in England from the late fifteenth to the early seventeenth centuries, the

concern about the 'absent writer' was at the heart of literary debate, probably exacerbated by the clash of manuscript and print cultures. If we look at the early printed books of the late fifteenth century, it is clear that they are trying to look like manuscripts, but they have very little marginalian commentary – it is as if the reading communities have been erased from the printed page.

The conditions of producing and receiving books changed dramatically with the introduction of print. Scriptoria were replaced by printing presses, and the people who worked in the print-shop may have had nothing at all to do with the writer whose book they were printing. Instead of a lot of people constructing different copies, there were a relatively small number of people producing large numbers of near-identical items. What did this do to the status of the text? Think of a painting in the National Gallery and the posters upon which it is reproduced downstairs in the Gallery Shop. Think of Philip Sidney, who never permitted any of his poetry to be printed, prefering the more prestigious medium of manuscript. Think, indeed, of people today who take publication in electronic form less seriously than publication in print.

On the whole, instead of individually commissioned copies for an intimate community, print allowed for a much wider distribution of texts. It was easier to produce copies, and much cheaper, although not yet within the reach of many labourers. Furthermore, the reasons for producing the copies changed. Print is a capital-intensive business, a risk venture with all the money for production up front before sales can be predicted let alone guaranteed, and with a lot of money tied up in space and equipment. Printers assessed their audiences, conducted basic market research, needing at least to cover their costs. An essential ingredient for this new set of relations was the bookseller, sometimes one and the same as the printer, but often an independent operator. The booksellers in London during the sixteenth century worked alongside their printer colleagues, in a remarkably compact area of London. Side by side with their competitors, booksellers and printers trying to distribute their wares may well have developed personal relationships with their customers, acting in effect as editors of a list of books upon which the buyer could depend. Nevertheless, instead of communities of people able to discuss a small number of texts in detail, print encouraged individual reading, possibly without any outlet for discussion. Despite the fact that the books became public, were published, the relation to the text became rather private.

Other attendant difficulties included censorship, patronage and copyright. With a medium capable of producing and circulating large numbers of books, there were obvious issues of government and social control. For the first two centuries of printing, this was effected by way of licensing the printers, and the printer was clearly at the centre of the new methods of book production. Writers did not necessarily earn anything from their efforts, and, when they did, it was often by way of their patron. Copyright resided with the first printer to get the book into print, or the first to register the book with the Stationers' Company. But from the early eighteenth century publishers who liaised among writers, printers, booksellers and readers became more and more powerful as they became the primary source of finance for a book. In 1711 writers received copyright to their work but, even then, up until the middle of the nineteenth century, they usually sold it on to the publisher in order to get the work into circulation. All of these issues inflected the relationship between the reader and the writer, but most of all the private act of reading. Texts even now are never written in isolation, and rarely read in isolation – we usually buy books on the basis of recommendations. So during the period 1475 to 1695, there were growing responses to the need for discussion and interaction.

For instance, during this period you can find more and more marginalian comment creeping into the book, but it is *printed*. That the issue was significant is indicated by the sheer extent of marginalian comment in the mid seventeenth century. Milton, for example, had to be courageous not to put in marginalia. D. F. McKenzie notes that printers tried to recreate the spatial dynamics of speaker and audience in a number of different ways, and quotes Milton saying that he had 'to club quotations with men whose learning and belief lies in marginal stuffings … and horse-loads of citations'. In addition, he quotes one Thomas Blake apologising that 'Some will complain of a naked Margin', but that he was away from his books when the sermon was being prepared for the press. What is more, the quotations would either have been 'friends' to his argument and therefore challenged, or else 'Adversaries' and provoke personal offences and distaste (McKenzie 1992: 143–4). Hence the marginal note was partly equivalent to the challenge and provocation of oral debate, as opposed to the conventional response to the footnote in the twentieth century, which was to close down debate.

Slightly earlier, but part of the same concern with the need for discussion and interaction around books, typography was being used to

differentiate between speakers, or between different kinds of argument or poetic. First published in 1589, George Puttenham's *The Arte of English Poesie* argues that diamond-shaped text, or lozenge-shaped text, or parallel texts, all have different argumentative weight for the reader. More well known are George Herbert's typographic experiments with verse in such poems as 'Easter Wings'. Other typographic techniques were also developed. About a hundred years after the introduction of print, books began to be paginated partly, I suspect, because it made reference to specific passages easier when two or more people were discussing a text from their own copies. With pagination came the flourishing of indexes, at first just tables relating to the progress of the pagination, but soon developing into alphabetical indexing, and becoming quite sophisticated by the middle of the seventeenth century, imposing particular structures of knowledge on the text. The book also began to acquire a title-page, a table of contents and sometimes a list of subscribers; and there were the various addresses to the patron, the reader and the colleague, each conveying various degrees of flattery and seduction. By the early seventeenth century it was common to find a lot of introductory material by other people, affidavits like the quotations on the back covers of books today, indicating an intellectual community at work into which the reader is invited. On a larger scale, it is notable that the late sixteenth and the early seventeenth centuries were filled with discussions about genre: partly a response to the arrival of classical learning, but also a response to the work that genre does in acting as a handshake between the writer and the reader that orients the reading of the text.

The push towards involving the reader, or, dealing with the writer's absence, came to a head in the late seventeenth century with developments in newspapers and magazines. As a result of the built-in local community audience and lowered financial risk, newspapers became the way that printing spread from London throughout England. With that spread came the regional English book trade and the slow evolution of the magazine which is, after all, a community of writers within one issue, and which usually addresses a specific community of readers. An important change was the relationship the magazine offered between the reader and the editor; for example, the originators of *The Spectator*, Addison and Steele, introduced a familiar editorial voice. Readers were also encouraged to write in to correspondence columns, and were even used as a source of free copy, often contributing articles,

Sound
O Harpe
Shril lie out
Temir the flout
Rider who' with sharpe
Trenching blade of bright steele
Hath made his fiercest foes to feele
All such as wrought him shame or harme
The strength of his braue right arme,
Cleauing hard downe vnto the eyes
The raw skulles of his enemies,
Much honor hath he wonne
By doughtie deedes done
In Cora foon
And all the
Worlde
Round.

8 'Lozenge', from Puttenham's *The Arte of English Poesie*

as well as serialised fiction which, frustratingly, they were under no
obligation to complete.

Nineteenth-century texts

The nineteenth century saw the relationship between writer and reader,
often by way of an editor, addressed rather sharply in the periodical press.
From the 1840s to the 1880s, printing and publishing went through tech-
nological changes at least as extensive as those we have seen over the past
thirty years of the electronic revolution. Possibly the most important of
the changes, which included the break-up of linear text, was the gradual
sophistication of the visual image. By the 1890s, millions of copies of illus-
trated magazines were selling each week. In a country with a population
less than twenty-five million, over a hundred thousand copies of *The
Boy's Own Paper* were sold each week, and between six hundred
thousand and a million copies each of *Home Chat* and *Tit-Bits*. In addi-
tion, the type of magazine had proliferated: there were magazines for
boys, for girls, for the housewife, for the lady, for the travelling salesman,
for the sportsman, for the angler and so on. Magazines are, of course,
among the most ephemeral of printed products, and the relationship
between the writer and reader needs continually to be reinstituted.

 This period was also the heyday of the editor, the one person who
'managed' all the disparate voices that were becoming available. From

Samuel Beeton to Charles Dickens and William Thackeray, the editorial voice was at the centre of the relationship with the reader. Laurel Brake tells the story of Oscar Wilde who, in 1887, became the editor of the magazine *The Lady's World* at the same time that he retitled it *The Woman's World*. Wilde is credited not only with turning *The Woman's World* into a magazine of ideas and reviews for women, which was most unusual, but also with constructing a parallel readership within the male homosexual community of London, encoded in the pages of the periodical by the visual display of women's clothes being modelled by men and boys.

PART II

Early computer applications

As with change of any kind, novelty and strangeness will initially encourage the participants to an interactive exchange as they learn about how things work. The difficulty comes when people have become habituated to particular techniques, because the engagement often loses imaginative energy. We can recognise this quite clearly in the contemporary attitude to magazines as being of subordinate aesthetic value compared with the book, even though they developed in the way they did precisely to engage readers rather than to impose upon them. In a similar way, many developments in computing have grown out of the attempts made in books to encourage an active relationship between the writer and the reader, despite the fact that writing opens a space between them, and yet they move inexorably toward conventions that are not welcoming to the reader. For example, databases: databases are elaborations on indexes, and as such are there to make textual material more flexible; yet they are also structures that are used to grid down upon material, fix it within categories that are assumed rather than questioned. Similarly, spreadsheets and statistics: statistics offer elaborations on visual argument close to Puttenham's lozenges and diamonds; they deal with probable results, and produce shapes such as bar charts that seem immediately to suggest significance through their physical shape. Nevertheless, as we all know, they also manipulate and restructure material into desired significance. The more disengaged they become from the context of the reader or the writer, the less interaction goes on.

At the heart of these elaborations are ideas about the relationship between the writer and the reader. Quite probably, database programmers do not want a relationship with their readers, but readers ignore the assumptions of the program at their peril. Until very recently, people writing in computer-aided genres avoided the literary, and stuck to what appeared to be 'hard facts' which needed no relationship. The early twentieth-century use of data for the Census, and the developments from the middle of the century by, for example, the United States Department of Defense were in fact using techniques developed to make books more flexible – like indexes. However, in their claims to isolation and neutrality, in their denial of any relationship with their readers, these techniques became mechanistic and alienating. Anyone who has worked with computers for more than ten years will remember the appalling vestiges of that attitude in the vocabulary of 'command', 'killfile' and 'abort'; some of these, like 'execute', are still with us.

Many different factors intervened to change this relationship, but, I would suggest, the most important of these has been the Internet, what we now tend to refer to as the Web. One of the reasons that earlier applications could deny a relationship with an audience is that they were made by and used by people with similar backgrounds and outlooks, who could infer enough of what they needed to know. The Web has changed all that. Many users are computer novices who know little about programming and nothing about hardware. Also, and possibly more to the point, Web readers still pay each time they use the facility, so if it does not keep on engaging them in pleasant or at least acceptable ways, they will stop using it. I will now look at an early experiment in making the computer a place where writers and readers could interact, in an environment conducive to the verbal arts.

SwiftCurrent

SwiftCurrent was an experiment run by Fred Wah and Frank Davey from 1983 to 1987 which, shortly after, transformed briefly into SwiftCurrent 2. As such, it was one of the first experiments in the field of electronic communication, and set a number of parameters for future developments. Wah and Davey used a database structure as a tool to enable writers to 'talk' to each other about work in progress, to refine their writing, to 'publish' it electronically and eventually to publish it in book form. There were between forty and sixty subscribers, each of

whom could define which members of the electronic community could read their work in progress, which could comment on that work, who could read subsequent polished drafts and who could read the final end product (usually all the subscribers). At the same time, users could also define whose work they wanted to read, so that they could eliminate writers at whose work they did not want to look, in effect acting as editors of their own personally selected magazine of writing. One of the requirements of SwiftCurrent was that subscribers had to have already published at least one book. However, with SwiftCurrent 2, this no longer held. The second version of the site attempted to be more responsive to the need for community building, and to the potential of the interchange for the supportive development of new work and new writers. Both versions offered an overarching structure of generic categories such as 'poetry', 'criticism' and so on, to make it easier to move around the information, and in this, as well as many other elements, they anticipated the structure of sites now operating on the Web, by which SwiftCurrent has been superseded.

One of the founders, Frank Davey, has pointed out in a number of articles that the electronic structure fundamentally changes the reader–writer–editor relationship, especially in the conditions governing the production and reception of the texts. The reader is actively involved, even able, when permitted by a writer, to change the words on the page – this, of course, is not unusual in the pre-publication phase of any writing in which friends and relations often get involved, but it is a radical departure for a 'published' text. The writer is not sacrosanct – not that they had not previously realised this, but the experience of the medium sharpens its intensity. Davey notes also that he suspects that writers desire the more conventional experience of book publication which lay at the end of SwiftCurrent, because it idealises the text (and author). Elsewhere he has suggested that electronic sites are often places where novice writers can participate helpfully in communities of other writers; they can learn a lot, and, more to the point, they can get some immediate recognition. SwiftCurrent received far more feedback in terms of response and reviewing than any print publication would have done. However, for more established writers the experience of electronic publication may, because of the sheer number of participants, be draining.

Editors, gatekeepers and navigational aids

What Davey's account, and the structure of SwiftCurrent, leave out
is the editor (they also leave out the designer, to which I will return).
Editors working for publishing houses are there to sift through all the
submissions, and to decide upon the appropriateness of selected items
for the larger list that the house is trying to present. They do an
immense amount of work for their readers, although they may act also
as authoritative gatekeepers who restrict what can be published. It is
interesting that the 'draining' quality of several large list servers for
writers, which comes from overwhelming subscribers with choices and
the sheer number of interactive discussion groups which are main-
tained, is modulated for example in the 'Literature Online' website
from publisher Chadwyck-Healey, by the employment of a professional
writer. This person offers tutorials on poetry, feedback on submitted
poems, a moderation of the responses to the tutorials, and the selection
once a week of one poem from among those submitted, for study by any
of the subscribers whose responses are also moderated. Effectively this
writer is acting as an editor and a teacher, and is certainly in a position
of authority and power, rather than being just another user. Meanwhile
a different kind of casual relationship builds up among the subscribers
which is far more free and easy. Yet as a whole, the website, the way it
is run and its various users, prompt the question: Who is the writer of
the website? Chadwyck-Healey: because the website is a text in itself?
The person who writes the program? The professional writer? The
writer-subscribers? Moreover, Who is the reader? The subscriber who
responds to the professional writer's work, and/or to the other writing?
Or the visitor who responds to the site as a whole?

Electronic publication has the potential for the first really radical shift
in reader–writer relationships since the periodical and the introduction
of mixed media in printed products, and is possibly more revolutionary
than any shift since the introduction of print in the fifteenth century.
Electronic media make it possible to be your own publisher at relatively
little cost, and the overall financial risk of publishing is considerably
diminished. Going into a bookshop could be like going into a mail-order
shop, where you flip through the pages of a catalogue, possibly look at
the 'sample copy', or listen to it, and then order it. You could get your
book on disk, on paper and unbound, on paper and bound, or on tape.
You could even design it yourself, choosing a practical large-print

edition, or a gift-designed version. What is more, 'out of print' would have no meaning, there would be no more risk of producing too many copies, no more storage costs, no more shipping costs. As many of us now know, we do not even need to go to a bookshop: we can visit e-bookstores such as Amazon.com to order a book via the Web, or view the literature lists to check out the first chapters of the most recently published novels before purchasing. Eventually we will be able to print out books in our own homes.

All of this could be liberatory and participatory, but with such open access to the verbal arts what happens to the 'author', to contracts, copyright and censorship? The 'author' is a concept that comes with capitalism: writers able to earn enough from their writing to live are given *authority* over the text so that they have the right to profit by any copies that are made: copyright. Both ideas are wrapped up in the concept of the individual as articulated by liberal democratic politics. For many writers, patrons gave way to contracts, especially as authorship became a viable profession in the nineteenth century. However, if writing is so easy to get access to on the Web, who will pay the writer? Will they be able to live from their earnings? These questions were sharply focused in the music publishing business and the successful case in 2000–1 against the Web-based distributor Napster that had tried to make music freely available. When Davey suggests that writers crave the idealisation of their work in the printed book, do they not also crave the potential for earnings that comes with the publishing contract? It is certainly the case that for the moment, because of the extensive powers of publishing houses to select and reject, the fact of print publication allows writers to call themselves authors, to line up for grants, for promotion, for reward. If they are not paid much directly for the book, a selected few may earn a lot indirectly. Yet writers on the Web are two a penny, a dime a dozen.

Perhaps this is the way the democratising of writing has to go. At the moment, reading writing on the Web is frustrating just because there is so much of it. Not long ago I was asked what was the difference between a book that was difficult to read because it was badly written, and one that was difficult to read because it was innovative and challenging us to new experiences with words. An isolated reader cannot tell the difference. In effect, enterprising readers often have to take the chance that the effort they are expending on a new text will, after a month or longer, have been a waste of time – although I think personally that any

reading engagement teaches us something. We each have to have a reason for committing our time and energy to an interactive reading, especially since the Web makes it possible for people to make public writing that print publishers would never touch because it does not fit into their generic categories. Indeed, the Web has already devised its own equivalent of the bookshop, with its generic categories inherited from the Renaissance, in the navigational aids that are available to move around it: AltaVista, Yahoo and so on. Go and visit one: they demonstrate the same problem as any subject guide in a library: the categories never seem to fit exactly what it is you want to know. They are helpful, but they fix knowledge into areas that construct particular views on how society works; they define the environment for our thinking and hence for our actions. Faced with the volume of information, no doubt we need them. Nevertheless, we run the risk of being enclosed within parameters over which we have little control.

Furthermore, the Web increasingly holds sites that offer to act as guides or gatekeepers to the verbal arts. They work by sifting through readers' responses to interactive discussion groups obscurely placed in the highways and byways of the Web and the list servers, by hiring professional readers, critics or reviewers to assess work on the Web, or by acting as an editor and collecting on one site the 'valued' writing they have chosen. It is perfectly possible to charge a subscription fee for entry to a site, and this would be a simple way of paying some of the costs. Printing off from the site could also be charged for, and yield income. Yet while writers could be paid according to how many times readers visit their work, or how long they spend there, this would be likely to cause problems. Perhaps the Web Guides to Literature will become the new patrons, instituting communities of readers around the physical object of the website, the text we read that has supplanted the library, and the printer and bookseller, in order to get access to the written word in the first place. Whatever else, the status of 'author' will be in flux for a while.

The Web also makes possible far greater reader–writer interaction and engagement: not merely as part of a word game that is technically loosened up by the electronic possibilities of choosing the hero's hair colour, but integrally in the work itself. This latter activity is so fundamentally alien to western readers and writers that I suspect there will be enormous resistance to it. Some people have argued that the Multi-User Dungeons, or MUDs, which are sites where users adopt and

construct characters that then play out narratives devised by the actions
of each member of the group, are a new form of integrated writing
and reading. They may well be. However, guidelines for their use are
far from clear; the etiquette is not elaborated, and users have been
abused and hurt. To avoid this, many users stick to fairly conventional
role-playing that offers the satisfactions of genre, but this is hardly
interactive engagement that extends the boundaries of our experience
of life and ability to value and act.

Censorship or gatekeeping is, notoriously, one of the largest issues
concerning the Web precisely because we do not yet know the guide-
lines for behaviour. There is, for example, an enormous amount of
pornographic material on the Web, and it is not always clear what to
avoid. One of the problems is that the Web is global, and there are not
only different attitudes to what is acceptable in other societies but also
different ways of portraying experience. The issue is particularly acute
in the area of satire and irony, which can be heavyweight political tools.
Critiques made in either of these generic modes necessarily have to
deal with the material that is being criticised. The closer the critique
comes to mimicking the structure and patterns of what is criticised, the
sharper it will be, the more telling the commentary. Yet to an outsider,
the critique can look like the activity being criticised. For example, in
the late 1980s and early 1990s the pop singer Madonna made a number
of videos satirising sex, religion and violence, but a large proportion of
her audience thought she was endorsing them. If censorship enacts a
society's 'bottom line' or tolerance level, what gets censored will have
as much to do with the interpretation of the art form as with the subject
matter itself. Moreover, censorship draws on specific ideas of human
'rights' which may or may not hold from one place to another. The Web
is still fairly open, although it is not as democratic as it used to be, and
if there is a case for guidelines about acceptable behaviour, we must
tread very carefully. Over the past five hundred years of printed media,
one consistent fact is that the more censorship there is, the more peo-
ple will produce material to be censored.

Design, typography and poetics

So far in Part II, I have discussed the way that the electronic revolution
has shifted the larger terms of engagement in production and reception,
and the relationship among writer, reader, editor and publisher. Yet

what about the medium itself and the more intimate relationship between writer and reader? In the next chapter I will look at one of the more interesting structures that has been introduced by the electronic revolution: hypertext. I would like to end this discussion, however, with a brief look at design and the ways in which the facilities of computers have changed our approaches to the layout of the page. If SwiftCurrent operated in a fairly standard typed-page format, the Web sites of a decade later look far more like magazine pages. SwiftCurrent resembled a cyclostyled or mimeographed piece of samizdat literature, whereas the format of Chadwyck-Healey's 'Literature OnLine' is a sophisticated display of 'visual bites', analogous to the short, digestible-in-seconds, sound bites of television and radio reporting. In fact, sites such as the recent Arden Shakespeare website self-consciously attempt to display status by finding a halfway house between sophisticated visuals and an analogue to the printed page. It is significant that the NetLingo site, which is acutely aware of the impact of the written upon the eye, offers a lot of white space around the typed sections, and plays with colour rather than typeface. Many sites are wildly excessive, as was Victorian typography in the flush of the new and easy methods for producing novelty designs.

Just as early medieval readers would have been faced with a solid block of writing, with no punctuation and no spacing between the words, and would then have proceeded to punctuate it for themselves, today's user of some electronic texts is expected to participate in the grammar, poetic and rhetoric of the text in front of them. The use of smileys or emoticons is remarkably similar to Alexander Pope's use of the asterisk, the bracket, the exclamation mark and so on, in 1723, to indicate to the reader of Shakespeare's texts, points of irony, beauty, or particular significance. Even earlier, at the start of the Renaissance, the parenthesis marks () could indicate either a subordinate remark or a point of emphasis, the latter being quite unconventional in usage today. As products of an education system that has focused on teaching us reading skills from the age of five until at least fifteen, we tend to forget that all these typographic conventions had to be invented, discussed and put into circulation. On a larger scale, but still typographic, Geoff Ryman's Web novel, 253, offers a guide to the narrative that is shaped like an Underground map. Yet such visual descriptions of story are found throughout printed literature, in, for example, the writing of Laurence Sterne's *Tristram Shandy*, which first began to be published in 1759.

To return to my Canadian/Asian colleague Uma Parameswaran, and her novice email correspondence: during the barely three-month email exchange we held, her style elaborated swiftly. She dropped the smileys, but increasingly adopted her writer's voice, with an exuberant fluidity that responds to the loose texture of the medium, moving from:

isn't this great that i have figured out (almost) how to get this going ...

to:

This e-mail medium is so fast; it makes me dizzy = with elation or trepidation, I have yet to figure out !

to:

>my muse used to be kindly, it's a bit rough right now but still hangs around
>making life difficult ...
re: agreeing to being moved to the 4:45 session, let me think.
should I grant a favour to anyone who refers to the Muse as it and not she?

to:

a loaf of bread a flask of wine and thou beside me on email and even winnipeg were paradise enow.

As her confidence grew she began to use the space of the computer display to good effect:

spoke to rina last night – she was away for three days.
she said the package she mailed to geetha came back, and so
she's mailed it to you – about four days ago.
she said she'd call geetha early morning your time.

The brief clauses, whose endings almost claim the status of sentence, with their pithy factual shorthand and insistent repetition of 'she' that turns into the overload of, 'she' 'she' 'she' 'she's' 'she' 'she'd', dramatically reconstruct an almost desperate attempt to pin down an amorphous mass of events, times and schedules. Even the possibly inadvertent central couplet rhyme of 'so' and 'ago' brings all these events into balance around the second and third line, but spinning into the first and out of the third. Although the interlacing of 'three days' (line 1), 'geetha' (line 2), 'four days' (line 3) and 'geetha' (line 4) mitigates this effect a little, the semantic shift from an implicit 'I' and 'she' in the first two lines to 'she', 'you' and 'your' in the last two follows the direction of intention, as if the speaker is now pushing this event away from her and towards the 'you'. Whatever

else, this writer has a distinctive and engaging voice that is making the most of the scope that this as-yet unconventional medium confers.

What is interesting is that the writer has returned to the poetic devices of writing that have been found in western texts since classical Greece, and with a particular awareness of spatial arrangement that has informed literature since the sixteenth century, as well as the printed word. The large structures of electronic production and reception may begin to mimic the conventions of oral transmission, particularly in areas of collaboration and the status of the author as critiqued in earlier essays. However, these Web texts are not ephemeral to the same extent as the oral. There is a record of every version, and this ties issues of the narrative copyright typical of oral societies, into issues of typographic copyright typical of print societies. In addition, although the small communities that form around particular websites encourage a self-censorship similar to that of the oral performance, the fact of the global audience for texts on the Web complicates the issue of censorship, and calls on many regulatory devices formulated for print.

Yet at the level of the page, the medium is still by and large resolutely tied to the poetics of the written. Hypertext could change all that.

CHAPTER SIX

Lost in hyperspace: hypertexts and textual value

Hypertexts have become widely used: in a sense an electronic cash dispenser is a form of hypertext, and their applications are now everywhere. However, few people have discussed the effects and structures of hypertexts, except in highly technical language. In the literary world, hypertexts have a central and seductive position because they promise to loosen up the static medium of print, and they have even been described as three-dimensional books. I think that they will become a dominant and popular genre. This is because they are directly analogous to periodical publications such as magazines and newspapers both in their structure, design and what we know about their reading patterns. It is said that people do not read any more. In fact they read all the time in our society, they just do not read books as much as periodicals. This is a problem, because *traditional literary value depends on three things: the single author (the myth of original genius), the consistent medium of print (the myth that illustrations render the words second-rate or that the 'words are the thing'), and the expectation that the reader will read from the beginning to the end ('the myth that stories must be stable and linear).* Periodicals, like hypertexts, are written by many people; even the editor is not necessarily apparent. They are usually printed with illustration as well as text, and are interrupted by advertisements. In a similar way, hypertexts are well known as users of many media, which is one of the reasons they are sometimes referred to as hypermedia. Finally, periodicals are rarely read consecutively; readers have been shown to prefer to 'dip into' sections that they look out for each week, and are only reduced to reading right through when waiting in queues to see doctors or dentists. Similarly, hypertext readers usually read along a series of links that they make for themselves, and they may well never read all the elements in the text. Unlike those who are anxious about the reader being 'lost in hyperspace', I have far more confidence in the reader's ability to travel intelligently through it, since they have been doing so in periodicals for centuries. However, as some recent hypertext poems and novels have

demonstrated, it is, not surprisingly, impossible to value these 'writings' in traditional terms. This chapter will suggest ways that we might begin to think of aesthetic value for hypertext literacy or orality.

What is hypertext? First and foremost it is a medium that has the potential to rival the book. In effect, it has become the primary means of organising communication with the general public by way of computers. Although it started as a specialised technique, it is now generic to nearly all electronic communication that uses words. So, what *is* it? Quite simply, instead of the page being in a linear order that we read from start to finish, with hypertext it becomes possible to read 'vertically', moving through a text by following keys or indicators that tell you where you can go next.

These keys might be point-blank questions, such as those on bank cash dispensers. We are given a specific set of choices, to opt for a savings, a chequing, a deposit account, for example. We move the pointer to the correct line, and the computer takes us to the next relevant page. This is hypertext at work. What is more, those keys to choice could be just page number references, akin to those we find in children's books that ask: if you want the princess to go through the middle door, go to page 21; if you want her to go through the left-hand door, go to page 43; and so on. The keys can be typographical, say an italicised word, or colour co-ordinated, or numbered, or indeed they can be put before us in the form of maps.

Reading a Web novel: 253

I would like first to have a close look at the Web novel *253* by Geoff Ryman. *253* is a version of what I call a central text hypertext, and I will come back to this. At its centre it has a series of 253 short, page-long stories about people sitting on the Underground. There are seven carriages, with 252 seats, plus one more seat for the driver. What Ryman has done at the basic level is to provide a physical description, a set of interests, and a short piece of stream of consciousness, for each person. Moreover, this is a full train. Clearly the device depends partly on the familiarity many of us have with travelling on the Underground. The clothes we wear are potential indicators of many social and cultural

issues, so the physical description tends to hook the reader in with an immediate visual representation, which I personally think has more impact for being presented in words rather than as a graphic. The set of interests is rather like a capsule introduction, part cliché, part serious, part entertaining, in much the same way that we might make a brief acquaintance of someone at a party or over lunch or at a meeting. However, these interests have another function. They allow the reader to follow a set of readings that are specific to their interests, and I will develop this later in the chapter. The third element, of the stream of consciousness that is offered for each person on the train, is a fairly standard first-person account of passing thoughts.

Significantly, each of the three sections has a slightly different narratorial voice. The physical description focuses on the visual, but is also capable of making implicit social comments by describing a dress as 'New Age', rather than 'long and colourful'. The voice that tells us about interests is a curious combination of sarcasm, irony, satire and parody, all of which are explicitly devices for social and political critique, even if the critique is fairly conservative. Yet the voice that offers the internal thoughts of the characters is quite various, and very personal. Ryman does not hesitate to exploit the first-person voice, and all that it calls up in terms of the readers' response. We tend to believe first-person voices. We tend to listen to them more intimately. In this case the overwhelming effect of these sections is emotive. They also often end on an anticipatory note which has at least two effects: first, they tend to keep the reader reading, not because we want to find out what happens to this character but because the way we are deprived of finding that out generates a desire to find out *something*, so we read on to another character. At the same time, it is possible, within this hypertext novel, to add one's own ending, which the reader may also decide to do. Indeed, Ryman encourages us to respond by writing our own 'seat-pages' for another train that he promises to turn into a new novel.

This brings me to the larger structure of the hypertext. If it has the central set of 253 texts as a base, it allows for a number of other kinds of communication. When we first enter the 253 website, we are met with a series of topics from which we can choose. We could find out more about the site, or go and look at an explanation for why 253 came into existence, or possibly go to an advertisement. This introductory page works similarly to the introductions to books. We find out a little about the writer, including the fact that he has set the journey on a date that

could be quite arbitrary, but which is highly significant for him, since it is the day he found out that his best friend was dying from AIDS. What exactly do we do with this information? Is it 'true'? Or is this a narratorial voice that is indicating the emotive quality of much of what follows? We also find out about the conditions of publication, and that Ryman works for a company that could produce similar hypertexts for ourselves, should we want them. Hence this might be simply a great advertising gimmick. Yet we also find out that Ryman, or his narrator, has a profoundly satiric take on advertising, since the 'advertising' page contains a spoof on those 1950s-style 'improve your memory' advertisements in newspapers, by suggesting that if you read this novel you will be able to impress your boss with your erudition and aesthetic insight.

At the foot of the introductory page, we also find out about the primary sites that we could visit apart from the train carriages themselves. One is the Journey Planner, which offers a map of connections between the different characters on the train. In a graphic that echoes the London Underground map, there are 'stations' that are called 'Chocolate and portfolios' or 'Gulf war syndrome', and these are elements taken from the set of interests that are given to each character (253 intro. page, Journey Planner). Hence the reader could read through 253 looking only at the sites related to 'Gulf war syndrome', for example. Or we could read the entire text, but not character by character, rather topic by topic. Among the other sites listed at the foot of the page is 'The End of the Line', which, it transpires, is the train crashing. Counter to convention, Ryman does not allow anything to happen on this train, but it does come to an end, because it crashes. Furthermore, it is possible to read the internal thoughts of each character just as the crash is happening. This is rather macabre, but the reader does not have to read it, and they can also be considered a meditation on death or possibly, an elegy for the narrator's friend. All these options are available to the reader; the response depends on how the reader chooses to contextualise herself or himself.

As we read, there are certain structural devices that guide us. Each carriage comes with a location map of its own that is a simple representation of the seats, and in each place is typed a character's name and main interest. We can simply use the mouse to click on a name, and the relevant page description comes up. We are also allowed to visit the seat immediately before and after the one we are visiting at the moment, and Ryman occasionally sets up intercommentary as one character looks at another, or becomes aware, for example, of a scuffle further down the

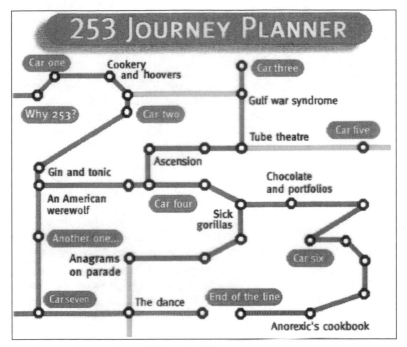

9 'Journey Planner' from *253* by Geoff Ryman

carriage (and you can go at once and find out what those scuffling char-
acters think they are doing). Every time we visit a seat and read the
material, that seat changes colour on the carriage map, so that we can
visually recognise where we have been, which seats/ characters we have
already visited. This is a happily stabilising strategy that helps the reader
to cope with the sheer number of potential characters. Most important
is the amount of white space on each screen, which reminds the reader
that they are in a fairly familiar environment, that has just been loosened
up a bit.

 I have spent some time considering this hypertext, because I think
it is clearly designed and that it incorporates a number of generic
strategies that I will go on to talk about in other hypertexts. However,
what I have not considered is the overarching effect of reading in this
manner, or the underlying persuasive rhetoric that the hypertext
employs. Without further critical interchange its effect is difficult to
assess, but I would characterise the text's stance as close to that taken

by Charles Dickens: densely plotted, using the novel in a radically new way. Dickens's way was to appropriate the periodical publication that came to dominate nineteenth-century literature, just as Ryman appropriates the hypertext Web publication. In addition, like the stance in many of Dickens's novels, 253 is potentially highly manipulative, drawing on cultural and social prejudice and cliché, with just enough of a distanced narrator to call these into question at the same time as exploiting them. 'The End of the Line' is one of the more contentious elements of the text, but one which needs careful critical attention.

Looking back: central text hypermedia, topic-driven and labyrinthine hypertexts

At this point I want to consider some earlier examples of hypertext, to get a better idea of how we might find guidelines for reading these, and more recent, texts. When hypertext first came into the public's imagination, it seemed to promise a utopia of intertextuality and interconnection: a text that would be flexible, self-regarding and therefore critical, and would fully involve the reader. It is no surprise that Ted Nelson's early hypertext was called XANADU, the site of Samuel Coleridge's famed pleasure dome. Many people, faced with the potential in hypertext for interconnecting texts, reacted at first by constructing what I call *central text hypermedia*, which was the first impetus I had as well. I had a vision of being able to place a Jane Austen novel in the centre of a web of other information concerning its historical and social background, language, a study of genre from the period, an analysis of that novel in the context of her other writing, the critical responses to it over a period of years and the cultural effects it was having on us today. The project envisaged only got to a planning stage, with a few student trials, since with the programs we had available the structure simply became too unwieldy. We had tried to provide routes to important secondary texts, but, in the absence of the World Wide Web and access to archive sites, we had to scan whole books in ourselves, and try to provide connections to other programs that would make concordances and allow for language analysis. In those days, fifteen years ago or so, this required heavy-duty computers that simply were not available to the undergraduate students whom we wanted to help. In addition, we inadvertently discovered that this kind of text is not necessarily helpful to the reader. This vast expanse of knowledge at

their fingertips left them feeling overwhelmed and confused. In fact, all we had needed to do was to provide references to the library locations of associated books, or to ancillary computer programs. In our attempt to bring texts physically 'nearer' the user, we had also reckoned without the effects of habitual research: that the space around a library or the mere bodily exertion needed to get there, were all tied up into the reader's patterns of study; that they wanted the context of other people during specific stages in the research process, which the computer erased.

There are, however, working hypertexts of this encyclopedic kind. The Brown University 'Victorian Web' is an example that has many of the elements typical of central text hypermedia. In my opinion the structure has the potential to be of considerable use, especially when directing the user's response is desirable. And it is becoming clear that users have begun to learn how to deal with the radically different scale of information available through electronic texts. One unexpected outcome of the work done on the Jane Austen hypertext was the gradual realisation that we had consistently directed the student reader towards 'history'. Although I know history is important, I had not known how important it was for my own pedagogical style until the hypertext revealed it to me.

A different kind of hypertext structure can be thought of as *topic-driven*, and this is the kind of hypertext that we find most often on the Web. The first experience I had of helping to design this kind of text occurred when the Chemical Pathology department of St James's Hospital in Leeds asked me and others to think about how to organise all the little bits of paper, which often took the form of useful hints stuck on the side of a filing cabinet, so that they could be helpfully accessible to any staff who might need them. What we could not do was disrupt the conventional method of categorising any of this information, since swift thinking in emergency situations often runs along well-worn paths. Medical staff train for years in highly structured knowledge, and we had to try to find an analogue for that structure. Similarly, the Web navigational aids I talked about in the previous chapter have to mimic some aspect of how users usually find out information. I mentioned that they often offer pages with lists of topic titles that are familiar to a discipline or to a bookshop, so that the user recognises that they can choose a topic in the way that they might physically 'go' to a section of the library or shop. The choice is most often made by using a computer 'mouse' to pass

the cursor (which locates the exact point on the screen that is currently active, and is frequently shaped like an arrow) over the words on the page. When the cursor changes shape (to say, a hand, rather than an arrow), we can click the mouse key to choose that word. These choices typically refine into smaller and smaller subsections, for example: they move from Humanities, to Literature, to Poetry, to Specific Poet.

A third kind of hypertext structure, which I call 'multidocument' hypertext or *labyrinthine* hypertext, is possibly the most expected within the hypertext world. These hypertexts allow for a large number of documents, written, visual and aural/oral, to be incorporated into a site. Once there, the reader can wander around the documents at will, but is usually directed along specific threads of inquiry by colour coding or typographic indicators. To draw again from my own experience, I was involved in the early stages of organising the Hartlib Papers Project at Sheffield University, a collection which almost necessitated this kind of approach. The Hartlib Papers consist of many shoeboxes full of letters gathered by Samuel Hartlib between 1630 and 1662. He had set himself up as an unofficial information agency, receiving letters from scientists and philosophers all over Europe and having them copied to the intellectual community around England. He also carried out the reverse process for that community, sending copies of letters by English writers back to the continent. Among his correspondents were Milton, Descartes, Pascal, Newton and many others.

The task of the Hartlib Papers Project was to make the papers accessible by publishing them in electronic form. Rather than simply transcribing them into computer-readable text, the editors of the project decided to help the reader move around in this mass of documents by coding the letters by topic. Furthermore, every time someone searches the Papers in electronic form, their groupings of texts can become additional topical areas. For example, say someone wants to search the letters for information on tobacco use in the mid seventeenth century: they would typically ask the database to search in the first instance for the word 'tobacco', and its variant spellings. While they are working through these texts, they may find that some of the letters refer them hypertextually to other letters which do not contain the word tobacco, but which some other user has at one time or another recognised as being concerned with the issue. By the time this reader or searcher has finished exploring the Papers, there will be a set of letters which could be grouped together under the term 'tobacco' as a topical area of help to future researchers.

However, the labyrinthine hypertext is always in danger of losing the reader – or the reader is always in danger of becoming lost in the labyrinth: 'lost in hyperspace' as it has been put. There is often no way of knowing if you have visited all the documents that make up the text, or of retracing your steps – although with some hypertexts, as with an early version of the Hartlib Papers, a retrospective map can be produced. The retracing of steps is often vital to understanding the genesis of an idea, its conceptual environment and limitations. When we read books and other paper documents, we can make physical, visible piles of 'where we have been', but without this facility in a hypertext we can easily get confused. Hypertexts challenge the fundamental critical assumptions of literary value which expect a single author, a linear reading from start to finish and the consistent medium of print.

At the same time, the overall effect of reading the Hartlib Papers electronic edition is of reading a periodical from the seventeenth century – when, of course, they did not yet exist. When we read magazines, for example, we do not read in a linear way from beginning to end; we even jump around following the 'continued on page 103' notes to the completion of an article, as we would follow a hypertext link. There is no one author of a magazine, although there is an editor, and in some senses the constructors of the hypertext take over the function of a guiding editorial voice. Finally, the medium for magazines is variously print, photograph, graphic, cartoon and so on, in much the same way as hypertexts often use multimedia, including film clips and music. The experience of reading magazines is not dissimilar to reading a labyrinthine hypertext; it is just that we have learned to read periodicals in this way over three hundred years, while the hypertext is quite new, and, while analogous, not exactly the same.

For the moment, to help the reader learn how to read, labyrinthine texts need to be quite short in terms of the number of 'pages' or screens they hold. I would put this number at no more than 150 pages, and preferably less than a hundred. One well-known example of a literary text structured in this way is Michael Joyce's *afternoon, a story* (1987). When we enter the hypertext, there is an initial introductory screen that tells us how to move around the labyrinth, what certain symbols denote about moving one screen forward or back, or how to go back to the beginning. The second screen, which we do not necessarily even see if we choose to go directly into the literary text, gives us conventional information about the author, the versions or editions of this text

and the producers: the kind of information we would normally glean from the opening pages of a book. Nevertheless, once into the text we can wander wherever we want. If we move the mouse in order to pass the cursor over the text, it does not change shape when it reaches an area or word that would take us through to another page. Hence we are free to click the mouse key when the cursor is over any word on the page. Many words will not take us through to any other page, so we have to choose another area or word. Once we have clicked on an 'active' word, we are taken to another page or screen, from which we can repeat the process, or go back to the earlier page and choose another word from which to move out.

The end result of the process is that we appear to move relatively randomly through the text's pages. The experience of reading is quite different from reading a conventional book. There are fewer large-scale generic clues to help us with interpretation, although there should be a word of caution here, since we may have a tendency to read more generically than usual precisely because we cannot assess the larger picture and so we use our knowledge of literary conventions to 'make sense' of the text. Yet on the whole we are focused on the level of the paragraph and the sentence. *afternoon, a story* even has some pages with only one or perhaps two words. What is more, the longer we use or read the text the more we come to understand which word groupings are active and which are not. We may even come to recognise specific threads of interest, and eventually we will acquire a memory for all the pages of the text, which reveals the writer's streams of interest and probings that underlie the superficial patina of randomness. This expe-rience is one that feels random partly because we are not used to it, and as hypertext literature increases in quantity and familiarity I have no doubt that the experience of 'randomness' will reduce. In effect, the next level of skill to be brought to hypertext literature, will be, just as with any other poetic, how it challenges its own conventions.

Books and alternative reading experiences

Now I would again like to look away from the electronic text and back to the book. The movement from one page to another in a non-linear fashion is something that writers have attempted to engage with for centuries. In the previous chapter I discussed the use of indexes and tables of contents, as well as the wonderful experiments of Laurence

Sterne in *Tristram Shandy* (1759–67), and in this chapter I have men-
tioned the way in which the periodical, which, after all, has been the
most popular mass printed medium for the last three centuries, deals
with this issue. In addition, I want to point out the many attempts at the
'loose-leaf' book made by early twentieth-century writers such as Ford
Madox Ford, through to more recent poets such as bpNichol. Much
concrete poetry has been an attempt to loosen up the apparent fixity of
the physical book, and the implications of absolutism in that popular
expression, 'it's down there in black and white'. Nichol's work is an
excellent example of this, because his books are radical explorations of
the potential for print to convey different kinds of reading experiences.
He plays, as have many twentieth-century poets such as e e cummings,
with typography; and he frequently incorporates graphics. *Book 5*
(1982) of his tragically shortened autobiography, *The Martyrology*, uses
the concept of 'chaining', which is similar to that of 'threads' in hyper-
text. The reader reads down a page, but at times finds a word with a
superscripted number attached to it. The number invites us to leave the
current page and to continue by reading from the section associated
with that number:

> each range
> which is the speech chain
> gang if i take it that-a-way[8]
> ridden rids one of conceits of knowing
>
> a showdown's where you let the words show
> k's now 3 is how
> kiss is where the lips make instead of take
> noise in the joy's pleasure ring
>
> to sing again
> songs sung in the beginning
>
> a recitation of repeat
>
> a song a longing ends then in the brain
> trained ears observe a change in tone
> recognitions of
> defeat
>
> ---
> despair[12]
> ---

> (Nichol 1982: 7)

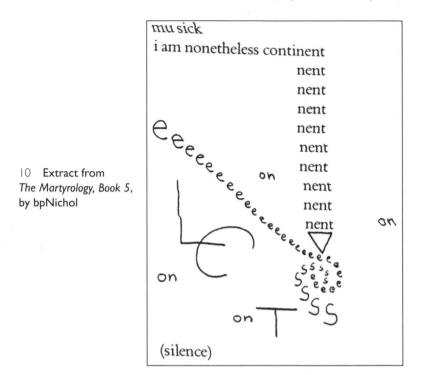

10 Extract from
The Martyrology, Book 5,
by bpNichol

But Nichol can be far more visually radical (Figure 10). The final volume of *The Martyrology* even scores most of its poetry on to a musical stave.

Nichol also produced many pieces of book art, by which I mean books constructed in a physically different manner to the conventional printed and bound gatherings that we associate with the word 'book'. Loose-leaf books are on the way to this kind of experiment, but there are many other examples of this kind of work. For instance, Deb Rindl's 'The Thin Blue Line' (1995) is a classic example of the physical extension of a pun, which draws out the associations with the phrase to an end that would be ludicrous were it not for the formally pleasing aesthetic form of the fold-out book, which creates a tension between joke and medium, which in turn becomes a commentary on the phrase. Similarly, Elizabeth LeMoine and Amy Gogarty's *Listener, and Other Texts* (1997) offers a simple yet highly effective piece of book art, which concentrates on the process of reading. Instead of turning pages from right to left and so on throughout, the reader has to unfold each opposing pair of pages so that they reveal their contents. The first and final pages contain the expected

information about the writers, the edition, the producers and the circumstances of the text. However, the central openings, each on paper that is unusually textured or with a designed background, and each with specific typography, offer different approaches to reading experiences. The physical form of the book draws the reader right into the issues of reading that are being considered.

Hypertexts and 'emergent' phenomena

Hypertext, like book art, currently draws attention to its physical form, precisely because it is so new. As implied above, I suspect that much hypertext will cease to do so as its forms become familiar. There is currently a debate about the way that hypertext, along with a number of other computing structures, can create 'emergent' phenomena. In other words, because it offers more flexible ways of moving around and combining textual elements, when those elements become juxtaposed in new and different ways they may generate completely unexpected and unplanned-for events. The reason for the concern over this debate is that in the field of Artificial Intelligence such emergent phenomena might lead to, for example, robots being able to take actions that are independent of their programming. In other words, they may mimic human intelligence, and possibly even take action against humans. There is some cause for concern about this in the area of robotics, since the robot-constructions will be able to take action and have effects in the social and political world. Hence we have to be concerned about the ethics of the situation.

However, this concept of 'emergent' phenomena and independent event does not differ in any other way from human constructions such as science and technology, which also have obvious effects on the social and political, or like the arts. When a scientist or an artist works on reality, phenomena emerge all the time from specific experience and experiment. When the public engages with those pieces of work, yet more phenomena emerge, often in interpretations. What makes these activities different from robotics is that the effects are put into action by way of human agents who do have social and cultural training in what is acceptable and what is not. Let us say a reader reads a hypertext program that is built to generate new links when that reader visits a sequence of pages; those new links subtly change the overall structure of the text for the next reader. Readers of books do not change the actual

words on the page; however, many of them go away and write different texts as a result of the act of reading. This is a function of the medium, but does not change the fact that new texts result. Another way of looking at this issue is laid out in a recent book by Espen Aarseth, *Cybertext: Perspectives on Ergodic Literature*, in which he argues that electronic texts require more interaction from the reader than do books. Yet the only sense in which hypertexts produce emergent phenomena and books do not is that we are more used to books and we take their activity for granted. Once we take the activity of hypertexts for granted we will forget that they are programmed by humans, and begin to think that they have taken on some new and magical quality.

Hypermedia nests

Hypertexts can make it much easier to represent the process of reading and interpretation, and the construction of different meanings and significances. The most recent hypertext that I have worked on is concerned with making available contexts for the study of Victorian periodicals. It is structured like a central text hypertext, but with nothing in the position of the central text. Hence readers wander around the groupings of contextual material, following the suggested pathways if they wish, but always needing to be aware of constructing the relevant connection to the periodical material under consideration that is physically in the different medium of print. The key facility that the hypertext offers is that of enabling readers to make their own links between different pages, so that their topic of interest gradually acquires a web of connections; a contextual nest is woven around it. Users may choose to keep the nest individual and specific to themselves; they may choose to develop it in discussion with others; or they may choose to join a group and develop it corporately.

The main point about the hypermedia nests is that they are on a scale small enough to encourage assessment of the implications of contextual strategy or patterns of links, on social actions. Here, most immediately, those social actions are concerned with how knowledge about periodicals is being constructed. The next stage of the project will be to turn the virtual nests of context that are made by users into a graphic representation that can itself be open to aesthetic interpretation in much the same way as a drawing or painting. What I would like to do is to find a way for the reader to think about the interactivity with the hypertext as

necessarily engaged, in other words, a way that makes it extremely difficult to take the medium for granted. The only way that we will be able to think of these texts in terms of responsible aesthetics is if we can work on strategies for writing and reading that engage the writer and reader into the production and recognition of shared value.

Synergetic texts

To conclude, I want to consider briefly the work of Susan Johanknecht, who is currently teaching the MA in Book Arts at Camberwell College of Arts. She has produced a number of texts that run hypertext programs alongside the printed book in fascinating, elusive and synergetic ways. One such combination is called *of science & desire* (1996). The book itself is a conventionally produced short book, in which she is considering what might happen if we tried to produce a GCSE physics explanation for events such as 'touch' or 'kiss' or 'stroke'. On its own it is an intriguing approach to a philosophical suggestion that emotions and sensory experiences are the source for conceptual categories, being pursued in challenging ways by people such as Alison Jaggar, who has famously defined 'rationality' as just an *authorised* emotion.

Johanknecht's short book is, by itself, enigmatic. The black cover is extraordinarily sensuous, and anyone who has felt it always comments on its unusual texture. However, the words and pictures inside demand longer and more acute attention. The accompanying CD program offers slow-motion enactments of the diagrams in the book, which the reader, listener or viewer must watch in the entirety of their unit. In other words, we cannot just click out of a page that seems uninteresting. This arrests our attention, slows down the casual speed with which we usually consume images, and prepares us for thinking about what we see on the screen. Then, the screen images become accompanied by an overlaid voice that whispers the words we find on the pages of the book. What is interesting is that, when we return to the book, we read more slowly, we retain vestigial memories of the whispering voice, and the text becomes infused with different significance.

The other book-CD combination by Susan Johanknecht with which I would like to end this discussion, *WHO WILL BE IT?* (1996), is even more elusive. The 'book' version of this work is a small, detailed and carefully produced box. When it is opened, the 'reader' finds a thin layer of gold gauze that covers a set of rectangular cards, some of which are

printed tokens that have 'WHO WILL BE IT?' on one side and a short piece of poetry or poetic commentary on the back, while others have photographic images on both sides. There is also one token that explains how the reader might read or play the 'book', which clearly relates to the game of scissors/rock/paper. The accompanying CD program displays a small rectangle, possibly around the same size as the rectangular cards, on a black background that takes up the rest of the screen. In this rectangle there is a photograph of a box within which a large pair of shears rocks back and forth. The reader uses the mouse to click on the shears, and, depending upon the point in its motion at which it is stopped, the photograph of the shears is replaced by various photographs of paper, scissors and rocks, which then engage in a graphic interaction that plays out the logic of the game while a voice-over speaks the poetic commentary. These short pieces of graphic interaction are visually exquisite, at the same time as being slightly ominous. They engage our attention partly because, as elements in the game, they challenge us to an allegorical reading: What do the elements of the visual picture indicate, especially when viewed with the poetry being voiced over them? What is more, those pieces of poetry are not necessarily the same for any one graphic; we may revisit a particular picture and have a different commentary being voiced over. Returning to the 'book', we are alerted to the potential in the words and pictures that we would probably have unleashed in the course of a slow and careful reading, but which has become pointed and prompted by the experience of the CD.

These book-CD combinations are not immediately gratifying and satisfactory in the way that 253 is, but they do generate highly complex responses that make us think about how we are reading in radically new directions. We need to think about both the satisfactions and challenges to the medium in sorting out how these texts can be valuable. Hypertext literature is full of such developments, and will continue to engage readers over the next century just as much as the novel or the sonnet have done in the past.

CHAPTER SEVEN

Is letter-writing literature? And what about diaries?

Writing that is published comes from a very small part of the population, and we tend to forget that many people write all the time – diaries, letters, journals, even poetry and prose for their family or group of friends. Examples of literary value are almost entirely derived from published material, for the obvious reason that it has a larger audience and is tightly integrated into the centres of cultural and social power that write reviews, give awards and allocate sponsorship. *One of the literary revolutions of the past two decades has been the recognition of the literary value in personal communications, even of their central role in the process that leads to publication. However, we have few words to describe or understand this kind of value.* The issue has become acute in the area of women's writing, because traditionally women have written in these 'peripheral' media; and despite the high profile of a small number of women writers such as Jane Austen, George Eliot or Virginia Woolf in English Studies, women continue to prefer ephemeral genres, particularly those of letters, autobiography and autography. This chapter will pursue the difficulties of reading many of these texts, and will suggest ways of valuing their verbal strategies and techniques.

I believe there is a world of difference between what writers say they do and what academics say writers do. What is more: that if we think more carefully about what some writers are saying about their practice at the moment, we may be able to open up areas of interaction, communication and value that we have not previously noticed. I would like to think about the fact that so many people write creatively, yet much of what they write does not get counted as 'literature'. Does that matter? Yes, I think it does. No piece of writing, if it is doing anything interesting whatsoever, can avoid doing something different in the text. If we

could find experiences, feelings or ideas written down in a way that appropriately matched our own, there would be no need to write (although there might be a need to repeat). It is the diversity of human beings that propels us to write, and to write differently from anyone else. Hence, the reader must learn to read differently – sometimes only a little differently and sometimes a lot. No piece of writing can be read without some work on the text, and we have to have good reasons to commit ourselves to that task. In our society, the label 'literature' is one of the words we have agreed to place on writing that we think is worth that labour. Without the title 'literature' we do not often get around to valuing the writing. However, I want to use the space of this chapter to spend some time looking at texts on the edge of the 'literature' exclusion zone, mainly but not exclusively by women.

Private correspondence and variable selves

Critics tell us that writers are authors: they have authority. Their work is unique, an act of genius revealing universal truths, and in the process creating great beauty that is recognisable by all (once the critics have explained it). Yet few writers ever say anything remotely like this in their letters, diaries or autobiographical accounts that we have available. In effect, most demonstrate in their private correspondence that they often work with other people, such as a friend, husband, mother and so on – frequently trading ideas and drafts, incorporating elements from letters into their texts. It is rare to find even a glimpse of the idea that the poet reveals universal truth or beauty, indeed they sometimes speak of being 'taken over' by their characters, and are bewildered about who their audiences are. The sense we get of writing from the writers' point of view is not of authority but of questioning, of the writing voice as varied and variable in time and space. Truth and Beauty: the words recall to us Keats's 'Ode on a Grecian Urn', which ends with a desolate picture of never-achieved humanity, arrested for ever without completion in action, on the urn, isolated as it is from any sense of the urn-maker.

Keats provides a good example of that to which I am referring. His letters are profoundly engaging, yet I remember being told rather sternly that they were not suitable for literary analysis. Why not? The reason was that because they were merely letters, academics could argue that the kind of care usually taken with 'literary' texts had not

been taken here. It may be that the focus on the unique individual voice is not there, and that there is a shift to the interaction between the writer and reader, but people cannot simply 'put themselves on the page'. No matter what they write, they always select the appropriate words, and that will happen with a letter just as much as any other writing. Keats used his letters to ask for advice on poetry he was writing and included a lot of verse, but in a sense that is a red herring. More subtly inbuilt into many prose sentences in his letters, such as that written on 19 March 1819 and addressed to the 'George Keatses', are phrases and lines that form the basis of poems such as 'Ode to Indolence', and which in themselves ask for an engagement into the structure and tension of the language (Keats 1958: 78–79).

The position of the writing voice is never as problematic as when found in first-person accounts: diaries, letters, autobiography, autography, and the first-person narrative itself. Even the lyric 'I', seemingly so stable, is usually being contested. These texts always have that extra edge or frisson of claiming that they have to be believed, because they are in the first person. At one point or another they claim an intimate relation. However, do we trust the voice? The narrator? The writer? I would suggest that readers read other people's letters to get a sense of the variety of relationships in which individuals engage. They read diaries to reach toward the real person who writes, even though that person can never be 'all there'. At the same time, people write diaries and letters, as other texts, because, as Nicole Brossard tells us, through the act of writing we can bring 'ourselves literally into the world' (Brossard 1985: 181).

Collections of letters attest more than most documents to the variability of people's lives and identities. If the letters are familiar and voluntary, we rarely write to two different people in exactly the same way, although I can remember that when I was an eight-year-old schoolgirl required to write three letters a week, I would copy huge sections from one letter to another. Moreover, letters have been for centuries the way that men and women coped with the growing diversity and vastness of our lives. Even though literacy rates for women were lower than those for men until the twentieth century, the Paston Collection of fifteenth-century letters contains many by women at a time when women wrote more infrequently than they do now. Indeed, letters were one of the few forms in which women could write and express their opinions without fear of criticism. Dorothy Moore, one of

the most important intellectuals of the seventeenth century, wrote entirely in letter form. In the following letter she addresses Lady Ranelagh, her close friend yet social superior. She pours on to the page the extraordinarily testing experience she is going through, of giving up her vocation to work for Christ by finding a place in the Protestant ministry for women, to marry John Dury, an important ecumenical leader of the time:

UNDATED [Nov 1644]?: To Lady Ranelagh?

Madame
 ... did I not know that foul coruption may and does lodge in the Heart of Gods child, as well as his free grace I should absoluty conclude my selfe noe member of Chrits body, which yett I dare not doe not withstanding my desperatte wickednes. I have beene putt upon the tryall of a very greatt submission, which truly as I might well forsee it, and take tyme to resolve it, I cannot but say for my one condemnation also, that I did apprehend it enough to have forced mee to take up the best Armour against it, which was a firme resolution to follow Gods Councell in it, the striving for which hath certainly brought on mee such fitts as I am not sure to bee read off, which shewes my abominable basnes that would contest in such a way bee rid of a feare (having more cause for that then formerly) as to bring myselfe into misery, before I saw my error, and all this when I made myself beleive nothing was more precious to me then the knoledge of Gods will in all things that I might observe it, tho wholly difficult Its true my ill diet And solitarinnes helpt me to my infirmity but thos fell in upon my not heeding any thing, butt my thoughts soe as to declare the Truth, inward worcking of mind (which I cannot call trouble because it was soe finely trimmed as that I perceaved not it) hath altered my health strangly and of latte with such variety as is odd sometymes seazing on me with such stupidnes as neither minde or body move to any action whatsoever which putts such a separattion betweene God and my Soule as these fitts are 1000 Millions worse then sownds truly of latte [space] been soe as my life was a most intollerable burden. I doe not thinke possible that any can imagine this Affliction, but those that have sufferd in it, I shall ever begg my Lady Wimbeltons pardone for my not being [space] to judge of her condition with more charity then I did ... I professe to live and dye most faithfull
 Madame
 your Ladyship
 most humbly affectionatte
 Servant
 D. Moore

 (Moore, in Hunter, forthcoming 2002)

Although this is a familiar letter, not one of her formal arguments, the reader can mark and feel the torrent of confusion, pain and self-reassurance, that characterises her dilemma. Without such testimony we could never have any sense of the import of this kind of religious vocation, or even of the possibility that such a dilemma would have been imaginable during the period, or of the rather curious tension between social standing and emotional intimacy that letter-writing can transcend.

Nearly three centuries later, Virginia Woolf recognises that tension in countless delicate shifts in tone and control. Look, for example, at two letters written on 11 February 1922, while she was ill. The first is to Lady Robert Cecil:

> My dear Nelly,
>
> It was very nice to get your letter, which confirms me in my belief that you have inherited the letter writing gift, along with your castles, and makes me think twice before I demolish the Nellies and the Castles.
>
> I'm now condemned to lie in bed for 2 or 3 weeks, until my heart gets right, which the influenza has put wrong. So letters are more than ever needed. I can't say that the disease is good for the brain.
>
> I read two lines, and go off into a trance, quite pleasant, like an animal in a hot house.
>
> I've been reading the life of Lord Salisbury. I find it absorbing. What a queer character – I'm reminded, oddly, of my father. And Lady G. writes like twenty able men crushed into one. As hard as a paving stone. I mean this complimentarily. When will the 3rd Vol. come out?
>
> Yr. V.W (Woolf, in Nicolson and Trautmann 1976: 502)

The second is to Lytton Strachey:

> Your correspondence is about the only bright spot in my day so please continue. My lethargy is that of the alligator at the Zoo. And the alligator doesn't have very clear ideas of Racine. A. B. W. in the Times almost suffocated me by saying that Molière, Don Juan, is tedious twaddle. Surely it is the best of the lot – so I seem to remember. Then that Mule, Alice Meynell, says that Jane Austen is a frump, and that Mr Patmore is equal to Milton and that Tristram Shandy should be read in Prof. Morley's edition with every 10th page cut out. There can't be anything left to castrate of Meynell, or I should do it myself. Alligators can't endure the moderns – Peacock is what I like. You don't know how good he is – Crotchet Castle – surely nothing survives except the perfection of prose. And you read Miss Sinclair! So shall I perhaps. But I'd rather read Lytton Strachey.

Well, if you do come it will be something to look forward to. Clive is sus-
pended above me, like a Cherub, all bottom and a little flaxen wig. Roger
looms in the distance, so let me know which day.

The infirmity of this handwriting is *not* entirely heart disease: I am
reduced to a fountain pen. And you make them work … Yr V. (Woolf, in
Nicholson and Trautmann 1976: 503)

In spite of the heart disease, Woolf carefully picks the correct register
for the relationship; she makes each feel as though they alone are the
one who has helped her through the day; and she caresses each, a
gentle stroking of their sense of self, by giving them the story they each
most want.

This ability to make the writer immediate on the page, yet to alert the
(unintended) reader to the variability of the writing self, is found through-
out her letters. One of her favourite correspondents was Roger Fry. Note
the immediacy of the opening of the following, dated 17 October 1921:

My dear Roger,

Your letter arrived precisely one hour ago, and here I am sitting down to
answer it. Whether the answer will be sent is, of course, another matter. Your
last – slightly tipsy, very brilliant, sympathetic, inspiring and the best you
ever wrote, – sent me flying to the inkpot, but when I read my production
and compared it with yours my vanity as an author refused to be pacified. I
can't endure that you should write so well. If you want answers let your
letters be like bread poultices: anyhow I tore up what was, I now think, the
best letter I ever wrote. Would you like it if I dashed off a little sketch of
the eclipse of the moon last night, which entirely surpassed your great
oil painting of the Rape of Euridyce – or whatever it is? … V.W. (Woolf, in
Nicolson and Trautmann 1976: 484–5)

Did she really write a wonderful letter that she then 'tore up', or is she
saying so as a device to speak to Fry about the brilliant nature of his
writing, or is this not rather over the top – perhaps she is gently teasing
him for his own excesses? The possibility of all these writing stances
is partly what engages the reader in the text. It is a shame that letter-
writing is dying out, drifting down the telephone, perhaps the reprieve
of email will not be temporary.

The diary and the illusion of a coherent self

Diaries usually give us far more of a sense of a coherent self, if only
because of the illusion of privacy. When we read a diary we reach

towards the real person who writes, we fill in the blanks of the text more generously than when reading a collection of letters, because we often put ourselves in the position of being the person to whom the diary is addressed. The diary is another form that has served women well, acting frequently as a place for spiritual self-examination in the sixteenth and seventeenth centuries, and gradually becoming more experiential. Margaret Hoby, at the end of the sixteenth century, and in the first few years of her third marriage, devotes her diary to an account of her daily service to God. She says, in September 1599:

> The Lordes day 16
> After I had praied priuatly, I went to church and, from thence returninge, I praised god both for the inableinge the minister so proffetably to declare the word as he had, and my selfe to heare wth that Comfort and vnderstanding I did: after dinner I walked with Mr Hoby tell Catzhising was done, and then I went to church: after the sarmon I looked vpon a poore mans Legg, and after that I walked, and reed a sarmon of Geferd vpon the song of Salomon: then I examined my selfe and praied: after supper I was busie with Mr Hoby tell prair time, after which I went to bed. (Hoby, in Moody 1998: 17–18)

Clearly this account tells us much about the time, but in a sense the cumulative effect of the lists of activities that builds up through the diary is far more telling. We become sensitised to small changes in the routine, at the same time as we are caught tautly into that habitual, rarely varying lifestyle. The editor notes that Margaret Hoby's barrenness would have been perceived by her as a punishment from God, and these entries carry with them a sense of duty that feels heavy, as if loaded with guilt. The almost imperceptible changes become charged with light, with the possibility of relief. Also, I do wonder why she stopped keeping the diary. Hoby was married for many more years. Perhaps its weight became too burdensome a reminder of her fallen state.

The capacity for the diary to act as a place to sort out one's life by sorting out one's words carries on to today. If we stop briefly in the nineteenth century to listen to Margaret Dickie Michener, a Nova Scotian, we hear the same process. She kept a diary from 1850, starting when her husband of only a year had to leave to work elsewhere. Her brisk, lively prose is full of energy. On 27 September 1850, she writes: 'Maria came in this evening and we have been taking turns reading aloud from a book

called "The Young Emigrant"; it is about two families who move to Ohio.
It shows how many difficulties the first settlers have to encounter in a
new country.' On 2 October she writes:

> How changed are all my prospects. What shall I write? I know not what to
> say or think. My beloved Simeon is no more! Can it be possible I will not see
> him again, or hear his sweet voice? I went to Mary's last night to wait till the
> mail would come in. Ezra went over and returned with three letters. I got a
> light and saw that two letters were for Maria. It was with fear and trembling
> I read my letter from Simeon; he was in quite good spirits when he wrote
> but not too well. I found Curry had received Maria's letter but Simeon did
> not get mine. I read my letter to Mary and Ann, and then in haste went up
> to Marcia's where Maria was. The road never seemed so long before; I could
> not go fast enough. At last I gave her the letters, wishing yet dreading to
> know the contents. I told her to read the latest one first. I arose ready to start
> at the news she looked [*sic*]; I saw her drop the letter and I went into the
> bedroom as I wished to hear no more. I knew Simeon was dead yet dared
> not ask. (Michener, in Conrad et al. 1988: 109–10)

The physical detail of her movements is extraordinary, especially since
she writes on the same day that she learns of the death. It conveys a
sense of surreal detachment, as if she sees herself from without,
because she has been driven out of herself by shock. Nestled at the
centre of the account is that tiny note, that her husband did not receive
her last letter before he died, as if her final chance to speak to him has
been thwarted.

Two months later she is attending at the house of a neighbour whose
child is terminally ill, and writes:

> Saturday night I went to stay the night [at Mrs. Holmes's]; about half past
> eleven the child died in my arms. It was the first time I had ever seen one
> die; it sank away so gently I hardly knew it was gone. I thought how sweet
> to die and be at rest from the tumult of this world. Dear little babe, it looked
> more beautiful in death than when living, for it was a great sufferer. Mrs.
> Hicks and Jane Lynch sat with me. Mrs. Hicks is a widow for three years.
> She has six children. I feel a nearness to widows. (Michener, in Conrad et al.
> 1988: 114)

We watch the strategies that she is devising for dealing with the death
of her husband, which are laid out in the soft consideration of this dying
in her arms. It is a death she still has not come to accept for she dis-
tances herself from 'widows'; she is only 'near' them, not yet ready to

become one of them. At the same time, we also hear the undercurrent of another realisation, in that proximity of Mrs Hicks the 'widow', with Mrs Hicks the mother who has 'six children', that Margaret Michener will have no children by whom to remember her husband.

Autobiography, life writing and the difficulty of experience

There is a fine line between diary and autobiography, except that the latter is usually explicitly for public consumption. It is helpful to remind ourselves that diaries were often circulated among friends until earlier this century, and were, like letters, a way of continuing relationships across distance. In addition, autobiographies were, and are, often written for spiritual reasons. However, in distinction from the 'lives' of great people, the tomes of national importance that seem to pick an all too selective way through the minefields of life, many life stories are written almost as confessions, and certainly for family use. These life writings are more a report on one's life (a viary?), a site for reminiscence, relishing, and maybe regretting, the way that past memory comes close in the final years of life. Ever since, and probably before, John Bunyan, this kind of life story has been written in English. David Vincent has compiled a list of the accounts held by the British Library, but until recently they rarely got into print. Many are of a kind, spiritual examinations from modest people, making a peace with themselves or God. One that I co-edited, 'The Autobiography of William Hart, Cooper, 1776–1857', lifts several devices directly from Bunyan, testifying to the genealogy of these texts and the way that they self-consciously learn from each other, as do canonical traditions.

However, one of the difficult aspects of this kind of writing is that people often do not find the appropriate style or tradition for the experience around which they want to write. Life writing is perceived to transgress decorum, to be naive or simplistic, if not downright clumsy. Over the past fifteen years, there has been an upsurge of interest in local, situated autobiography, and this has been aided by the availability of cheap printing that has made the circulation of this material more possible. One powerful collection of life stories, written in many genres, is *Writing the Circle* (1990), a collection of texts by First Nations women in western Canada which make claim to tell the self of people who have never before put themselves into published words. What is particularly interesting is the nature of the self that is told, for it is rarely unitary. Lee

Maracle has said of the stories: 'We have become. The veil of silence
in the world of literature is removed by the relentless march of words
contained in this anthology. Sketches of our lives, passionate visions out-
lined in poetry, and analytical essay bring the reader from an ancient
past into the painful and inspiring present. We are visible at last' (Mara-
cle, in Perreault and Vance 1990: back cover). Referring to the same col-
lection, Thomas King writes: 'The voices of Native women in this
anthology transcend western literary genres and carry us to worlds and
realities – traditional and contemporary, spiritual and secular – that have
been all but invisible' (King, in Perreault and Vance 1990: back cover).
Invisibility and silence are swept away by the sheer volume of the col-
lection, story after story putting into place a lost piece of life that needs
valuing. Writer after writer gives testimony to the fact that they are writ-
ing not only or even primarily for themselves but for their communities.
They dedicate their texts to their families, their teachers, their neigh-
bours, their tribes, their children, the future of First Nations people.

The stance is one that derives straight from the organisation of First
Nations society, and from the communal role of the storyteller. The
voice of the writer may be direct and immediate, but it is not only the
voice of the private individual. Robin Melting Tallow writes 'The Patch-
work Quilt', a story about herself, but also a story which teaches the
reader what they find there:

> Sometimes, late in the evening, my husband and I would lie together in the
> darkness of our bedroom. It was never completely dark, because I was afraid
> of the dark, and each night my fear would become a point of dissension
> between us. However, he would eventually relent, and I would turn the
> closet light on. If I closed the door all the way, there wasn't enough light, and
> if I left it open there was too much and he couldn't sleep. So we would com-
> promise, and I would prop the closet door open with his cowboy boot. After
> our customary disagreement was settled, we would pull the comfort blanket
> over us, right up to our eyes. The blanket was really a patchwork quilt made
> for my husband by his mother for his thirty-ninth birthday. Our girls had
> christened that precious quilt 'the comfort blanket,' because it had brought
> them comfort on the days they were sick and during times of sadness …
> Lying there beside him it was hard to believe that I was not a young woman
> any longer. I felt robbed. Childhood had stolen by me so quickly that I could
> hardly remember it. I could scarcely believe myself at times. I had actually
> begun to day-dream about grandchildren. I didn't want to be a grandmother,
> not yet, anyway. Imagine some cute little creature calling me granny. How-
> ever, I do believe that the maternal instinct has a mind of its own and that

this entity had begun to toy with my heart and soul. I longed to hold a tiny, bundled, sweetly powdered form in my arms once more. But, a crazy thought struck me and made me giggle out loud (which caused my husband to give me one of *those* looks). How could I tell my grandchildren that I was afraid of the dark. This was ridiculous. I could just imagine them taunting me, 'Granny's afraid of the dark, granny's afraid of the dark!'

OK, I thought, so I am getting slightly ahead of myself. Maybe I can still squeeze in a few more years of being Mom and that 'sexy lady' (some days). Looking at my husband's profile, I felt a warm tenderness surge through my body and I realized that I really was too young to make love to a man by the name of grandpa. Now, if only the kids will co-operate!

(Melting Tallow, in Perreault and Vance 1990: 203–4)

On one level this story is simply a description; on another it is an intensely condensed autobiography. At the same time, it is a subtle rendering of a wedded life, which conveys the negotiations between the husband and wife while underlining the present moment of concern, what she currently has on her mind. Rather than talk to her husband about it she talks to us, takes us on a journey through end-of-the-day tiredness, towards that borderland of dream and wishing where she sees herself as a grandmother – thereby implicitly past the immediate responsibility for her own children, which would be a relief. Then, her humour breaks through, her sense of reality comes striding in, to remind her that she has so much more yet to do. The words take us forward on a second wind of prosody that carries her own renewed energy to the point where she can contemplate making love. She is too young to feel old, she is too unlearned to be as wise as a grandmother, she is still in the middle of life and must find the energy for it. After all, it was not until his thirty-ninth birthday that her husband's mother made him a quilt. Undoubtedly, another reader will take away another reading, and this one tells you much about me. In fact, it probably tells you more about me as a reader than about the writer, which is an effect to which I will return in the next chapter.

Fiction and saying the self

In the conventional world of publishing, writers are usually placed by publishers and critics as individuals. The rounds of interviews, awards, rewards and so on are geared to the packaged writer. Yet the voice of the writer frequently speaks of a disparate identity. If the line between

diary and autobiography is fine, that between autobiography and fiction
is close. All writers use their own experiences to write, and women
writers in particular have turned to fiction and short story as appropri-
ate generic forms for writing themselves into existence. It is a com-
monplace that the short story is dominated by women writers, and
is the main focus for women readers, partly, it is argued, because
women have fewer coherent periods of time in their day. One only has
to think of Katherine Mansfield, Virginia Woolf herself, Joyce Carol
Oates, Margaret Atwood or Alice Munro to recall the broad scope of
women short story writers today. If I look briefly at a story by Alice
Munro, the title story from the collection *The Progress of Love* (1986),
we can see her experimenting with identity, with the saying of self,
almost as if the conventions around her are not sufficient to tell the
story the way she would like.

'The Progress of Love' is narrated in the first person by a character
called Phemie, and the story starts with a moment in Phemie's life when
her father rings her to let her know that her mother has died. Initially,
the reader assumes that this is the present day. Yet even within this
opening section, the chronology shifts us forward so that we hear
Phemie speaking of her father later on in a nursing home. The second
section moves into a memory of her mother, and the third into a mem-
ory of the farm where she lived as a child. Both of these memories are
anchored to a more recent present by intercut comments from her
father and her ex-husband. Possibly we should be warned by the com-
ment from the ex-husband, because we know from the opening that
Phemie has been divorced for some time, and in the time of the fourth
section we find the chronology shifted even further forward, to the
father as a 'very old' man, and the fifth brings us to the point when she
is dating other men, post-divorce (Munro 1986: 5). In the sixth section
of the story we are taken firmly back to a childhood event, the arrival of
Aunt Beryl at the farm, for which Phemie is redecorating her room with
cornflower wallpaper. The narration of this event is interrupted by a
story from the early life of her mother and Aunt Beryl, about the appar-
ently tragic suicide attempt of her grandmother upon finding out about
the affair her husband is having. We then return to Beryl's visit, during
which she tells her version of the suicide story: that it was a 'set-up' and
not serious.

Despite all the shifts in time we have already progressed through,
the reader is exposed to even more as Phemie moves the present day

forward to the point when she has a steady boyfriend who goes with her to look at the old farm, many years after she left. Several people have owned it, including a hippie commune which has painted sexual slogans all over the walls. Phemie then finds her old bedroom, and on the vandalised wall she can see the cornflower wallpaper which affects her hugely. Her boyfriend assumes that it is all the 'sexual shenanigans' that have upset her, and she is angry about his presumption (Munro 1986: 27). The experience sends her back again to the memory of Beryl's visit, and the reader begins to recognise that it is the visit to the farm with the boyfriend that is probably the present time, since the memory of Beryl picks up from where it left off: with another story told two ways. Her mother had inherited money from her grandfather, which she had then burned. Phemie remembers this as a visual event with her father standing beside her mother at the stove, supporting her decision – which incidentally also makes it impossible for Phemie to realise her dream and train as a teacher. However, Beryl 'corrects' this memory, saying that Phemie's father had not been there at all. The different way that people remember the past is shown to shape their future. More than this, Phemie recognises that we have a choice in how we remember, that she can choose to take her boyfriend's comment differently, for 'Moments of kindness and reconciliation are worth having, even if the parting has to come sooner or later' (Munro 1986: 30–1).

Munro builds this first-person voice wandering through a maze of time and memory. As we follow it we may feel as though we know the narrator, but there is never the sense that we are reading about the writer, although there is an indication of the writer's sensibility. What we watch is the voice writing the narrator/character into existence before our very eyes, making choices within the fluidity of memory and time, recognising the way that memory reflects need, what we need to remember to make the present possible. This is not the I-narrator of dramatic monologue, in which the 'character' is well-defined yet reveals, inadvertently, more about themselves than they would necessarily like. The narrator's voice is many-sided, self-conscious, enacting the progress of recognition in a patchwork of memories.

In this, Munro demonstrates, as do many women short story writers, a playing with a sense of self, an inhabiting of many bodies at the same time in the first person. Among the more formal experimenters with this sense of self is Claire Harris, whose verse narrative *Drawing Down a Daughter* dislocates the speaking voice or narrator or writer so fully

that it is difficult for the reader to put a finger on who the 'self' might
be. The strategic evasion of 'self' is one of the key areas of postmodern
writing, often attempting to evade social responsibility. In contrast,
Harris is keen to explore the impossibility of saying her particular self
within a traditional literary culture. However, the diaries, letters, auto-
biographies and even fictions that I have mentioned above all deal with
the same difficulty.

Autography: topical, performing and agential selves

I would like to conclude with a brief look at the developing genre of
autography: a strategy that Jeanne Perreault illustrates as a kind of
culling from autobiography. If autobiography allows one to write one-
self into being in the world, autography turns that being in the world
into knowledge that can be shared by many people. Autography
requires a more self-conscious turning of our actual voice into 'selves'
that work as topic, or performance, or agent (Perreault 1995: 1–30). Yet
it retains the proximity of the speaking voice with the narrator and/or
with the writer. When Daphne Marlatt writes *Ana Historic* (1988) in
three voices from three different generations of women, there is a sense
in which the reader reads all three as part of the writer, simultaneously
reading them as exemplary of particular historical responses to women
who are trying to say their selves. In contrast to Munro, who casts the
various women in her stories as people who help Phemie learn, Marlatt
creates a speaking voice whose character is made up of all the women
in the novel: as if the entire history of women is coursing through the
blood of one.

In the recent work *Taken* (1996), set largely against the backdrop of
the Second World War in the Pacific, Marlatt extends the movement into
the 'ghosts' of energy that each person's contact with another leaves in
the biochemistry or memory of the body. A constellation of voices in the
past, of mother, father, grandparents, friends, those who escape and
those who are taken, circulate around the woman narrator as a child.
They form an evanescent character that gradually coalesces around the
nodal point of the adult speaker. The story from the past, of her mother's
separation from her father during the war, is overlaid on to her own pre-
sent-day separation from her lover. What is more, as she speaks herself
into a way of recognising not merely the memories and mementoes of
her mother but the way her mother (and father) are ghosted into her own

actions, she speaks herself also into a place in which her lover, too, has become ghosted into her continuous present. The writer here is a varied and variable voice, in process, embodying itself as it recognises the ghosts of contact with others, responding to different need, and generating a range of different values, all of which come into place at resting points in the novel, points at which the reader recognises identity.

None of the examples I have chosen presents the writer or narrator as a unique and stable voice, generating truth and beauty, although the short story genre would certainly yield some instances where this might be the case. Instead, these diaries, letters, autobiographies, short stories and autographies work to point out the variability of self, the questioning and ambiguity of identity, in which the speaking voice asks not only the reader but also itself what is trustworthy. While these are for the most part texts by women, who may have good reason to believe that the traditional literary forms do not appropriately fit their needs, I suspect that all writers would connect with the processes illustrated here. These processes are not the canonical critical ends, but they inscribe a whole world of other experience that readers can appreciate and learn to value. In doing so, they will also learn to value these elements in their own lives.

CHAPTER EIGHT

Do you take risks when you read? Or: risk-taking in reading

Words, above all else, bring us together: they can also keep us apart, but without them we never get together. One highly contentious field of writing that is based on this maxim is that of life writing. It is used in therapy, in literacy courses, in English as a second (or third or fourth …) language instruction, in oral history and community projects.

Yet traditional literary value teaches us to maintain a distance between our personal lives and our art, as if it is somehow bad manners to talk about our selves. *I want to suggest that what is really at issue is the way in which the story is told, rather than that it is told at all, and that there are innumerable communities in England and the UK more generally, that simply do not speak or write in the conventionally accepted way.* The result is that these voices, these different verbal arts, are excluded from literary value. There *is* a real problem here because I would not want to get rid of value and have a free-for-all in aesthetics, but I suspect that this problem arises mainly from the absence of any common vocabulary for approaching and understanding these texts in the first place. The broader ethical issue is that a failure to understand these writings and oral stories means that we are kept apart from the communities that produce them.

In the preceding chapter I looked at several extracts from diaries, letters and autobiographies, and asked whether any of these could be thought of as having literary value. With those pieces I carried out short analytical and critical studies precisely to address that question, and I would happily defend any of that writing's value in fairly conventional literary aesthetic terms. Any one of those pieces could be brought into a position in the literary canon used by the educational institutions in the UK.

This takes me back to the first chapter in this book, 'What is literary value?', in which I explore the way that the educational canon was put

into place by people from a particular social position, and with particular aims. I point out that the aesthetics and critical values for which they argued answered their needs – but not necessarily those of other communities. Subsequent chapters have looked at the verbal arts in poetry, song, prose, narrative, book art, storytelling and electronic forms such as hypermedia, which are today coming from places with rather different needs. However, in this chapter, I will look at some writing whose form seems to place it outwith conventional literary value, and ask *if* we can read it, and if so, *how*? What risks are we willing to take? The risk of boredom? Alienation? Frustration? Or other more complicated risks?

What I am not talking about here, although it is far more 'sexy', is the risk of shock. Shock is part of our aesthetic vocabulary. Artists of various kinds play with it all the time, often in egocentric pursuit of being 'the first' to do something, making it a hangover from the Romantic notion of original genius. It has other functions too, although many of them are about the disruption of conventional ideas of 'beauty' that may frequently claim to act on your behalf. The kind of risk I am talking about is not the kind that comes from fear of someone throwing something *at* you, but the kind that you yourself take on when you decide to take the time to read something that comes from outside your own aesthetic and social community. The risk of a waste of time perhaps, or, more difficult, the risk of what you will need to give up in order to appreciate another way of expressing experience.

Aesthetics and unrecognised writing

Words, above all else, bring us together – without them we cannot have a democracy. One area committed to extending the franchise on words is life writing, which is used in therapy, in literacy courses, in teaching English as a second (or third, or fourth) language, in oral history and in community writing projects, among many others. Yet traditional literary value teaches us to maintain a distance between our personal lives and our art, as if it were bad manners to talk about ourselves. I want to suggest in this chapter that what is really at issue is the context for the way the story is told, rather than that it is told at all. There are innumerable communities in England and in the UK more generally that simply do not speak or write in the conventionally accepted way. In addition, conventionally trained readers have more or less resistance to particular ways of writing.

Some would argue that this resistance is a good thing, that otherwise we might see the death of the English language. Yet quite apart from a wealth of evidence that shows that the inventiveness of these communities is what keeps English alive and changing, these voices, these different verbal arts, are excluded from literary value. To echo a point I made in the last chapter: if the writing is excluded from recognition, from value, our society is denied the wealth of experience, the precious environments of existence and economies of survival that these voices have so painstakingly worked out in their words.

I would not want to get rid of the concept of value and have a free-for-all in aesthetics, after all, aesthetics are there to introduce ethical and moral issues into skilled play or work. I suspect, however, that this problem arises mainly from the absence of any common vocabulary for approaching and understanding these texts in the first place. The broader ethical issue is that our failure to understand these writings and oral stories means that we are kept apart from the communities that produce them, and they are kept apart from us.

Who do I mean by 'us'? I mean *me*: living in England, middle-class, white, educated, culturally Christian, heterosexual (at present), no marked disabilities (temporarily able-bodied), middle-aged and a woman. I am what used to be called a 'Sunday-supplement' person, nowadays a 'newspaper-supplement' person, targetable: you can sell me things, predict the commodities I will buy, I am part of the market, marked out, a right good mark for the slings and arrows of advertising. In many ways I am indistinguishable from that mass of people who corner culture, who hoard aesthetics as a 'high art' form which is not accessible to the many, and in which beauty is a rare thing. For people like me, there is no real desire to look beyond the confines of our understanding of art and verbal communication in particular. We are closed up in our rooms of recognisable genres and values partly, at least in my case, because the variousness of the world is overwhelming, and to let more of it in is, simply, terrifying.

Nevertheless, 'to let in' is a significant phrase, and I am aware that I am part of a group of people who can let things in or keep them out. What right do people like me have to 'let in' or not? What makes me think that other people want to be 'let in' to this world? In other words, it is not necessarily their loss, but the loss of people like myself, if we live in a closed world. When we read like this, we encourage texts to speak *at* us or *for* us. Writing or speaking depends upon conventions

and habitual common ground. The audience knows what position to take up and falls in with expectations. When the words are presented as if they are 'on our behalf' or for us, no matter how conservative or subversive, we still position ourselves in a predictable location. In these responses there is a tendency to feel that the audience is at the mercy of the writer or speaker, and there is certainly a weight of convention that can compel this response. However, if we stay alert to the different possibilities of a text, we can to some extent choose to respond as if we are being spoken *to*, as if the text is inviting us in to work on constructing a location for communication and interaction. It is the case that a lot of unconventional writing is published, and the action of generosity explicit in publication asks for this last kind of response as it offers a hand to take, or builds a floor to meet upon.

If we look at writing on the edge of convention, writing that seems so outside of aesthetic value, so specific to a small and intimate audience, we have to take great risks when we read. The question has to be: Why bother? Why do we read this material? Do we feel somehow guilty about it? Inquisitive? Prurient? Proprietary? For me, being Canadian but English by birth, and having lived in a number of other countries, including, since returning to Britain, Scotland and Wales as well as England, I feel a responsibility to this country that now gives me a home. I need to find out about its communities, and not only to understand it in terms of a commodified tourist England, or the England of power. I feel the same way about Canada, and have talked in other essays about the various literatures to be found there, but alternative writings in Canada are far more valued socially than they are here; there are, for example, more attempts to bring them into cultural common ground through teaching.

Among the many areas of writing I want to explore in this chapter is that of communities moving between oral and written forms, and here the focus will be on texts written by Irish Travellers and by recent migrants to this country from further afield. There is also the area of writing carved out by those people moving from other literacies into English, such as the Chinese, and those moving from other English verbal cultures into UK English, such as the Caribbean community. What is more, there is the kind of writing that is emerging from completely different aesthetic cultures such as those articulated in individual therapy or in community writing groups, of which there are very many in the UK.

Bibliotherapy: writing toward personal and social change

Writing as individual therapy is such an intimate act that it is often inappropriate for publication, and bibliotherapy is a much maligned area marginal to 'literature'. Bibliotherapy takes very seriously Brossard's comment, cited in the previous chapter, that by writing we bring 'ourselves literally into the world' (Brossard 1985: 181). It works with the basic premise that writing and reading do help us sort out events in our lives, and then allow us to move on. Its most extensive use has been in the treatment of trauma, the soldiers returning from 'peace-keeping' duties in Somalia for example, the after-effects of road accidents, survivors of child abuse and the impact of wider, possibly insidious social violence.

It is the case that many of the experiences that are written out of the body and on to the page need to be told not only for the sake of the individual but for the general knowledge of society. Some of this material is too painful to repeat. I would risk traumatising my audience if I selected portions out of the carefully structured contexts of writing in which they are conveyed. Yet you may be familiar with the literature of abuse, which, since it began with no formal models to help it, produced early material that hovers, terribly, on the borderlines of pornography. In other words, some texts read like pornography, an advocation rather than a critique, because the writer has consciously or unreflectively chosen to use the main literary genre for sexual violence. However, over the past two decades the writing has developed techniques that work against such ambivalence, in the process also becoming less terrifying. Examples include Elly Danica's *Don't: A Woman's Word* and Janice Williamson's *Crybaby!*, which were published in 1988 and 1998 respectively.

Bibliotherapy has provided an immense help to the abused, and the accounts are essential to society if it is to deal with the longer-running problems that instigate that abuse. It is the interdependence of social, political and personal factors within this process which supports the claim that such uses of writing are emancipatory. Sonia Linden, talking about the Write to Life residency at the Medical Foundation during a conference in 1999, 'Transversal Politics, Translating Words' at Gresham College, explained that a life experienced as incoherent achieved coherence through the process of remembering, talking and writing (with or without scribe) which the project made available. She has stressed its cathartic value, noting that the writing was often con-

cerned with details which had not been shared with others: 'Family are the last people they want to burden with these dark memories' (Sonia Linden, Gresham conference, Jan. 1999).

One of the people who has worked with Sonia Linden is Nasrin Parveez. The content of her account of torture in Iran is profoundly personal, yet the context in which it took place was clearly social and political. The act of writing it down generated two very different kinds of value. For Nasrin, the experience released her from it in an immediate way: it stopped the nightmares; it also achieved the aim she had first brought to the Write to Life project, that of raising awareness about the political regime under which she had suffered. For her, and for those of us listening to the account, there was no conflict between personal, social or political value, as their interrelatedness was clear. Yet in some contexts there can be conflict between social and personal use values.

It is rare to find a book as balanced on the edge of what can and cannot be said as Binjamin Wilkomirski's *Fragments: Memories of a Childhood, 1939–1948* (1996), supposedly a searing account of a child survivor of the Nazi concentration camps published in 1996, but subsequently recognised as fiction. Before it was revealed that Wilkomirski was not Jewish and had not been in the camps, the book was taken as an example of life-writing-as-bibliotherapy. Since the revelation, response has been confused partly because readers invest themselves in the reading of life writing in a manner different from reading fiction. Many felt betrayed for having directed their emotional energy, possibly even in an attempt to allay their cultural guilt, to a 'survivor'. Many felt that the Jewish people were again being exploited. The case is similar to the debates about the 'appropriation of voice' in the field of First Nations writing and orality discussed in the fourth chapter. By all accounts, *Fragments* is still an act of bibliotherapy on Wilkomirski's part, yet the writing transgressed an ethical understanding both about Holocaust stories and about genre. It may be significant that the balanced edge of the book is achieved by a writer who is constructing a fictional representation; it may also be significant that the genre of writing about the Holocaust is one with a substantial literary tradition and a growing body of formal elements.

Writing can sit uncomfortably with politics because of the different relation each has to the individual and the group. This is heightened when therapeutic values and purposes are introduced. The stress on individual solutions to individual problems within therapeutic

practices can lead to a situation where determination is obscured and social conflicts are experienced as personal problems. However, it is not inevitable that the use of writing and orality in arts for health, personal development and therapeutic contexts does this. In fact, work in the area of bibliotherapy in Canada and Australia often starts from precisely this challenge to such individualism and has worked in areas such as domestic violence, homelessness and chemical dependency which emphasise the social dimension of these experiences.

Community writing groups

As Rebecca O'Rourke and I have argued in our discussion of community writing and orality, 'The Values of Community Writing', they are distinguished from traditionally valued literary writing on the basis of a concern with participation, diversity and inclusivity (Hunter and O'Rourke 1999). However, we go on to argue, these do not explain why, and to whom, they continue to be useful and valuable. We suggest that community writing and orality widen the base of those participating in mainstream culture, they contribute to a more equitable or representative common culture, and they return culture, and its role in the creation of meaning and identity, to a more broadly defined social location than it often inhabits. There are several groups active in promoting community writing and orality in the UK, among others the Workers' Education Associations. To take just one example, the West Mercia WEA in Stoke-on-Trent has extensive programmes of writing which encourage both individuals and community groups to tell their own stories, put them into words. The activities are a facilitating move that is not directive, but which extends democratic access to words and gives the writers the experience of writing themselves into existence. Most of the accounts are written directly to the reader:

> I do hope you will enjoy them [the poems] and maybe relate to some of these emotions. (Rigby 1997?: 1)

> I would like to think that my grandchildren and great grandchildren would read this to find out what my life was like as a young person. (Rhodes 1998?: 1)

> We needed to write about them so we could tell our stories to other people and because it was good to write them down. (*The Trials and Tribulations of Being a Mum* 1997?: 1)

I hope you will enjoy reading them as much as I have enjoyed learning of them. (Stewart 1996?: 1)

They invite an audience, they address their community of readers, whoever they may be, and in doing so they deal with their own identity, a basic activity that generates a sense of social position and agency from which social definition and change comes about. This is slow but fundamental enfranchisement of the gifts of writing, of poetry and of other verbal arts.

Rebecca O'Rourke and I chose the word 'useful' deliberately, signalling a break with the values of rarity or scarcity and exchange often more traditionally associated with artistic activity. Community writing and orality are also distinctive for another reason, which bears on the broader relationships between culture and politics raised here: namely the way in which models of cultural production are so often individualistic in their focus and the challenge to this of co-operative and communal forms of artistic (and critical) practice. Yet we argue also that community writing does not just widen the pool of potential participators in mainstream cultural forms, and nor are its purposes limited to the literary. The way in which it encourages participation, builds individual and social confidence and communicates across as well as within specific cultural situations provides a model of how individuals become empowered and active within groups. This can then be extended to other areas of social and political activity. Larger community projects, such as the project of 'Theatre and Reconciliation' in Eritrea or Northern Ireland, carried forward by Jane Plastow and Gerri Moriarty respectively, to deal with broad ethnic and religious differences, have proved vital to their societies, giving them, at times too briefly, hope. Moreover, these projects highlight the difficulty of bringing the activities and specific resolutions achieved by these projects into a political agency, a place where those strategies for resolution could gain a broader and more long-lived currency. The social uses of community writing and orality are, then, varied and powerful, but within our culture it is impossible to talk about writing for very long without coming up against questions of literary value.

Negotiating different verbal cultures

A similar negotiation of identity is found in much writing from communities that have come to live in the UK over the past few decades. In

Leeds there is a substantial population from the Caribbean, and one of
the writing groups that has emerged is the Chapeltown Black Women
Writers' Group, who published *When Our Ship Comes In: Black
Women Talk* in 1992. What strikes me most about reading this book is
its cumulative effect. Many of the accounts are about similar events, yet
each is distinctly different in its voice. The overriding effect is that I am
listening to a group of Black women talking, and that, just as with an
exchange that has acquired the formality of storytelling, I am listening
acutely for the repetitions that betray or portray personal rootedness,
for the shift in tone that adds another dimension to the speaking char-
acter. Some of the stories in the book draw on traditional genres, par-
ticularly the writing of Odessa Stoute, and a few pick up a metaphorical
or figural edge, especially when the women speak of religion or spiri-
tual experience. Katie Stewart's 'What Is Your Life?' begins:

> What is your life? Does it have meaning? Does it have purpose? A direction.
> What is your life? Is it a vapour? This is a question. What is your life?
> Well, what is a vapour? A vapour is water from the sea. We call it fog. If it
> stays in the ocean nobody would have noticed it. But it climbed out of the
> ocean overnight and it gets noticed in the morning ... So man is like a vapour
> that appear for a time. Today you are here, tomorrow. (Stewart 1992: 36)

Yet most of the accounts acquire their weight from the way the sentences
are structured, the prosody and its rhythms, which carry you both with
ease and with difficulty through the thoughts of the speaker. Notice how
in the following extract Jean White lets the structure of the sentences
reconstitute her own thinking:

> One of my achievements was starting a Sunday School in Roseville School.
> It was in the early 1970s when Enoch Powell was bringing the blood into the
> streets of Britain through the black people. We were scared. On the English
> people's side they were scared and on the black people's side we were
> scared. And my part in this was to ask the church to pray for that situation
> because there was fear on both sides. (White 1992: 37)

After her introduction there is the short line, 'We were scared', which
forms the centre of the historical memory of that period, followed by
the recognition that the English were scared too, in which we can see
the writer following her memory. The memory is balanced with a repe-
tition and augmentation of 'we were scared', and then she lets the next
sentence expand out into what she is going to do. These are tiny archi-
tectures of meaning, easy to miss, yet, when we pay attention to them,

quite robust if you read through the cumulative effect of the prose. As with the Caribbean writing I looked at in the third chapter, one of the vibrant strengths of the book is its ability to bring elements from the English verbal culture of the Caribbean into the English of Leeds in the 1980s and 1990s.

Other communities that have come to England from non-English-speaking countries present different kinds of difficulty in their writings. *Brushstrokes: A Collection of British Chinese Writing and Drawing* (1998) from Liverpool brings together a wide variety of written genres some of which are clearly part of a global media culture, such as Paul Wong's 'The Adventures of Sidekick Shang'. Others, such as Katherine Li's 'The Story of Mandarin Peel', have what I would call an allegorical focus (the multiple ambiguities that circle around the preparation and use of the peel) that also makes use of fable (embedding that ambiguity into the deathbed gifts of jewels and peel, the speaker taking only the latter), and yet situates the whole within a generational structure which moves in four paragraphs from the speaker's early childhood to her mother's life, her mother's death, to her own children. What is difficult for me as I read this account is my awareness that I know virtually nothing about the conventions of Chinese literature or its society, and yet this is clearly a highly literary piece of work. My problem arises from the ease with which I can appropriate the strategies and devices of the story, and, while it may be suitable to do so, it may not. It could be argued that this does not matter because at least some value is constituted from the reading. Nevertheless, my concern is that I am not listening attentively enough to the differences in the text, not positioning myself as an audience to be spoken to but one that is spoken at or for, and hence not learning about the values that it offers to me. I can address this by seeking advice from those who are more knowledgeable, visiting China and, of course, reading a lot more, all of which will have a cumulative effect. By generating this concern, however, the text brings us closer to the issues that surround the reading of world literatures in general, which I have discussed in earlier chapters.

Communities in transition: moving from the oral to the written

Back along the edges of conventional literary value are the texts from writers living in, or in the process of moving from, oral cultures, such as the Tlingit stories from Chapter Four. There are, for instance, a number

of books that have brought together writings from Irish Travellers
and from Gypsies. I would like to look at one of them, the collection
Moving Stories: Traveller Women Write (1992), which because of its
structure, placing stories by older women first and then accounts by
younger and younger contributors, takes the reader imperceptibly from
firmly oral devices into increasingly literate ones. As story after story
attests, the fact of the Traveller's way of life interrupts and prejudices
so much of society's response, particularly for the younger writers in
the key area of education where they come into extended contact with
settled people. This is nowhere more obvious than in the stories them-
selves, which could easily be dismissed as digressive, occasionally
ungrammatical and poorly shaped.

Yet the opening account by Kathleen Joyce draws clearly on orature.
The writing starts with the immediacy of 'The most important person in
my life was my mother', and moves swiftly on through an extraordinarily
compressed narrative of her mother's relationship with her, which serves
to delineate the mother rather than the speaker, and comes to rest in her
mother's death. This movement is all within one fairly short introductory
paragraph that is full of tightly knit parallel phrases, and pointed syntax
lightened with conversational devices and colloquialisms, the speed of
which is arrested in one of the final lines as it expands into 'She loved the
black apron with all the colours of threads going through it and embroi-
dery like flowers on the pockets'. Just as the First Nations oral stories I
looked at in the fourth chapter always begin with an acknowledgment of
their source, so Kathleen Joyce tells us first of her source, and in doing
so also offers us an enormous amount of contextual material that can help
us to position the narrative that follows. It is a profoundly moving
account whose focus is unusually not upon the individual but upon the
community, and once the introduction is complete, once the speaker
is located for the audience, Joyce proceeds with her history, 'One hun-
dred years ago Travellers used to ...' (Joyce, in Southwark Traveller
Women's Group 1992: 11).

There are, of course, many different kinds of oral cultures, and orality
itself is no guarantee of democratic access to words. One group of
writers quite aware of the problems that beset the oral is the MAMA East
African Women's Group, from one of the Somali communities that have
built up in England over the past decade of civil war in Somalia. Their
collection *Shells on a Woven Cord* (1995) offers a mixture of legend, fable,
realist life story, lyric, epic, prayer and testimony – an overflowing bowl

of verbal diversity that has been transposed with exceptional sensitivity and craft on to the page. One of the points made by the collection is that the entire life of these women is infused with poetry, as one woman put it, 'You need the words, the poetry, to put one foot in front of the other, to walk from one place to another' (Amina Souleiman, MAMA East African Women's Group: Gresham conference, January 1999). Poetry can be used to oppress, to humiliate and shame. It can also be used politically. One extract from the collection says: 'East African women organise events where we actually invite the tribal chiefs and show them the brutality. We do performances and sing to reveal the extent of the brutality' (MAMA East African Women's Group 1995: 80). Within oral culture too, we find a hierarchy of power in the world of aesthetics: poetry by men about men's lives, about heroism and fighting, is the valued verbal culture. In contrast, the poetry of women is kept out of public view, rarely circulated in the larger society, kept to the gatherings of women.

Contexts for storytelling

What is impressive about the MAMA women's collection is the range of topics that are addressed through working with words: business, spirituality, survival, family patterns, racism, refugee camps, Bedouin lifestyles, personal behaviour. The range underlines the book's fundamentally democratic approach, which accumulates density as one reads through it. Like the other collections of work that I have considered in this chapter, we cannot just dip in or out of the book, we have to spend time with it. This is partly for the very good reason that the community of speakers may not be familiar to us, and we have to learn about it and the techniques and devices that are being used. However, it may also be because much of what is talked about is in a sense too familiar, the domestic detail that can appear to be banal on its own, and needs context to throw forward the depths and particularities of its difference. To illustrate my point, let me tell you a story.

(1) Once upon a time there was a white woman who went to live in the country of black people. She travelled with her husband for they were trying to make a family. When they got there they went to live in a camp where all the other white people lived, although the white woman did make friends with some of the black people who lived on the surrounding farms. Well, that white woman, she finally got pregnant, and when she was about six months gone the baby clothes arrived

from the white country she had left behind, and she decided to have a party. The day of the party there was a knock on the door, and a man said to her that her husband had died while he was at work for the white people's camp. So there was no party. But then, all the women came anyway and told her she would have to leave the camp, because it was unlucky for a woman whose husband had died on camp business to stay. So she went to live on one of the farms. Then she went home so her baby would not be born in a black country. Good thing she had some black friends though.

(2) Shortly after the Second World War, when that extraordinary mixture of cultures which had converged on Europe to help the motherland was melting away, an English woman married one of the officers in the Royal New Zealand Air Force. They tried New Zealand, but the society was so different to that of England, that she persuaded her husband to join the RAF, and they were almost immediately posted to what was then Southern Rhodesia. In Bulawayo they lived on the usual RAF base, one of those carefully rule-governed spaces that have allowed the British to keep up morale throughout their ventures into other countries around the world, by providing them with an analogue of home life. But they travelled widely and made friends among their black neighbours. The couple had been trying for some time to start a family, and as luck would have it a Harley Street doctor kicked out for some indiscretion but at the top of his field in gynaecology and obstetrics, had come to live there and treated her successfully. When she was about six months pregnant, the baby clothes arrived from England, and it was a tradition on the base to hold a party among the officers' wives. Yet the very same day as the party, her husband died on a training exercise, and a fellow officer came to the door to tell her that she must leave. It was bad luck if the widow of a man who had died on duty stayed on the base. So she went to the farm of a black woman who lived nearby, and after a couple of months she returned to England, having the baby just as she landed at the Air Force base at home.

(3) My mother was by all accounts a very beautiful woman. During the war she married a New Zealand air pilot, and went with him to New Zealand afterwards. But she was not cut out for the kind of life she lived there, and they decided to go back into the forces by joining the RAF. By 1949 they had been posted to Bulawayo in what is now Zimbabwe, where they, of course, lived on base, but made friends among the surrounding farming families both black and white. My mother had had a

terrible history of miscarriages, but was desperate for a family, and when an ex-Harley-Street doctor, reputedly kicked out for abortion, came to Salisbury, she went to him for an examination and he success-fully treated her for a hormone deficiency that is well-known these days but was not at the time. My father was a pilot of considerable skill. He had, after all, survived the war. One of his duties was to train other pilots, and one day he was out teaching a pilot to fly when they went into a loop and the plane did not pull out. One of his friends went to tell my mother, and came to the door soon after a package of baby clothes had arrived. She said she had them all out on the sofa, and some friends were round, when the man came. The trainee pilot lived thank God, but my father died in the ambulance taking him to hospital, and later that day my mother was asked to leave the base because it was unlucky for the widow of a man killed during an exercise to stay. For the next two months she lived on the farm of a black woman called 'Lynette', but decided to return home so that I would be born in England.

There is a life story which, if I had told it in reverse order, might have been embarrassing for you, too close to the personal, too private. The first version is clearly fabular, telling us a story about who we think our friends are and who is really a friend. The second version is more of a novelistic, magazine read, which situates the story historically and geographically in a public space. By the time we reach the third, I would hope that you have been exposed to a wide enough range of approaches that you can read it without feeling cornered by its personal location and be able to build your own textual situation as you go.

Repetition gives us structures for reading, not only in the generic which we know about but in the small details and skeletal architectural features that hold writing together and that we glimpse in passing. It seems to me that, as we read more, these elements acquire significance as we begin to notice them in a variety of different environments, but we do need to take the risk of reading more and reading slowly, if we are to appreciate them. With each writing project, each individual adds their density and weight to the collective whole, so that the writings demonstrate the variability of self, the questioning and ambiguity of identity, in which the speaking voice asks not only the reader, but also itself, what is trustworthy and what is of value. The voices provide a context for each other; the web of differences they share helps us untang-gle the complexity of the lives that are being told. I firmly believe we need new democracies of words, we need to learn how to engage with

the arts in everyday lives, to engage with other people's artistic skills in order to value their lives. Working with words is one of the central strategies for constructing difference, and one of the central strategies for valuing difference. If words may keep us apart, without them we never get together.

CHAPTER NINE

Textual communities: how do we recognise value in the verbal arts?

The history of rhetoric tells us that people in the west have been extraordinarily consistent about how to recognise literary value. From Plato onwards, there is a long line of commentators who agree that value never comes only from sensual satisfaction, nor only from a recognition of worthy craft skills. Although value needs these elements, it also comes from a recognition that the audience is welcomed into the work of art: in literature, that the reader and the writer quite literally meet in the words and get to work on meaning and pleasure. However, nothing is so simple. What rhetoric also tells us is that, just because value depends upon communities of people, there may be shared elements of strategy or technique that go into producing value, but that each community is different. *Today, there is an acute problem with literary value because there are, for the first time in our recorded history, a host of communities within one nation, as well as hosts of other communities from around the world brought close to us by ever-more-intimate media, all making claims on literary recognition and value.* This final chapter will focus on the different ways in which we set about forming communities within which we can recognise value.

Writing and speaking are 'small p' political. Verbal arts, like other arts, are there for us to articulate ourselves into being, into recognition and into value. Without them we are excluded, devalued and have lost a primary mode for constituting the meaning of our lives. When I have asked, are the words speaking *at* us or *for* us or *to* us, the interesting thing is that whether a text, say a poem, does one or the other depends not only on the poet but also on the audience. Do we want to be spoken to? Or do we prefer the comfort of being spoken for? Or, do we feel so estranged from poetry that we respond as if we are spoken at? In this

final chapter I want to explore some of the different approaches to texts taken by critics – culturally recognised 'readers' – and by general readers. Readers are the other part of a textual community and we need to have a more flexible idea of what they contribute to 'literary value' to address some of the new issues of access and power and value raised by the verbal arts today.

For example, when Ted Hughes writes:

Black Coat
I remember going out there,
The tide far out, the North Shore ice-wind
Cutting me back
To the quick of the blood – that outer-edge nostalgia,
The good feeling. My sole memory
Of my black overcoat. Padding the wet sandspit.
I was staring at the sea, I suppose.
Trying to feel thoroughly alone,
Simply myself, with sharp edges –
Me and the sea one big tabula rasa,
As if my returning footprints
Out of that scrim of gleam, that horizon-wide wipe,
Might be a whole new start

(Hughes 1998)

Is he speaking for us – or to us? Is he valorising a sense of individual self-sufficiency, of starting again, the 'Every man is an island' philosophy of the modern world?, or Is he inviting us to participate in labouring over these words so we think about the hesitation of 'I suppose' and 'as if', the ironic edge to a self-serving 'tabula rasa' that has inspired so much liberal philosophy, and the seductive way we re-member into the 'good feeling' of nostalgia when we try to explain things to ourselves (Hughes 1998)?

What I would like to discuss, more raising questions than offering answers, is the difference between what I have called aesthetics *à la carte* and aesthetics in the kitchen. In the last chapter I made a distinction between the rhetoric of speaking for and that of speaking to, by drawing on Aristotle. He makes it quite clear that speaking for others means treating them as if they were all the same, and one example of this kind of writing might be a poet laureate such as Ted Hughes or, currently, Andrew Motion. A great deal of the critique that these chapters have attempted to make has been of aesthetic systems and their critical

vocabularies that try to treat us as if we were all the same. And simul-
taneously the critique has tried to think of approaches that could begin
to deal with the sheer amount and diversity of orature, book art, elec-
tronic script, writing and print, coming as it does not only in different
media but from all different parts of society, with which we currently
are faced. Many people are concerned with exactly these issues, and
over the past several years many new approaches to aesthetics have
been drawn up. I want to consider some of these and ask if they can
help us in deciding what kind of textual communities we would like to
support and further. At the same time, I will present some poems and
consider some stories, as a counterpoint to the philosophy.

Can there be new approaches for criticism?

In Chapters Seven and Eight I was concerned to look at problems that
arise in terms of understanding the literary value of texts that are
peripheral to the canon, problems that arise because of the blinkers put
on by canonical criticism. In this final chapter, I would like further to
explore the social implications of writing and reading and discuss the
intersection of aesthetics with social change. Criticism, for historical
reasons I mentioned in Chapter One, has for over a century colluded
with educational policies and the publishing businesses, in valuing
writing from a small privileged sector of society that had been in place
from the late seventeenth century at least: people who had the leisure
time to write were by definition privileged in a world without social
security plans or a national education provision. During the twentieth
century, social policy shifts in Britain and many other parts of the Eng-
lish-speaking world made possible a quite different access to cultural
production and consumption. Yet the three partners of criticism, edu-
cation and publishing maintained the privileged attitude to literary
value – and, as our university syllabuses demonstrate, the privilege still
largely dominates to this day.

Beyond issues of cultural power, as we all know, lie issues of social
and political power. In nation states similar to Britain, governments and
civil servants gain credibility partly from the stability and coherence
they are able to project, and one of the primary strategies for maintain-
ing such stability is through the representations of identity that culture
mediates. A crude way of putting this is to say that nation states have
certain requirements in order to exist, an ideology, and that all people

living within those states have to fulfil some part of those requirements to be recognised as citizens. Some commentators get more specific and point out that in effect not everyone *is* recognised as a citizen. Most states have a more or less privileged group, a hegemony, that maintains itself by calling the shots and fulfilling the requirements, while everyone else is outside that participation in power. The extent to which we participate in power is a measure of the extent to which we are part of the hegemony.

If we focus on ideology and the representations it allows, such as 'housewife', 'teacher', 'teenager' and so on, one of the key elements to emerge is that sense of compromise. If we fulfil the role, then we are recognised. But we all usually feel that these representations are not adequate to our larger sense of 'who we are'. For those people who do not fit the representation very well, this is often a frustrating experience, testified to by many studies of the split personality, the gothic, the criminal, the insane, the hysteric. This is where the concept of 'hegemony' is useful because it implies that if we can get a foothold on to power then we can challenge the representations, even change them a little – but not too much. For many people, simply getting heard within an arena of power is a major achievement, change is an added luxury. Writing and reading, speaking and listening, work the same way. Valued literature is recognised as such when it fits the representations. What history teaches is that too close a fit produces writing that dates; what we like to remember is writing that challenges. As explored in the first chapter, the artist is the licensed transgressor of the state. If I continue the vocabulary from the preceding chapter: literature that 'fits' speaks *at* the audience, but all too often writing that challenges tries to speak *for* the reader.

This book has asked: what happens if the writer and reader, speaker and listener, try neither to 'fit' nor predominantly to challenge, but to write or speak into existence the lives of people who are peripheral to ideological requirements – people who have little or no representation within the nation state? And it is concerned to explore how criticism has to change so that it can speak of literary value in the broad and diverse fields of writing and orature that are emerging and claiming cultural recognition. In broader social arenas this kind of recognition is a hallmark of much twentieth-century change. For example, many people classified as 'mad' even as recently as fifty years ago (so they are still alive), because society did not know what to do with 'them', are now being given a measure of dignity and individuality. There have been

similar shifts in cultural recognition, for example, for writing in English from countries outside Britain and America. As explored in Chapter Two, recognition of value is obtained more easily for cultural products that 'fit'. Yet precisely because many writers do not find themselves even adequately represented by existing ideas of literary value, much recent verbal art, like that discussed in Chapter Three, has experimented wholesale with the ideas of authorship, linearity (or a stable text one can read from beginning to end) and a single medium, in order to articulate their particular and situated lives.

What is interesting is that valued writing and reading from the canon is in itself no different in kind from recent situated written and oral texts. The socially privileged writer whose work fits the canon is just as concerned with the inadequacy of his or her representation, although necessarily, because their privilege comes from the support they give society, that inadequacy will not be as marked as that of someone more marginal to the location of social power. The privileged writer is less pressured into articulation than those with lives that have rarely or never been told or valued. Yet many of the challenges offered to representation are precisely concerned with the fact that the situated life of the privileged writer does not fit the permitted images, and they have generated much experiment with form in attempts at better 'fit'. More difficult to handle is the idea that criticism often does makes a distinction in kind between the valued canonical literature of privileged writers and the situated writing of groups peripheral to power. Even if canonical writing in effect does many of the same things, the filter of cultural power put in place by criticism, education and publishing categorises it as valuable and other writings as not worth the name 'literature'.

It is hard work to construct a different critical vocabulary that can speak about literary value across the many diverse voices that are now emerging, and even harder to establish rough guidelines for oneself about what we are going to read or listen to, given the exceptional amount of verbal art that is being produced. Chapter Four is an example of an attempt at using current critical vocabulary to do just this, and subsequent chapters explore ways that critical language may articulate value in electronic texts. Yet each of these attempts demonstrates that not only critical skills but also general reading skills need change if they are, analogously, not to read *at* or read *for* but read *to* their texts. If readers read *at* or *for*, they also will be dealing with texts as if they can command their meaning, or as if they are there simply to satisfy and

comfort the reader: these are activities that I call aesthetics *à la carte*. To participate in the work of articulating our own situatedness as readers or listeners we need to read and listen *to* a text, get involved with how it makes meaning and negotiate with it: this is an aesthetics that reminds me of being in my kitchen surrounded by people coming and going, preparing, waiting for and enjoying the meals that come out of it.

Aristotle, Plato and the rhetorics of love

These approaches, of aesthetics *à la carte* and aesthetics in the kitchen, were explored further in Chapters Seven and Eight. The discussion ranged over increasingly non-canonical texts – the questions they raise, the responses they generate and the strategies we can employ as guidelines to negotiating their often radically challenging textuality.

If Aristotle makes the distinction between speaking for and speaking to, a little earlier Plato made a similar distinction but went further. In the *Phaedrus* he argues that there are three types of rhetoric: the first is persuasion to do with appetite and satiation – it is a rhetoric of exploitation; the second is persuasion by exchange, in which all parties know what the hidden agenda is and agree to talk, listen and respond on an equal footing – most of our interactions with politicians are of this kind; and the third type of rhetoric, the type to which the others should aspire, is love. But Plato seems to have a very specific kind of love in mind. In fact, the *Phaedrus* presents the first two types of rhetoric as two types of love, one for power and one for property. The third type of rhetoric is philosophical love, in which we come to an appreciation of the other person or people not because they reflect or mirror ourselves back to us but precisely because they ask us to negotiate with their difference. Where Aristotle says that plausible rhetoric, the rhetoric that speaks for us, is appropriate within small circles of knowledge, Plato argues that, although we may not always achieve it, we should always be attempting to persuade through the rhetoric of the probable, the rhetoric of love that speaks to us.

Plato's images of how this persuasion works are gardening and medicine, a medicine that does not try to cure all people with the same drug in the way western medicine does, but which remains sensitive to each person's location and place and which will offer twenty treatments for one illness, suggesting different amendments for each individual. The history of Platonic philosophy has in many ways been a response to this

idea of the negotiation of difference. If Socrates says, through Plato's mouth, that we have to lose ourselves to find ourselves, the giving up to difference can happen in many different ways. Among many other things it can be, as religious discourses of criticism once reminded us, and as Lacanian discourses remind us today, a description of a fallen state, of loss, or inadequacy: in either it may be an invitation to sacrifice; it can also be an exercise in tolerance or in oppositionality; or it can be, as it is for me at least, a negotiation with the elusive but incontrovertible edge of difference that cannot be argued away.

A lot of modern writing does not ask for anything like this. It offers us conventions that we recognise and understand, that are part of our own field of vision. Much writing works self-consciously like Aristotle's sense of 'science', a closed community of writers and readers, especially in the area of genre fiction such as the detective story, fantasy, horror and/ or science fiction. This writing often gives us the representations of ourselves as we are used to seeing them. It is comforting, seductive, sometimes annoying in its predictability, and always implicitly inadequate to who we are or where we think we are located. It is more likely that we will value writing that to some extent challenges those conventional representations of who we are. We do not like being homogenised and universalised. We appreciate the value in language that recognises that we are individual, and that, in doing so, values us.

'Command' and 'tolerant' aesthetics

We do not enjoy a Shakespeare sonnet because we are told to do so, because he is a 'great writer', but because we feel it – aesthetics means 'feelings':

Sonnet 29
When in disgrace with fortune and men's eyes
I all alone beweep my outcast state,
And trouble deaf heav'n with my bootless cries,
And look upon myself, and curse my fate,
Wishing me like to one more rich in hope,
Featured like him, like him with friends possessed,
Desiring this man's art and that man's scope,
With what I most enjoy contented least;
Yet in these thoughts myself almost despising,
Haply I think on thee, and then my state,

Like to the lark at break of day arising,
From sullen earth sings hymns at heaven's gate;
 For thy sweet love remembered such wealth brings
 That then I scorn to change my state with kings.

 (Shakespeare 1997: 169)

The heaping of miseries that are in the first eight lines with repeated
'and's and 'like's that explode into the grasping tension of 'this man's
art and that man's scope', and the way that the verse lines will not let
the reader go, just pushing our eye on and on through an obsessive
grammar that only rests with 'Yet ...' in line nine: these are rhythms and
patterns that many readers can literally 'feel' as physical events of
despair's frustration (Shakespeare 1997: 169). If we read slowly
enough, we do not need an aesthetic judgment about the writer's
canonicity to enjoy the words.

Richard Holloway, the recently retired Episcopalian Bishop of
Edinburgh, has spoken of the collapse of 'command ethics' in the
church. In a parallel argument, with the growing number of diverse
voices, there has been perhaps not a collapse but an erosion of com-
mand aesthetics. The 'canon' of English literature, as the bastion of
what is credited as good writing, is challenged with regularity if not
fundamentally altered. One response to the challenges has been the
development of a tolerant aesthetics, one that benignly puts up with
diversity. The philosopher Richard Rorty posits this kind of approach,
describing it as a 'cultural bazaar', in which we shop around or display
our wares with some kind of equality. Nevertheless, as I have argued
earlier in this book, in this cultural market some traders are more
equal than others. Some have better routes for education, for produc-
tion, for distribution, for recognition and reward. Some simply have
better food and clothing.

Tolerant aesthetics, like command aesthetics, is appropriate only for
those already being heard and valued, for those who already have
access to cultural power. Poets seem to know this, but critics often do
not. If command aesthetics speaks at people, tolerant aesthetics is more
insidious in the way it claims to speak for people while at the same time
implicitly upholding the values of the cultural community already in
power. A curious thing happens in tolerant aesthetics: different uses of
language appear to be inadequate, and hence failing, while in effect
they are being assessed within an inappropriate context, a context that
cannot even hear them.

This is not new. Think of the difficulty Wordsworth had in being heard – how could the early nineteenth century ear not have responded to:

Lines Composed a Few Miles above Tintern Abbey
Five years have past; five summers, with the length
Of five long winters! and again I hear
These waters, rolling from their mountain-springs
With a soft inland murmur. – Once again
Do I behold these steep and lofty cliffs,
That on a wild secluded scene impress
Thoughts of more deep seclusion; and connect
The landscape with the quiet of the sky.
The day is come when I again repose
Here, under this dark sycamore, and view
These plots of cottage-ground, these orchard-tufts,
Which at this season, with their unripe fruits,
Are clad in one green hue, and lose themselves
'Mid groves and copses. Once again I see
These hedge-rows, hardly hedge-rows, little lines
Of sportive wood run wild: these pastoral farms,
Green to the very door; and wreaths of smoke
Sent up, in silence, from among the trees!
With some uncertain notice, as might seem
Of vagrant dwellers in the houseless woods,
Or of some Hermit's cave, where by his fire
The Hermit sits alone.

(Wordsworth 1992: 116–20)

The lack of a classical vocabulary, the personal immediacy of the writer, the experiments with the verse line, all struck his contemporaries as odd and wilfully unpoetic. Yet the writing has become the bedrock for lyric poetry in English written over the past two hundred years.

Recent critical responses: 'sacrificial' and 'agonistic' aesthetics

Responses to command aesthetics and tolerant aesthetics often perpetuate the idea of *à la carte* representative structures that fit the dominant ideological set. One of the predominant responses to the way that poetics tries to do something radically different with language has been to think of marginalised writers as pushed to the periphery of recognised culture, and therefore somehow unable to use the available strategies of poetry to talk about their position. This kind of approach argues that,

because the conventions of language and poetics are so strong, it is literally impossible to use them to voice the concerns of those excluded from cultural power. Hence, for example, women, hence Black writers, will be able to arrive only at a sense of value tied to the recognition of loss, or absence, or lack – and end in silence. It makes sense that, if we choose to write within the strategies that are on offer, we may not find anything appropriate, because if we have been excluded from valued writing for so long then there may not be a tradition for working on our (also excluded) lives. One example of this might be lesbian love poetry, for, despite Sappho, the love poetry tradition has been centred mainly on heterosexual male love. This critical approach can be summed up by the phrase 'sacrificial aesthetics', and is quite widespread in the scholarly world. It assumes that writers sacrifice something of themselves in order to be able to write at all within the conventions on offer.

Read and listen to Daphne Marlatt. I cannot say I find her poem 'Kore' sacrificial:

Kore
no one wears yellow like you excessive and radiant store-
house of sun, skin smooth as fruit but thin, leaking light.
(i am climbing toward you out of the hidden.) no one
shines like you, so that even your lashes flicker light, amber
over blue (*amba*, amorous Demeter, you with the fire in
your hand, i am coming to you). no one my tongue
burrows in, whose wild flesh opens wet, tongue seeks its
nest, amative and nurturing (here i am you) lips work
towards undoing (*dhei*, female, sucking and suckling,
fecund) spurt/ spirit opening in the dark of earth, *yu!*
cry jubilant excess, your fruiting body bloom we issue
into the light of, sweet, successive flesh …

(Marlatt and Warland 1994: 13)

What emerges from these critical approaches is a picture of a central systemic tradition which contains the legitimate images through which we may represent ourselves. If we do not fit, then that tradition of criticism thinks that our writing loses something, perceives it as inadequate. Similarly, there are critical approaches that could be called 'agonistic aesthetics' which set themselves up in opposition to that central tradition, continually testing the limits to which it can be pushed or shifted. Significantly, proponents of such an approach tend to be those who have

at least some cultural power, often those relatively empowered 'intellectuals' whose business it is to translate the changing needs of individuals into something that can be represented within convention. All poets are to some extent faced with the critic's problem, that's why they work on language. Here is the first stanza of Andrew Motion's 'To Nelson Mandela: A Tribute':

> That straight walk from the
> prison to the gate –
> that walk the world saw, and
> which changed the world –
> it led you through to life from
> life withheld,
> from broken stones with your
> unbroken heart
>
> (Motion 2000)

The writing is faced with the problem of bringing into words experience that challenges the representative images on offer within nation states. Nations repress and oppress people who want to change them in ways that will displace the powerful. Here the English poet laureate, representative of a nation, pays tribute to someone repressed by another state. The verse circles around the two perspectives, 'that walk the world saw ... / which changed the world', 'to life': 'from / life', 'broken stones' / 'unbroken heart' (Motion 2000). The language is direct, using a simple device of repetition with sureness and delicacy (the repetitions are never quite the same). To have attempted to articulate the radical otherness of Mandela's convictions might well have alienated the reader. Here the verse offers that otherness as an opposite to something the reader knows, hence it will be based on a political position with which we are familiar. The strategy is politically important and encourages the reader to understand that dissent occurs and can effect change. Yet it does not try to make available a radically different alternative.

None of these approaches really addresses the needs of those people outwith the system of representation, those people who do not worry about inadequate representation because they cannot be heard at all except within their specific location. Most of these critical approaches to aesthetics present the writer as transgressor, a single individual making little impact on the larger structures of the canon. Moreover the reader, on whose behalf the writer transgresses, becomes caught within

representations. The process leaves the reader in particular feeling deprived of agency, unable to discuss our responses, to articulate the things we find difficult to value yet which are immediate to our lives.

Situated knowledge and texts

These considerations are at the centre of a growing area of philosophy concerned with situated knowledge, knowledge that is specific to local communities. Bringing these philosophical issues into the area of language, writing and poetics is work at the leading edge of literary aesthetics, for situated knowledge cannot work without a sense of textuality. I want to explore this area for the remainder of the chapter, and ask first, What is situated knowledge? and then, What is situated textuality?

Situated knowledge looks at the knowledge and value formed from the standpoint of people who do not usually get access to cultural power, and argues that precisely because that standpoint is so different to the traditional system it can be a place for change, assessment and renewal. Situated knowledge is necessarily partial because it is specific to particular communities, and it is concerned with redefining knowledge and value to account for those people who are not in the mainstream of access to power. In other words, it is obviously outside command and tolerant aesthetics, but it also denies that sacrifice and continual opposition are helpful strategies. Who has elaborated on it? As you might expect: those people who are not usually allowed to contribute to conventional systems – women working on science, 'community writers', Black people working on valid knowledge, aboriginal people working on philosophy and so on. Inuit storytelling in the newly formed political entity of Nunavut is a further example of situated knowledge finding textual strategies, to which I will shortly return.

People concerned with situated textuality are concerned with the way that this kind of knowledge gets put into words; after all you cannot have knowledge without communication. Situated textuality asks: Could you do poetics differently if you did not erase people outside conventional representations? and if so, How could you do it differently? Could we put into words lived experience that has not been spoken, recognised, legitimised by mimetic repetition, agreed to, valued and acted upon? – the tacit that we all have to work on within the limitations of language. And, could we recognise the value in those words, not primarily because they speak of similarity but also for their difference? Asking these

questions lies at the centre of philosopher Lorraine Code's suggestion of a knowing through stories that develops responsibility for others through empathy. Despite its potential for manipulation, empathy and, I would add, story are a 'nuanced mode of knowing' through which we learn a rhetoric of speaking to people rather than for them (Code 1995: 130). The point, for Code, is to learn to treat others as the 'friend'. She says that we learn to respect people as a 'second person' not 'third person' individual. Second-person ethics is central to a rhetoric of 'speaking to', because it brings us together in both a commonality and a difference that is based on trust and friendship (Code et al. 1991: 23).

Code's deployment of narrative and story is extraordinarily helpful in the way it begins to lay out a vocabulary for textual valuing. She notes that, because we cannot 'know' everyone intimately, there is the 'cognitive and moral importance of an educated imagination as a way for moral agents to move empathetically beyond instances they have taken the trouble to know well to other, apparently related, instances'. Such textual work with narrative is 'responsible cognitive endeavour', which educates individuals in the dangers and corruptions of social stereotyping. She continues by saying that empathic knowledge is intersubjective and necessarily ambiguous. Drawing on the work of Simone de Beauvoir, Code defines empathy this way because 'Its ambiguity is manifested in coming to terms simultaneously with the other's likeness to oneself, and her/his irreducible strangeness, otherness' (Code 1995: 92–93, 141). In resisting the attempt only to find sameness in other people, and in recognising the simultaneity of mutuality and difference, empathic knowledge is, according to de Beauvoir, love. Specifically, it is the love of Plato's philosophic lover in *Phaedrus*, who engages with love as gift always entailing responsibilities, and as possibility for change, and for whom such love is allied with a particular kind of engaged speaking and writing. As Hilary Rose concludes in her work on science, *Love, Power and Knowledge*, 'It is love, as caring respect for both people and nature, that offers an ethic to reshape knowledge, and with it society' (Rose 1994: 238). These quotations from a few philosophers may give you a sense of the ethical, in other words the social, commitment of situated knowledge, but how might this work with words in a situated textuality?

Labouring with the situated writer: *Selected Organs*

In practice, learning how to be a friend to the text as a reader, or writer, speaker or listener, means first of all working on words, and opening out textuality into articulations of different and immediately common ground. This work is vulnerable. Unravelling the representative leaves moments, sometimes longer, of free fall. We need support and we need to want to do it, and hence we need communities with a shared sense of what has to be done, if not urgency. Textual communities for opening out and building common ground usually go on in writing, particularly in the activity before the written enters the commercial world. The communities are often intimate and personal, families, writing or reading groups, newsletters, newspapers, magazines and, recently, email discussion groups. These communities implicitly involve not only writers but also their audiences, the readers and listeners. In these settings people work. We labour on the articulation of grounds – often initially with just a glimpse of commonality and shared ground that we seize upon and repeat, and in the to and fro of repetition gradually texture the movement into location, valuing and legitimating it.

I would like to think about this by looking at two extracts from one of my favourite pieces of writing, a prose poem by bpNichol, *Selected Organs* (1988). Nichol is someone who reaches into the body of language, its heart, mouth and musculature, in rather literal ways. He breaks apart words, letters, sounds and syntax, and restructures them so that they may release different feelings. Sometimes his work is exceptionally difficult to read, but in *Selected Organs* he plays oral storytelling devices against the written to loosen the ties of grammar and narrative. One of his key locations is the pronoun, and each section of the poem focuses in a different way upon pronouns. A curious event happens in the section 'The Mouth', as the 'I' moves toward becoming a noun:

The Mouth
1.
You were never supposed to talk when it was full. It was better to keep it shut if you had nothing to say. You were never supposed to shoot it off. It was better to be seen than heard. It got washed out with soap if you talked dirty …
2.
Probably there are all sorts of stories. Probably my mouth figures in all sorts of stories when I was little but I don't remember any of them. I don't

remember any stories about my mouth but I remember it was there. I
remember it was there and I talked & sang & ate & used it all the time. I
don't remember anything about it but the mouth remembers. The mouth
remembers what the brain can't quite wrap its tongue around & that's
what my life's become. My life's become my mouth's remembering, telling
stories with the brain's tongue. (Nichol 1988: 13–14)

The section begins with a series of clichés that distance common experi-
ence from the self by way of the collective 'you': 'You were never
supposed to talk when it was full. It was better to keep it shut if you had
nothing to say.' However, part 2 moves into the personal with a repetition,
from 'Probably there are ...' to 'Probably my mouth ...'. The phrase 'my
mouth' alternates with the pronoun 'I' for two sentences, as if 'my mouth'
is something separate from 'I', before a shift to an alternation between 'my
mouth' and 'my life': 'Life' displacing 'I'. Part 3 continues the dislocation
of 'I', and part 4 increases the momentum by way of a cumulative series
of stories about what dentists did to his mouth, which become longer and
more violent until he reaches dentist number six, when he brings back
'I' as a noun, as a character: 'I'd begun to see that every time I thot of
dentists I ended the sentence with the word "me"', who concludes, 'My
mouth was me'. Parts 5 and 6 anchor the 'I' down to 'bp' or 'books & pam-
phlets' [Nichol], who 'really runs off at the mouth' (Nichol 1988: 13–16).
Yet by the time we reach this cliché it is no longer a cliché but literal, and
we as readers can feel the personal life that invests the cliché with the
particular truth of this individual, that makes the pronoun a noun.

The section on the mouth is also a meditation on the Biblical phrase
'In the beginning was the word ...', and as the reader reads through the
whole book each section may be read as an elaboration on a Christian
aphorism or phrase. 'The Chest' is partly a meditation on 'the Word ...
made flesh', and how we tell our bodies into words, or, in effect how
very bad we are at doing just that (John 1.1 and 14, Revised Version).

The Chest
1.
... Until you were twelve everyone who was your age had a chest. But
then you turned thirteen & you had a chest & she had breasts on her chest
& your chest was puny & he really had a chest & she was chesty & all the
bad puns began about being 'chest friends' & it was 'chest too much' or
'two much' or 'two for tea anytime baby' ...
2.
From the age of five to the age of sixteen you kept getting chest colds.

Once a year for three weeks you'd be sick in bed, your voice getting
deeper (which you liked), your breathing shallower (which you hated),
your nostrils redder, your face whiter, saying mutter for mother muttering
for her. She'd bring you gingerale (to soothe your throat), vicks vaporub (to
clear your head), & you'd say 'I'm gedding bedder' over & over again like
a charm clutched to your hopeless chest, 'I'm gedding bedder' you'd say,
sinking further into the sheets, 'I'm gedding bedder', til the bed & you
were one pale continuous tone, white on white in white, 'I'm gedding
bedder – bedder.' (Nichol 1988: 21–22)

Nichol starts with the social language for the chest that promises all sorts
of recognisable narratives, and then undercuts them in part 2 by allow-
ing sound to take over from visual image, moving to an alternation
between 'redder'/'whiter', 'mutter'/'mother', 'muttering'/'for her', and
ending with the increasingly desolate monotone repetition of 'gedding
bedder' (Nichol 1988: 22). But parts 3 and 4 return us swiftly to the pub-
lic world, and the way that nouns are often almost 'things', they take over
what the body does, and often end in a tense explosion between feelings
and words – especially for a teenager experiencing sexual excitement for
the first time. The fifth and final part of 'The Chest' is a sad performance
of the social insistence upon the separation of the word and the body.
This particular body goes into therapy where it is told what and what not
to do, to separate the head from the body, the word from the body, to
stick to the conventional social story and keep the body out of it.

Each section of *Selected Organs* negotiates precisely that constric-
tion on what it is that we are conventionally expected to put into words,
and what this writer has to do, to rearrange language in order to speak
his body into it. I have described these parts in detail simply to give you
a taste of the kinds of strategies that Nichol develops so that he can
write from his particular knowledge and situation. There is no way we
can value his writing without engaging in those strategies immediately,
and labouring with him on the words. But as I have mentioned rather
frequently in these essays, this involves hard work.

The importance of situated readers: listening to Inuit storytelling

If we shift the focus slightly to emphasise the reader and listener in the
textual negotiation, we find ourselves looking more directly at the dif-
ferences thrown forward in a situated textuality. To do so I would like to

turn to some recent research that has taken me to Nunavut, the newly formed territory in the eastern Arctic of Canada, to explore the interconnection of storytelling and social change. The first aspect I learned about was that the stories, whether told to convey information, to demonstrate knowledge or display belief, depend on the recognised experience of the speaker. Hence if I asked a question of a woman interviewee about 'hunting', I would usually not be given an opinion or generalised comment such as I might have expected from someone in my own culture in England, but politely be told, 'I don't know about that'. Pauloosie Angmarlik put it this way: 'I have already stated that I can say that I don't know anything about it if I have only heard about it just once. If at a later time someone were to tell about it like it really is, and though I did not intentionally lie, I would be like someone who had lied' (Nunavut Arctic College et al. 1999: 6).

Just so, the listener brings their own experience to the story. The teller does not instruct or order the listener to hear a certain message, the listeners have to make the story their own.

At the same time, the crucial element of this textuality is the interchange between skilled tellers and skilled listeners. Tellers learn how to tell stories through observing and listening. Most of the accounts to which I listened said that there is no direct teaching. Similarly listeners, in time, learn how to listen. Elisapee Ootoova claimed the action of listening as a way of defining herself: 'We were often reminded that we weren't supposed to listen to conversations, but I was an expert listener' (Nunavut Arctic College et al. 1999: 20). Other interviewees backed this up, one commenting that 'She understood more over the years, after she had heard so many stories that she had learned a lot from them. That they are real. It took years to understand them' (Interviews 2000: 2). The skills being acquired were those of identifying common grounds through recognition of experience in common, but also of recognising differences.

Storytelling allows speaker and listener to locate and contextualise what is told. Conveying practical information in this way is usually more effective than simply stating or describing factual material because contexts are incorporated into the telling, and listeners can decide on how to apply the information appropriately. One story I was told remembered that, in the days when soap was not available, white sealskin clothes would be cleaned with eggs. The story had many points of commonality: it drew on a sense of 'fashion' and the lengths to which

people will go to follow it; it assumed a common concern with keeping clothes clean; and it underlined a common need for resourcefulness. At the same time, the listener from 'the south' would recognise differences. For example, washing with eggs leaves the clothes smelling in a way we might find unpleasant – and it is this very difference that might make the technique inappropriate for me. Yet, because this detail of difference emerges from an exchange where we work on constructing common ground, I understood why it was there. A commitment to that understanding which results from the work we carry out not only legitimates common ground but values the difference.

Similar valuing of difference will be constituted by storytelling around knowledge and/or belief. For example, Hervé Paniac told the story of 'that which remains undisclosed': about what happens when there is something that has been done and then hidden, which affects the whole community. In the instance he chose to tell about, a woman hid a stillborn child under a rock because she feared her husband's anger (Nunavut Arctic College et al. 1999: 58). After this, hunger came to the camp and the surrounding area, but a young shaman began to ask questions about the famine. Once he had found out where the problem was, he went to the camp of the woman and her husband, and heard from them all the things that they had done which might have contributed to the problem. He then went to the tent of the couple and told them that they had brought the famine. The wife disclosed what she had done, the husband was angry, and after hearing the confessions of the rest of the camp once more, the shaman departed. Sure enough, that night the ice broke and hunting resumed.

Hovering on the edge of a realistic story, the tale has elements in common with the more mythical stories of figures such as Sedna, whose hair must be combed to release the sea animals and relieve famine. Among many common grounds it might develop with a southern listener, particularly one from a Christian culture, could be the concept of 'confession'. Yet the story indicates that 'disclosing' is rather different because it is public. Indeed Elisapee Ootoova, also present at this telling, tried to explain that public disclosing, or *annqaqatuviniq*, is even more subtly distinguished in Inuktitut from another traditional concept related to but different from 'confession', of 'healing ... to get rid of their pain ... letting go of their wrong doings' which is *aniattunik* (Nunavut Arctic College et al. 1999: 153–161, 58, 59). I do not know why public disclosure is necessary, nor do I agree that it is usually helpful, but I can

recognise that it is important to sustaining this community and its practices. Reading or listening to this story with attention and the skills needed for the situation of this telling necessitated the formation of common grounds, which may not in effect have been common but made communication possible. Those common grounds then allowed the negotiation to point up differences in attitude and behaviour which could be valued even if not agreed with or even fully understood.

Discussion

The teller and listener effectively constitute an event where there is a subtle negotiation between the context of each. They find common ground, but the process also points up differences, indeed it constructs them. Yet because the differences have arisen in the course of negotiating over, labouring on, the words, each person learns why they are there, how they come about, and where each stands in relation to the other's differences. They recognise more than anything else, that the particular differences that have arisen are partly due to their own participation. These textual communities are not stable, and their basis in negotiation over difference means that they change. The account of listening offered above draws more on an understanding of rhetoric than of literary criticism. Yet the strategies of the storytellers and their listeners also cast light quite helpfully on the strategies I used for reading the writing of bpNichol. In effect, many of the issues have been pertinent to the explorations of previously marginalised verbal arts now asking to be valued. The rhetorical activity describes a process of becoming a 'friend' to the text, and through this activity building textual communities.

As I said in the introduction to this book, I think we need to work on different ways of approaching how we think of literary value or value in the verbal arts. Cultural power is shifting radically at the moment, and aesthetics and criticism need urgently to respond. Art is not something that stands isolated, strained mysteriously through human bodies. It is something human beings make in order to reach out, to touch, to interact with other human beings. What this book has tried to explore is not how we might identify which texts are 'good' or 'bad' but how we can work with texts to communicate better with other people.

REFERENCES

Aarseth, Espen (1997), *Cybertext: Perspectives on Ergodic Literature*, Baltimore, MD, London: Johns Hopkins University Press.

Adams, Robert M. (1990), 'Lucy and Lucifer', *The New York Review of Books*, 1 March, 38–39.

Ahmed, Kabir (1995), 'Orature, Politics and The Writer: A Case Study of Ngugi wa Thiong'o's Novels', in *The Pressures of the Text: Orality, Texts and the Telling of Tales*, ed. Stewart Brown, Birmingham, Centre of West African Studies, 47–59.

Atwood, Margaret (1976; 1966), 'The Circle Game', *The Circle Game*, Toronto, Anansi.

—— (1972), *Survival: A Thematic Guide to Canadian Literature*, Toronto, Anansi.

—— (1982), *Dancing Girls, & Other Stories*, London, Jonathan Cape.

—— (1996; 1985), *The Handmaid's Tale*, London, Vintage.

—— (1989; 1988), *Cat's Eye*, London, Bloomsbury.

—— (1991), *Wilderness Tips*, London, Bloomsbury.

—— (1994, c. 1993), *The Robber Bride*, London, Virago.

—— (1995), 'Down', *Morning in the Burned House*, Toronto, McClelland & Stewart.

Bannerji, Himani (1995), 'The Sound Barrier: Translating Ourselves in Language and Experience', in *Thinking Through: Essays on Feminism, Marxism and Anti-racism*, by Himani Bannerji, Toronto, Women's Press, 159–179.

Beardy, L. (1988), *Talking Animals/pisiskiwak kâ-pîkiskwêcik*, ed. and trans. H. C. Wolfart, Winnipeg, Memoir 5, Algonquian and Iroquoian Linguistics.

Brake, Laurel (1994), 'Oscar Wilde and "The Woman's World"', *Subjugated Knowledges: Journalism, Gender and Literature in the Nineteenth Century*, by Laurel Brake, Basingstoke, Hampshire, Macmillan Press, 127–147.

Brathwaite, Edward Kamau (1984), *History of the Voice: The Development of Nation Language in Anglophone Caribbean Poetry*, London, Port of Spain, New Beacon Books.

—— (1987), *X/Self*, Oxford, Oxford University Press.

—— (1992), *Middle Passages*, Newcastle-upon-Tyne, Bloodaxe Books.

Brossard, Nicole (1985), 'Tender Skin My Mind', trans. Dympna Borowska, in *in the feminine: women and words / les femmes et les mots*, Edmonton, AB, Longspoon, 180–183.

Brown, Stewart, ed. (1995), *The Pressures of the Text: Orality, Texts and the Telling of Tales*, Birmingham, Centre of West African Studies.

Brushstrokes: A Collection of British Chinese Writing and Drawing, 10 (October 1988).

Burnett, John, David Vincent and David Mayall, eds (1984–9), *The Autobiography of the Working Class: An Annotated Critical Bibliography, 1790–1945*, Brighton, Harvester Press.

Campbell, Maria (1995), *Stories of the Road Allowance People*, Penticton, BC, Theytus Books.

Chapeltown Black Women Writers' Group (1992), *When Our Ship Comes In: Black Women Talk*, Castleford, West Yorkshire, Yorkshire Art Circus.

Cockburn, Cynthia (1998), *The Space Between Us: Negotiating Gender and National Identities in Conflict*, London, Zed Books.

—— (summer 1999), 'Crossing Borders: Comparing Ways of Handling Conflictual Differences', *Soundings: Transversal Politics*, 12:94–114.

Code, Lorraine (1995), 'I Know Just How You Feel: Empathy and the Problem of Epistemic Authority', in *Rhetorical Spaces: Essays on Gendered Locations*, London, New York, Routledge, 120–143.

——, M. Ford, K. Martindale, S. Shewin and D. Shogan (1991), 'Is Feminist Ethics Possible?', *CRIAW/ICREF* (Ottawa).

Connor, Steven (1995), *The English Novel in History, 1950–1995*, London, Routledge.

Conrad, Margaret, Toni Laidlaw and Donna Smyth (1988), *No Place Like Home: Diaries and Letters of Nova Scotia Women 1771–1938*, Halifax, NS, Formac Publishing.

Cruikshank, Julie, Angela Sidney, Kitty Smith and Annie Ned (1990), *Life Lived Like a Story: Life Stories of Three Yukon Native Elders*, Vancouver, University of British Columbia Press.

Daley, Ian, and Jo Henderson, eds (1998), *Static: Life on the Site*, Castleford, West Yorkshire, Yorkshire Art Circus.

Danica, Elly (1988), *Don't: A Woman's Word*, Charlottetown, PEI, Gynergy Books.

Davey, Frank (September 1989), 'SwiftCurrent Returns', email.

—— (1991), *Popular Narratives*, Vancouver, Talonbooks.

—— and Fred Wah, eds (1986), *The SwiftCurrent Anthology*, Toronto, Coach House Press.

Davis, Norman, ed. (1958), *Paston Letters*, Oxford, Clarendon Press.

'Doing Transversal Politics' and 'Translating Words', 'Translating Practices' conference (29–30 January 1999), Gresham College, London.

Donnell, Alison, and Sarah Lawson Welsh, eds (1996), *The Routledge Reader in Caribbean Literature*, London, Routledge.

Eagleton, Terry (1976), *Criticism and Ideology: A Study in Marxist Literary Theory*, London, New Left Books.

Fanon, Frantz (1986; 1967), *Black Skin, White Masks*, trans. Charles Lam Markmann, London, Pluto.

Feather, John (1988), *A History of British Publishing*, London, Croom Helm.

Fowler, Alistair (1982), 'Literature as a Genre', *Kinds of Literature: An Introduction to the Theory of Genres and Modes*, Oxford, Clarendon Press, 1–19.

Ghosh, Amitav (1996), *The Calcutta Chromosome: A Novel of Fevers, Delirium and Discovery*, London, Picador.

—— (1997), Arthur Ravenscroft Memorial Lecture at Leeds University.

Godard, Barbara (1986), 'Voicing Difference: The Literary Production of Native Women', in *A Mazing Space*, ed. Shirley Neuman and Smaro Kamboureli, Edmonton, AB, Longspoon/NeWest Press, 87–107.

Haraway, Donna (1988), 'Situated Knowledges: The Science Question in Feminism and the Privilege of Partial Perspective', *Feminist Studies*, 14:3, 575–599.

Hariharan, Githa (1996), *The Thousand Faces of Night*, London, Women's Press.

Harris, Claire (1986), 'Poets in Limbo', in *A Mazing Space*, ed. Shirley Neuman and Smaro Kamboureli, Edmonton, AB, Longspoon/NeWest Press, 115–125.

—— (1992), *Drawing Down a Daughter*, Fredericton, NB, Goose Lane.

Harris, Wilson (1996), '*From* Tradition and the West Indian Novel', *The Arnold Anthology of Post-colonial Literatures in English*, ed. John Thieme, London, New York, Arnold, 532–537.

The Hartlib Papers: A Complete Text and Image Database of the Papers of Samuel Hartlib (c.1600–1662) (1995), Disc 1 and 2, Ann Arbor, MI, UMI.

http://lion.chadwyck.com

http://www.amazon.com

http://www.ardenshakespeare.com/ardennet

http://www.netlingo.com

Hudson, Pat and Lynette Hunter, eds (winter 1981), 'The Autobiography of William Hart Cooper, 1776–1857', *The London Journal*, 7:2, 144–160.

Hughes, Ted (1998), 'Black Coat', *Birthday Letters*, London, Faber & Faber, 102–103.

Hunter, Lynette (1999), *Critiques of Knowing: Situated Textualities in Science, Computing and the Arts*, London, Routledge.

——, and Rebecca O'Rourke (summer 1999), 'The Values of Community Writing', *Transversal Politics, Soundings*, 12, 144–152.

——, ed. (forthcoming 2002), *The Letters of Dorothy Moore, 1640–60*, The Netherlands, International Historical Archives.

Interviews (2000), Lynette Hunter conducted interviews in Nunavut in the summer of 2000 under Arctic Research Institute Licence: 010190 ON-A.

Jaggar, Alison (1989), 'Love and Knowledge: Emotion in Feminist Epistemology', in *Gender / Body / Knowledge: Feminist Reconstructions of Being and Knowing*, ed. Alison Jaggar and Susan Bordo, New Brunswick, NJ, Rutgers University Press, 145–171.

——, and Susan Bordo, eds (1989), in *Gender / Body / Knowledge: Feminist*

Reconstructions of Being and Knowing, New Brunswick, NJ, Rutgers University Press.

Johanknecht, Susan (1995; 1996), *of science & desire*, London, Gefn Press; and cd rom, Interactive Design & Programming, Everol McKenzie.

—— (1996), *WHO WILL BE IT?*, London, Gefn Press; and cd rom, Interactive Design & Programming, Everol McKenzie.

Joyce, Michael (1987), *afternoon, a story*, Cambridge, MA, Eastgate Systems.

Julien, Eileen (1992), *African Novels and the Question of Orality*, Bloomington, Indiana University Press.

Keats, John (1958), Letter to the George Keatses, 19 March 1819, *The Letters of John Keats, 1814–1821: Volume Two 1819–1821*, ed. H. E. Rollins, Cambridge, MA, Harvard University Press, 78–81.

Kincaid, Jamaica (1985), *Annie John*, London, Pan Books.

—— (1995), 'My Mother', in *Concert of Voices: An Anthology of World Writing in English*, ed. Victor J. Ramraj, Peterborough, ON, Broadview Press, 204–208.

King, Thomas (August 1997), 'A Short History of Indians in Canada', *Toronto Life*, 68.

Knockwood, Isabelle (1992), *Out of the Depths*, Lockeport, NS, Roseway Publishing.

Landow, George (1995), *The Victorian Web* [computer file] web access via http://library.brown.edu/search/ttle+victorian+web, Providence, RI, Brown University.

LaRocque, Emma (December 1992), 'My Hometown Northern Canada South Africa', *Border Crossings*, 11:4, 98–99.

LeMoine, Elizabeth, and Amy Gogarty (1997), *Listener, and Other Texts*, N.P., Truck Gallery

Li, Katherine (October 1998), 'The Story of Mandarin Peel', *Brushstrokes: A Collection of British Chinese Writing and Drawing*, 10:8.

MAMA East African Women's Group (1995), *Shells on a Woven Cord*, Sheffield, Yorkshire Art Circus.

Maracle, Lee (1990), 'Polka Partners, Uptown Indians and White Folks', *Sojourner's Truth & Other Stories*, Vancouver, Press Gang, 80–98.

Marlatt, Daphne (1988), *Ana Historic*, Toronto, Coach House Press.

—— (1996), *Taken*, Toronto, Anansi.

——, and Betsy Warland (1994), 'kore', 'Touch to My Tongue', *Two Women in a Birth*, Toronto, Montreal, New York, Guernica.

McKenzie, D. F. (1992), 'The London Book Trade in 1644', in *Bibliographia: Lectures 1975–1988 by Recipients of The Marc Fitch Prize for Bibliography*, ed. John Horden, Oxford, Leopard's Head Press.

Moody, J., ed. (1998), *The Private Life of an Elizabethan Lady: The Diary of Lady Margaret Hoby, 1599–1605*, Stroud, Gloucestershire, Sutton Publishing.

Moriarty, Gerri, and Jane Plastow (summer 1999), 'Theatre and Reconciliation:

Reflections on work in Northern Ireland and Eritrea', *Soundings: Transversal Politics*, 153–162.

Motion, Andrew (7 April 2000), 'To Nelson Mandela: A Tribute', *The Guardian*.

Munro, Alice (1986), 'The Progress of Love', in *The Progress of Love*, Toronto, McClelland and Stewart, 3–31.

Murray, Janet (1998), *Hamlet on the Holodeck: The Future of Narrative in Cyberspace*, Cambridge, MA, MIT Press.

New, Melvyn, ed. (1992), *The Life and Opinions of Tristram Shandy, Gentleman, Laurence Sterne*, Basingstoke, Macmillan.

Ngugi wa Thiong'o (1982), *Devil on the Cross*, trans. from Gikuyu by the author, London, Heinemann.

—— (1986), *Decolonising the Mind: The Politics of Language in African Literature*, London, James Currey.

Nichol, bp (1982), *The Martyrology, Book 5*, Toronto, Coach House Press.

—— (1988), *Selected Organs*, Windsor, ON, Black Moss Press.

—— (1993), *The Martyrology, Book 9*, Toronto, Coach House Press.

Nicolson, Nigel and Joanne Trautmann (1976), *The Question of Things Happening: The Letters of Virginia Woolf, Vol. II: 1912–1922*, London, Hogarth Press.

Njoroge, Hezekiel (1994), 'The Riddle', in *Teaching Oral Literature*, ed. Masheti Masinjila and Okoth Okombo, Nairobi, Kenya, Kenya Oral Literature Association, 45–65.

Nunavut Arctic College et al., eds (1999), *Interviewing Inuit Elders, Volume 1, Introduction*, Iqaluit, Nortext.

Okpewho, Isidore (1992), 'The Oral Performance', in *African Oral Literature: Backgrounds, Character, and Continuity*, Bloomington, Indiana University Press, 42–69.

Ondaatje, Michael (1992; 1983), *Running in the Family*, London, Bloomsbury.

—— (1993; 1992), *The English Patient*, London, Picador.

—— (1995; c. 1987), *In the Skin of a Lion*, London, Bloomsbury.

Oyebode, Femi (1995), 'Prosody and Literary Texts', in *The Pressures of the Text*, ed. S. Brown, Birmingham, Centre of West African Studies, 91–95.

Pañcatantra: The Book of India's Folk Wisdom (1997), trans. Patrick Olivelle, Oxford, Oxford University Press.

Perreault, Jeanne (1995), 'Autobiography / Transformation / Asymmetry', in *Writing Selves: Contemporary Feminist Autography*, Minneapolis, University of Minnesota Press, 1–30.

——, and Sylvia Vance, eds (1990), *Writing the Circle*, preface Emma LaRocque, Edmonton, AB, NeWest Publishers.

Philip, Nourbese (1988), 'Burn Sugar', in *Imagining Women*, ed. The Second, Second Story Collective, Toronto, The Women's Press, 11–19.

Plato (1998), *Phaedrus*, trans. James H. Nichols, Jr, Ithaca, New York, London, Cornell University Press.

Poole, Steven (10 May 1997), 'So English Writers Should Stop Being Smug and Give America What It Wants ...', *The Guardian*.

Puttenham, George (1968), *The Arte of English Poesie, 1589*, ed. R. C. Alston, Menston, England, The Scolar Press.

Quayson, Ato (1995), 'Orality – (Theory) – Textuality: Tutuola, Okri and the Relationship of Literary Practice to Oral Traditions', in S. Brown, ed., *The Pressures of the Text: Orality, Texts and the Telling of Tales*, Birmingham, Centre of West African Studies, 96–117.

Ramraj, Victor J., ed. (1995), *Concert of Voices: An Anthology of World Writing in English*, Peterborough, ON, Broadview Press.

Reynolds, Nigel (7 May 1997), 'Book Prize Judge Attacks "Smug" English Novelists', *The Daily Telegraph*.

Rhodes, Pat (1998?), *From Victoria Street, Burslem, to Marriage*, Stoke-on-Trent, West Mercia WEA.

Rigby, Ann (1997?), *My Life, My Reason, My Rhyme*, Stoke-on-Trent, West Mercia WEA.

Rindl, Deb (1995), *The Thin Blue Line*, London, Deb Rindl.

Rollins, Hyder Edward, ed. (1958), *The Letters of John Keats, 1814–1821; Volume Two: 1819–1821*, Cambridge, MA, Harvard University Press.

Rose, Hilary (1994), *Love, Power and Knowledge: Towards a Feminist Transformation of the Sciences*, Cambridge, Polity Press.

Rushdie, Salman (1988), *The Satanic Verses*, London, Viking.

—— (1991), *Imaginary Homelands: Essays and Criticism, 1981–1991*, London, Granta Books in association with Penguin.

——, and Elizabeth West, eds (1997), *The Vintage Book of Indian Writing, 1947–1997*, London, Vintage.

Ryman, Geoff, 253, http://www.ryman-novel.com

Sahgal, Nayantara (1993), 'Some Thoughts on the Puzzle of Identity', *Journal of Commonwealth Literature*, 28:1, 3–15.

Schoffeleers, J. M., and A. A. Roscoe, eds (1985), *Land of Fire: Oral Literature from Malawi*, Limbe, Malawi, Popular Publications, Montfort Press.

Shakespeare, William (1997), 'Sonnet 29', in *Shakespeare's Sonnets*, ed. Katherine Duncan-Jones, Thomas Nelson & Sons, 3rd Series.

Soundings: Transversal Politics (summer 1999), 12.

Southwark Traveller Women's Group (1992), *Moving Stories: Traveller Women Write*, intro. E. Laing, London, Traveller Education Team.

Spivak, Gayatri Chakravorty (winter/spring 1985), 'Can the Subaltern Speak? Speculations on Widow Sacrifice', *Wedge*, 7/8, 120–130.

Stewart, Chris (1996?), *Granny's Tales*, Stoke-on-Trent, West Merica WEA.

Stewart, Katie (1992), 'What Is Your Life?', in *When Our Ship Comes In: Black Women Talk* by Chapeltown Black Women Writers' Group, Castleford, West Yorkshire, Yorkshire Art Circus, 36–37.

Stillinger, Jack (1982), *Complete Poems/John Keats*, Cambridge, MA, Belknap Press of Harvard University Press.

Thieme, John, ed. (1996), *The Arnold Anthology of Post-colonial Literatures in English*, London, New York, Arnold.

The Travellers' Cultural Heritage Centre (1992), *Traveller Ways, Traveller Words*, Pavee Point, Dublin, Pavee Point Publications.

The Trials and Tribulations of Being a Mum (1997?), Stoke-on-Trent, West Mercia WEA.

Tyendinaga Tales (1988), collected by Rona Rustige, illus. Jeri Maracle Van der Vlag, Kingston, Montreal, McGill-Queen's University Press.

Walcott, Derek (1962), 'Ruins of a Great House', in *In a Green Night: Poems 1948–1960*, London, Jonathan Cape, 19–20.

White, Jean (1992), 'Voicing Our Needs', in *When Our Ship Comes In: Black Women Talk* by Chapeltown Black Women Writers' Group, Castleford, West Yorkshire, Yorkshire Art Circus, 37–41.

Wilkomirski, Binjamin (1996), *Fragments: Memories of a Childhood, 1939–1948*, trans. Carol Brown Janeway, London, Picador.

'Views: A Personal Essay', in *Standing Ground: Strength and Solidarity Amidst Dissolving Boundaries* (1996), ed. Kateri Akiwenzie-Damm and Jeannette Armstrong, *Gatherings*, 7, Penticton, BC, Theytus Books.

Williamson, Janice (1998), *Crybaby!*, Edmonton, AB, NeWest.

Wong, Paul (October 1998), 'The Adventures of Sidekick Shang', *Brushstrokes: A Collection of British Chinese Writing and Drawing*, 10, 7–8.

Woolf, Virginia (1985), *The Complete Shorter Fiction of Virginia Woolf*, ed. Susan Dick, London, Hogarth Press.

Wordsworth, William (1992), 'Lines Composed a Few Miles above Tintern Abbey, on Revisiting the banks of the Wye during a Tour, July 13, 1798', *Lyrical Ballads and Other Poems, 1797–1800*, ed. James Butler and Karen Green, Ithaca, NY, London, Cornell University Press, 116–120.